THE SUBJECT IN ART

The SUBJECT in ART

PORTRAITURE *and the* BIRTH *of the* MODERN

CATHERINE M. SOUSSLOFF

Duke University Press

Durham and London

2006

© 2006 Duke University Press

All rights reserved

Printed in the United States of America on acid-free paper ∞

Designed by C. H. Westmoreland

Typeset in Adobe Garamond by Tseng Information
Systems, Inc.

Library of Congress Cataloging-in-Publication Data appear
on the last printed page of this book.

Publication of this book has been aided by a grant from the
Millard Meiss Publication Fund of the College Art Association.

CONTENTS

ILLUSTRATIONS

Color Plates (between pages 82 and 83)

ACKNOWLEDGMENTS

During the six years of exploration that have taken me from the subject portrayed in the art of portraiture to the social context of the history of art, I have journeyed to many places in Europe and the United States where I have incurred, with pleasure, many intellectual and practical debts. I cannot adequately acknowledge all of them here. I have enjoyed and benefited from the generosity of family, friends, colleagues, students, and institutions. If I neglect anyone in what follows I apologize while remaining grateful to all.

Genya, my daughter, and Bill Nichols, my husband, have offered patience and understanding when my research opportunities presented them with the necessity of relocation and travel they would not otherwise have undertaken. As a family we have enjoyed the society and generosity of both strangers and friends that such scholarly emigrations provide. My brother Andrew Soussloff and his family, Patricia, Caroline, and Stephanie, gave me comfort and love on my cross-country research trips to New York City. My mother has been curious and enthusiastic. In all my travels I have always known where to find my brother Gregory and my sisters Elizabeth and Margaret, and my dear cousin Marie André.

My friends have given me support, sustenance, advice, and love,

even as I have traveled far from them. I thank Heather Thomas, Craig Czury, Melissa Colbert, Susan Montague, Glen and Susan Lowry, Bert and Lorle Wolfson, David Cast, Steven Z. Levine, Lisa Saltzman, Keith Moxey, Todd Olson, Claire Farago, Bluma Goldstein, Carmen and Percy Chirinos, Mark Franko, Don Brenneis, Margaret Brose and Hayden White, Karen Bassi and Peter Harris, Deanna Shemek and Tyrus Miller, Raoul and Celesta Birnbaum, Greta and Mark Slobin, Audrey Stanley, Christine and Brad Asmus, Kim and John Furman, Gretchen and Mark Block, Gabrielle Houston, Keith Moxey, and Jim Rubin.

I had the good fortune to begin this book as a scholar at the Getty Research Institute in Los Angeles, California. I want to thank Salvatore Settis, Michael Roth, Deborah Marrow, Charles Salas, and Sabine Schlosser for their generosity and for their belief in the value of my project. At the Getty, the research associates, the staff of the Special Collections Library, and the Getty Museum Department of Photographs provided essential materials and help in this project and others. Without the unfailing support of all of these departments and people I could not have done the research necessary for this book. To my GRI colleagues — many of whom have now become dear friends — I owe an immeasurable amount. Because of their learning and grace, the nine months I spent in Los Angeles changed forever my outlook on the project of this book specifically, and on what scholarly life offers in general. My thanks to: Stephen Bann, Paul Barolsky, Iain Boyd-Whyte, Michael Brenson, Elspeth Brown, David Carrier, Tim Clark, Hubert and Teri Damisch, Francesco de Angelis, Heinrich Dilly, Otneil Dror, Lydia Goehr, Tapati Gupta-Thakurta, Paul Carter Harrison, Neil Harris, Ingo Herkoltz, Michael Ann Holly, Stefan Jonsson, Sara Danius, Thomas DaCosta Kaufmann, Juliet Koss, Donata Levi, Steven Marcus, Yue Meng, Griselda Pollock, Robert S. Nelson, Margaret Olin, Ernst Osterkamp, Elena Phipps, Ingrid Rowland, Erika Rummel, Ilona Sámársky-Parsons, Nick Parsons, and Elizabeth Sears. In Los Angeles, the Skirball Cultural Center and the Judaica Collectors' Club of Los Angeles were generous and welcoming. Friends living in Los Angeles gave much to our transplanted family: Jonathan and Deborah Berek, Kerri Stein-

berg and family, Marina Goldovskaya and her husband George, Eva and Gyula Forgacs. In the summer of 2000 Robert Rosen, dean of the School of Film, Television, and Theater at the University of California, Los Angeles generously appointed me a visiting scholar so that I could continue my research on photography. Also that summer, a travel grant from the Getty Research Institute enabled me to conduct further research in Vienna and Berlin. In Vienna I am grateful to Nick Parsons and Illona Sámársky-Parsons who offered their hospitality. I met with Monika Faber, now curator of photography at the Albertina, who with her assistant gave me access to the entire art photography collection formerly held by the National School of Photography and on its way into storage at the time. I owe much to Monika Faber's generosity. Uwe Schlegel at the National Archive also shared his great expertise on the colored photography of Heinrich Kühn. In Berlin Ernst Osterkamp and Ulrike Bosse extended to me everything an itinerant scholar could need, including a great deal of their valuable time.

Further research on this book was made possible by a grant in residence at the Center for Judaic Studies, University of Pennsylvania, in spring of 2001. I am particularly grateful to Barbara Kirschenblatt-Gimlett, Carol Zemel, and Larry Silver for their comments on my work at that time.

In the summer of 2001 I was fortunate to have a fellowship at the Clark Art Institute in Williamstown, Massachusetts, which enabled me to finish a draft of the book. I thank Michael Ann Holly for her support and kindness throughout the duration of this project and Michael Conforti for providing such a hospitable museum environment in which to work. Mariët Westermann, Darby English, and Charles Haxthausen provided a warm and rigorous research experience. My colleagues that summer—Stephan Koja, Karen Lang, Dick DeCourcey McIntosh, and Monique Nonne—became generous friends and interlocutors.

In the spring of 2002 I was able to expand on the issues of subjectivity that I have dealt with in this book in a seminar that I taught at the University of Rochester Visual and Cultural Studies Program, where Peter Hobbs gave me an important insight into the history of the theory of the subject. My colleague Douglas Crimp's intel-

lectual leadership was an inspiration to all, and his friendship and that of Joan Saab and Betty London mattered to me enormously. Maureen Gaelens and Kim Kopatz provided administrative support of the highest caliber. The graduate students in Visual and Cultural Studies served as an example to me that year of how ethical and open collaboration over issues of cultural significance can occur in the university, and I thank all of them.

I extend my gratitude to Whitney Davis, chair, Department of the History of Art whose generous invitation to teach in spring of 2003 at the University of California, Berkeley, gave me the opportunity to both refine my book manuscript using the resources of the library collections and to solidify relations with UC colleagues. With special thanks to Whitney and to Albert Ascoli, Pat Berger, Tim Clark, Darcy Grigsby-Grimaldi, Eric Gruen, Elizabeth Honig, Loren Partridge, Andrew Stewart, Randy Starn, Anne Wagner and to Linda Fitzgerald, department manager. The students in my graduate seminar that spring gave much thoughtful reflection to the topic of the subject in performance: Brynn Hatton, Meredith Hoy, Anna Marie Krarup, Kris Paulsen. In the following summer stimulating conversations with Ann Jensen Adams and Norman Kleeblatt gave me considerable insight into the idea of portraiture that the Viennese may have been responding to.

In the last two years I have been fortunate to present various aspects of this book in public lectures and seminars. I am grateful to the following institutions and to the individuals who extended invitations and hospitality to me: Harvard University, University of Pennsylvania, Cornell University, University of Delaware, University of Copenhagen, University of Alberta.

Over the last five years of work on this book I have been aided immeasurably in my research by assistants at the University of California, Santa Cruz, the Getty Research Institute, and the University of Rochester. I thank the following for the use of their patience and intelligence on my behalf: Damara Ganley, Julianne Rosenbloom, Peter Schertz, T'ai Smith, Norman Vorano, Jodi Waynberg, Andrew Wegley, Michael Williams, and Catherine Zuromskis.

Finally, the University of California's Santa Cruz Committee on

Research and the Arts Division Research Institute provided me with funds in support of this project. I would also like to thank my colleague Carolyn Dean, former chair of the Department of History of Art and Visual Culture, for her understanding of the priorities of a research scholar. None of this work would have been possible without the knowledge and expertise extended to me consistently over the course of fifteen years by the visual resources and special collections of McHenry Library, uc Santa Cruz. I remain as always indebted to Christine Bunting and Kathleen Hardin, friends and fellow pursuers of knowledge through pictures and books.

Preliminary versions of chapters 3 and 4 appeared as "Portraiture and Assimilation in Vienna: The Case of Hans Tietze and Erica Tietze-Conrat," in *Diasporas and Exiles: Varieties of Jewish Identity*, edited by Howard Wettstein (Los Angeles: University of California Press, 2002), 113–49; "Art Photography, History, and Aesthetics," in *Art History and Its Institutions: Foundations of a Discipline*, edited by Elizabeth Mansfield (London: Routledge, 2002), 295–313. I remain grateful to the editors for the confidence they showed for my work then in progress.

INTRODUCTION

The Subject in Art

There have long been debates about whether or not the knowledge of past events that history provides can prevent us from making future mistakes. There have been fewer debates about whether art history can provide us with meaningful methods and models that will better our situations. In regard to events, the history of the twentieth century offers few lessons learned. In regard to visual culture, history begs to differ. Early-twentieth-century Vienna saw a utopian moment for art and art history. If only for a brief time, the collaboration between the practice of art—specifically portraiture—and the discourse about art had the potential to transform the way individuals, groups, and viewers could envision interacting.

The pictures and the texts discussed in this book remain with us today, having endured a century with two world wars, the attempted genocide of the European Jews who did so much to bring Vienna's utopian moment into being, and the destruction of the culture in which they flourished. My aim in discussing them is not to invoke the past, but to explore the meaning of art history through an examination of art's central subject: human beings and their relation-

ship with the rest of humanity. These portrait representations, and so many others, persist in the present. They may well be reminders of another time and place, but as depictions of others they also show us something of ourselves, and of our present situation.

This statement of the meaning of portraiture, found in the critical writing of the time (much of which has not been brought together before), has led me to understand the power of this type of visual representation for the history of art. Since the middle of the twentieth century the discipline of art history has flourished in many parts of the world, seen in the proliferation of university departments and courses and in the rise in number and importance of museums and cultural institutions devoted to visual culture. So, too, all evidence— including books, paintings, photographs, museum exhibitions, and, now, digital images—points to the continuing strength of portraiture in the cultural imaginary of human beings today. These confluences in the visual and textual history of the subject in art of the last fifty-five years fascinate me because portraits—*depictions* of the subject in art—have compelled so many artists, art historians, and viewers of art over the course of this time, but without any satisfactory answer as to why this might be so.

Thus, when I began this book I knew that I did not want to ask the usual question asked by art historians of the portrait: who is this singular human being represented in this picture? It then followed that I chose not to consider artist self-portraits in my study, because, as I argued in my earlier book *The Absolute Artist*, this cultural figure may be considered the epitome of the singular human being, at least since the Renaissance. I did not want to reconstruct or to posit a historical or metaphysical identity for any one portrait depiction, or for any group of them. I do not deny that highly significant and successful histories of portraits have attempted to do just this, but they have done so without allowing us to penetrate into the fascination that these kinds of representations held, and continue to hold, for the modern human.[1] The question of who, although a legitimate one, has not led to a satisfactory history of the actual, and powerful, engagement with portraiture found in the twentieth century. The question of who necessitates a nostalgic and metaphysical response and prevents

another way of perceiving both the portrait and the history of art, for example, the history of portraiture. Put somewhat simplistically, because the portrait more clearly than any other genre of representation elicits the question of who, it reinscribes more emphatically than any other kind of image a history that can do no more than name. If art history desires to do more than name, another way of understanding the portrait image, such as the one offered here, will be central to this aim. The apparently simple alternative to naming the subject in the portrait was the very response delivered by the Viennese art historians themselves: when I see another represented in the portrait I see my social context and myself, including my history.

This alternative manner of viewing the subject in art turned me away from the question of who is in the portrait. This purposeful turning away from the often overwhelming desire to see a named individual in the history of art would be unthinkable without the guidance of the Viennese art historians who were my intellectual predecessors. My position as a historian relies on the history I have told, just as Alois Riegl's understanding of Dutch group portraits came from his own engagement with issues of democracy and fraternity in the Vienna of his day. After all, the Vienna School art historians, too, had inherited a method of viewing that privileged the individual over the group or engaged social interactions among other beings. Indeed, this had been an exceptionally strong aspect of portraits and their interpretation since the Renaissance period. Yet, even as they turned away from this tradition of viewing, they embraced a method—although it could not have been seen as such at the time—with a powerful potential to ask different questions of the depiction of others, one that offered the possibility of a less rigid and a more generous response than the name of a singular historical individual.

Like these Vienna School historians of art, I asked of the subjects in art: What have we seen in them? What can be seen with them as models, guides, or precedents? The search for answers to these questions posed by the subject in art has led inevitably to philosophy—to thinking about the meaning of human life and human lives in this world. In the course of my research on Viennese portraiture, psychoanalysis and its history also emerged as major factors in the quest for

an understanding of the subject in representation in the twentieth century. I came to understand more precisely the profound hold that psychoanalysis had on twentieth-century artists who explored portraiture and the subject, although it had been kept at bay by art historians outside of the Vienna School, except in some analyses of surrealism. The search for answers to the questions of what we have seen in portraits and what we can see with them has ultimately confirmed the power of art to offer a visual alternative to textual explanations of the human condition. Indeed, the portrait image, and the writing on portraiture that has subtended it since the beginning of the twentieth century, provide modern men and women with a visual thinking through of the place of humans in human society. For this most significant of reasons, we are compelled to consider daily the subject in the portrait, represented in a wide variety of media, as we go about our normal routines.

I assume that this search for the subject in art through the genre of portraiture will not end because part of it has been historicized here, particularly because the episode on which I focus in this history came long ago now, at the beginning of the last century. There remain other chapters in this history to be written. Indeed, I have tried to suggest with my historical research that there could be alternative readings to this long tradition of the depiction of the subject in the portrait, at least to the depiction of nonrulers. For, given my findings here, it will be clear that the *subjection* to which we as art historians have fallen prey in our traditional history of portraiture originates at a period preceding modernity, and from the portraits of an even more distant epoch than most of the ones that I have examined in this book.

A GENEALOGY OF

THE SUBJECT IN THE PORTRAIT

Today, the words *portrait* and *portraiture* are used interchangeably to designate a genre of art. Before the twentieth century, *portrait* referred solely to an image or material object, such as a relief sculpture, and *portraiture* usually denoted the action of portrayal or depiction that resulted in an image of a known person.[1] Two apparently discrepant claims about the genre of portraiture both distinguish it from other kinds of art and signal its significance for the larger question of how human beings understand their world in visual terms. We might call these discrepant claims the functional dialectic of the portrait representation. The truth claim of an indexical exteriority, or resemblance, to the person portrayed simultaneously coexists in the genre with a claim to the representation of interiority, or spirituality. Both of these are said to reside in the portrait representation itself and in the eyes of the beholder.[2]

The truth claim relies on the assumption that the portrait depicts an identifiable individual. However, likeness to a historical person is not equivalent to absolute identification, meaning it cannot be strictly maintained in the genre.[3] Passport photographs purport to depict in

a very empirical and obvious way the person named and shown, yet they may be forged or use falsified photographs. So, too, a lack of identification may be found in other portraits, such as paintings of sitters whose resemblance to actual persons can never verifiably identify them, because any reference to their names has been lost. Likeness, as in the visualized physical aspects of a singular human being that correspond to an empirical reality, often exists in portrait representations, but many portraits said to be of particular individuals may not necessarily be congruent with a perceived exterior reality. Recognition, which is less precise than identification, will often be used as a primary indicator of depiction in general, and becomes of great importance to the concept of portraiture precisely because it turns resemblance into a matter of viewing, rather than maintaining that a standard of likeness resides in the portrait itself.[4] The standard of likeness cannot be maintained in the object portrait with any consistency, but the expectation that we can potentially or actually recognize an individual in the portrait makes the genre what it is. Thus, studies of anonymous portraits rely on the assumption that these depictions resemble historical people, often without any way of ascertaining that they do.

The expectation of the truth claim of portraiture has allowed artists, such as Pablo Picasso and Andy Warhol, to use effacement of physical characteristics as an effective means of highlighting the contingency of resemblance and, consequently, of emphasizing the other pole of the functional dialectic of portraiture, interiority. Picasso's portrait of Gertrude Stein documents both in its overworked brush strokes and its hieratic, seated composition (see figure 1). After numerous sittings in which Picasso wrestled with the problem of exact resemblance, he finally painted out Stein's face and substituted the conventions of an African mask for her features. Even with this erasure and substitution, we have long "recognized" Gertrude Stein in the portrait. Or, as Gertrude Stein herself said, "He painted in the head without having seen me again and he gave me the picture and I was and I still am satisfied with my portrait, for me, it is I, and it is the only reproduction of me which is always I, for me."[5]

Warhol's lithograph series of portraits, *Ten Portraits of Jews of the*

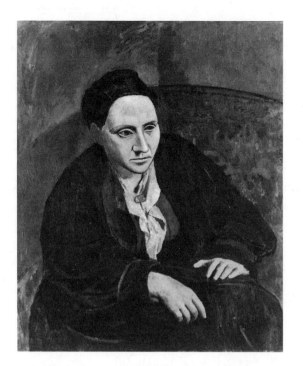

1 Pablo Picasso, *Portrait of Gertrude Stein*, 1906.

Twentieth Century includes a picture of Gertrude Stein, which, like
the other likenesses of twentieth-century figures he provides, plays
with the limits of resemblance necessary for the identification of the
historical person (see color plate 1). Each one of the lithographs in
the series references a photograph of the well-known person, thereby
giving photography as the documentary proof required for identifica-
tion of the individual.[6] Photography upholds the exteriority and truth
claim of the portrait genre.[7]

Because referential representation is a central aspect of the docu-
mentary aesthetic, the portrait lays claim to the historical, particularly
to historicist approaches that use literal correspondences between the
portrait and the subject to interpret both character and events.[8] As
"one of the typologies [of art] most intimately connected to the social
sphere," portraits have most commonly been considered in the history
of the family, or its immediate circle.[9] The intricate interpretations
provided by art history for Jan Van Eyck's *Arnolfini Wedding Portrait*

illustrate this point clearly (see figure 2).[10] Indeed, the large number of paintings that exist in the generic subcategory of "wedding portraits," "marriage portraits," "companion portraits," or "conversation portraits" from the fifteenth century to the present, gives strength to the typological casting of such pictures that reassert the social relations between individual, spouse, family, the institution of marriage, and class. Portraits are, therefore, pictures particularly indicative not only of an individual, but also of kinship and social status.[11] Beginning in the nineteenth century, portraits became an essential part of the decoration of the home of the rising bourgeois. Since the Roman period death masks, or posthumous portraits, had ensured the continuation through the generations of an emphasis on kinship in portraiture. So, too, the fidelity to an exacting resemblance in this form of the portrait signifies that the sociality of the genre relies historically on upholding the idea of the singular individual in relationship to others for whom recognition is essential.

The other side of the functional dialectic of portraiture contrasts with the indexical, or factual, resemblance. It relies on an understanding that the portrait gives us more than itself, for example, that the portrait is not only about adherence to an exterior reality. This excess to resemblance in the portrait resides in the projection of interiority onto the depicted person, and it may be called iconic. Projection comes from within the viewer(s), although it has often been said to be inherent to portraiture itself. By the beginning of the twentieth century, the face was commonly held to be a window to the soul. The portrait had long been seen as the tangible representation of this belief. In 1901 the Berlin philosopher-sociologist, Georg Simmel wrote about the face in terms of its status as the synthesis of the ideal view of representation in both political and aesthetic contexts. He concludes "The Aesthetic Significance of the Face" with the following words: "The eye epitomizes the achievement of the face in mirroring the soul. At the same time, it accomplishes its finest, purely formal end as the interpreter of mere appearance, which knows no going back to any pure intellectuality behind the appearance. It is precisely this achievement with which the eye, like the face generally, gives us the intimation, indeed the guarantee, that the artistic problems of pure perception and of the pure, sensory image of things—if perfectly solved—would lead

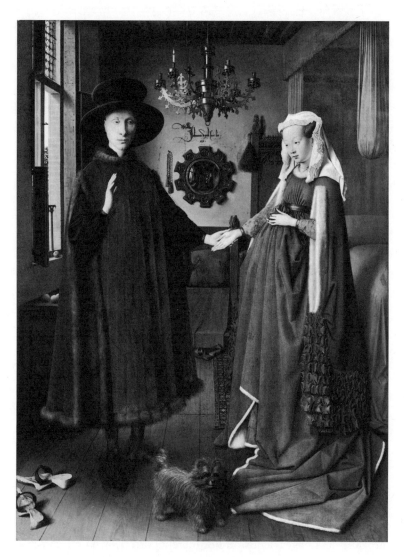

2 Jan Van Eyck, *The Arnolfini Wedding Portrait*, 1434.

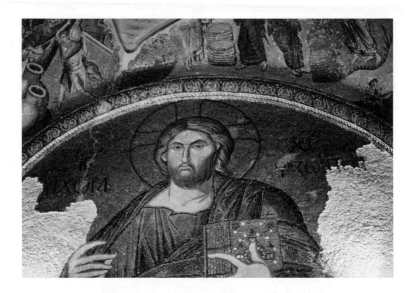

3 Medieval icon, *Christ Pantocrator*, fourteenth century.

to the solution of those other problems which involve soul and appearance. Appearance would then become the veiling and unveiling of the soul."

In the Western tradition, the term for a foundational mimetic image is *icon*, understood also as a portrait image of a holy being.[12] In the history of European art this central term situates the portrait in the context of the dominant religion, Christianity, where the icon purported to be the invisible God made visible. In the Christian icon the resemblance is not merely to a physical being, but rather to immanence, that is, the image gives the sign of the God within. Unlike other visual images, icons do not merely portray or narrate; instead they are in the deepest theological sense holy. Thus, the inscription on the medieval icon of the *Christ Pantocrator* from the Kahrieh Djami in Istanbul refers to the image as *chora*—land, space, or container (see figure 3). The image is "the land of the living," "the place of the living," or "the container of the living."[13] The presence of the icon in the Western tradition illustrates most clearly how the physical object, for example, the portrait, can warrant full veneration. The icon demonstrates most clearly how the history of portraiture necessarily entails a viewer who projects his otherwise invisible God, onto or into

the portrait, yet, in this same tradition that sees man as created in the image of God, the believer also inevitably projects himself onto the image.

To be sure, in the early modern period the theology of the image in the religious context began to dissipate, particularly with the rise of Protestantism. By the time of the Enlightenment, Christian religious art no longer bore the full weight of the burden of immanent sacredness. Images could represent the quotidian and the real. Yet, in the case of portraiture, the lingering cultural belief in the immanence of the subject's presence remained.

In recent times the work of art, much like the medieval icon in the Christian context, has been understood to give "an intensified illusion of having unmediated access to meaning."[14] Extending this idea to the secular context of art history where we find the portrait of the historical person, the view of the capacity of that portrait to be more than simply a material artifact or resemblance has been called an aesthetics "informed by theological conviction."[15] Using the terminology of the anthropologist Gregory Bateson, we might prefer to call this understanding of the portrait "a metaphor that is meant."[16] This terminology admits of the dialectic function of the portrait in the human imaginary, for which I have been arguing. The photographic portrait, to take the best example from the genre of portraiture, is in part indexical. Optical processes that depend on the coincident presence in time of apparatus, subject, and photographer in part determine its resemblance. On the other hand, we could say that painted, and most sculptured, portraits are iconic because there is nothing about their appearance that is necessarily determined by that which they represent. Yet, the iconicity of every portrait image, its ability to be, will be alluded to even when indexicality, or a physical connection to the referent, appears the more visible means of understanding.[17] We will see in subsequent chapters that the portrait of the historical individual predominates in visual representation in Vienna around the beginning of the twentieth century. A key monument in the history of both portraiture and the visualized subject in art at this time is the portrait of *Hans Tietze and Erica Tietze-Conrat*, painted in 1909 by the Austrian artist Oskar Kokoschka (see color plate 2). In its generic form

of the conversation or marriage portrait, in the recognizable faces of two individuals, in the overt gestures and gazes of the figures depicted in the painting toward each other and toward the viewer, and in the artist's own "gestural" handling of the paint material and its expressionistic color effects, this portrait exemplifies the dialectic function of portraiture to simultaneously give both interiority and exteriority. The portrait of the Tietzes makes us aware of them, of the artist, and of the subjectivity of the response to viewing entailed. In this complex example of the portraiture genre, the secular human subject may be said to have replaced the religious icon in its ability to give both interior, subjective access while maintaining its fidelity to exterior appearance. We will see that Kokoschka's painting demonstrates that the portrait's function in society at this time extends to relationships among the subjects portrayed, the viewer(s), and the artist, producing a new subject in art.

The emergence of the modern subject into visual representation and art-historical writing in Vienna around 1900 serves as the foundation for a later, more complex theory of the modern subject that began between the world wars in Continental philosophy and Lacanian psychoanalysis. The significance of the philosophical strains of this investigation of the subject resides in Alexandre Kojève's thinking through Hegel, in Jacques Lacan's "mirror stage," in Jean-Paul Sartre's book on the imagination, and in Judith Butler's genealogy of postmodern subjectivity in the political sphere. The interpretation of portraiture offered here provides major conjunctions with a vital intellectual genealogy that has, until now, eluded art historians.

Modern and Postmodern Ideas of Resemblance

Jean-Paul Sartre was the first to describe the fallacy of thinking "that the image was *in* consciousness and that the object of the image was *in* the image" by calling this belief "*the illusion of immanence*."[18] In his 1940 study of imagination and the imaginary, *The Psychology of Imagination*, Sartre pointed to the venerable philosophical tradition beginning with Hume in which "the radical incongruity between con-

sciousness and this conception of the image has never been felt."[19] Although Sartre's argument is a general one about consciousness, it can be applied to portraiture. According to Sartre, dominant views of the image from Hume to 1945 contradicted common sense. Importantly, Sartre gives portraiture as the exemplary genre, or site, with which to illustrate this radical incongruity between what we "know" about the image of someone and what we know: "When I say that 'I have an image' of Peter, it is believed that I now have a certain picture of Peter in my consciousness. The object of my actual consciousness is just this picture, while Peter, the man of flesh and bone, is reached but very indirectly, in an 'extrinsic' manner, because of the fact that it is he whom the picture represents. Likewise, in an exhibition, I can look at a portrait for its own sake for a long time without noticing the inscription at the bottom of the picture 'Portrait of Peter Z.'"[20]

In effect, Sartre argued here that the *history* of portraiture relies on a theoretical structure in which lies a basic dilemma in the *concept* of portraiture, one between desire and effect. This dilemma between desire and effect creates what I have called the functional dialectic of the portrait representation. For Sartre, the viewer must complete in his imagination a picture of a whole person to whom the portrait refers if the basic desire for resemblance is to be satiated. At the very beginning of his study, Sartre indicates that completion is an active process, just as his understanding of consciousness "designate[s] not only the unity and the totality of its psychical structures, but also 'a function.'"[21] Accordingly, we might say that the person depicted may be made whole in the consciousness of the viewer. (This assumption of wholeness through consciousness, indicative of Sartre's view of the subject, contrasts drastically with the thinking about the subject found in Lacan.)

Applying Sartre's argument, the portrait would be the visual instantiation or material evidence of the desire for resemblance and connection, of the very function of the imagination. If we take this thought further than, perhaps, Sartre would have done, we can say that the status of the portrait as the primary instantiation of exacting representation in modernity is a desire on the part of sitter, artist, and viewer(s) for social connection through visible means. The por-

trait makes visible what we imagine of others. This consciousness of the other displayed in the genre of portraiture gives rise to the useful understanding of portraiture as social engagement, a now common way of speaking of the genre.

When he uses the portrait of Peter Z. as his example, Sartre argues that acts of recognition are joined by the imagination in the portrayal of the other. For him, consciousness completes the circuit of representation, portrayal, and recognition.[22] Every act of recognition of another requires the imagination. To bring a portrait of my mother into consciousness, or recognition, requires that I perform my own acts of identification with this other who is portrayed. Of course, this process is easier to imagine in a portrait of a loved one than in an anonymous portrait that hangs in a museum. Nonetheless, it is common enough today to imagine connection to celebrity portraits of all kinds. As Sartre put it: "However, in order to avoid all ambiguity, we must repeat at this point that an image is nothing else than a relationship. The imaginative consciousness I have of Peter is not a consciousness of the image of Peter: Peter is directly reached, my attention is not directed on an image, but on an object."[23]

For Sartre, consciousness must always have an object to which it is directed.[24] This obvious claim about intentionality in Sartre's argument about mental objects may be adopted creatively to understand the process of the dialectic function of portraiture, what we might call a psychic investment in both a material object and a generic art form. For Sartre, the portrait provides the perfect material example—the object of the subject, so to speak—with which to illustrate the function of consciousness. When I look at a portrait of my mother I look upon her because I desire to see her as if present. To think "that the image was *in* consciousness and that the object of the image was *in* the image," as Sartre said, upholds a cultural fiction, albeit one that continued to be endorsed by many viewers of portraits.

Despite its elegant argument based on visual representation, Sartre's work has had little effect in art history, with the significant exception of the history of photography.[25] We can trace the influence of Sartre in the field of philosophy more easily. In Theodor Adorno's theory of aesthetics, he does not discuss portraiture in his investigation of what

he calls "subject-object." Instead, he overtly deflects Sartre's theory by insisting on the "viewing subjectivity's" difference "from the subjective moment in the object itself."[26] Adorno maintains the necessity of distinguishing "a false aesthetic feeling" brought on by "the arousal of subjective effect by art" from the actual feeling that the art object itself holds.[27] This turns the issue of subjectivity back to the creator and production of the art object and away from a theory of social engagement, or reception, that would result as a process of consciousness instigated by the viewer of the portrait, such as we find in Sartre. Adorno takes Sartre's "illusion of immanence" to belong *in* the work of art with the artist as the central factor in its achievement.[28] Adorno's views on the "subject-object" prevent us from reconceptualizing the meaning of the genre.

Ideally, in the Sartrean sense, the identity of the portrait belongs with the interpreter because s/he recognizes it in all of its dimensions: the person depicted, the artist who made it, and the work of art that it often has become. Today, we take for granted the representation of the "whole person" in diverse media, such as film. The idea of wholeness is rampant in popular psychology, together with the corollary belief that we are affected, or even transformed, by knowing or learning about such "whole" individuals. Although this last statement has a distinctly postmodern ring to it, the realization of the intersubjectivity or sociality of portraiture can be historicized precisely in Vienna circa 1900 when artists, art historians, and photographers shared similar views about the genre. Photographers sought to make portraits like paintings, and painters sought to make portraits more expressive. These artists were joined by art historians and critics who wanted to explain the significance of the depiction of the modern individual through reference to earlier traditions and media in which portraits occurred. Thus, the birth of the genre of portraiture came about as an invention, an explanatory system, if you will, necessary for the understanding of the modern subject in the portrait.

The Vienna School of Art History provided the logics behind the history of the depiction of the modern subject and called it portraiture. It also provided a starting point for the construction of the modern subject that was to take place in other, textual, disciplines after

World War I. Before that time, the modern subject was theorized visually—through the genre of portraiture. The echoes of this earlier, visual theorization of the genre can be found in Sartre's study of the imagination, as his own use of the portrait metaphor and example so strikingly show. In the investigation of psychoanalytic tradition that follows here we will see that Jacques Lacan historicized the abstract general account of the self found in philosophy. In what follows, and for the first time, the psychoanalytic genealogy of the subject will be joined with the Sartrean philosophical position in order to provide us with insight into the conceptual history of the portrayal of the subject in art.

The Visualized Subject in Psychoanalysis

The research undertaken for this book indicates that early Viennese psychoanalysis did not undertake the full account of the modern subject that could be found in contemporary Viennese portraiture. The term *subjectiv* is used in regard to portraiture by Viennese art historians at the beginning of the century, but this and other cognates of *subject* used in the discourse of art history were not used at the time by psychoanalysis. Because the subject per se was not part of Freud's investigation of the individual he preferred the terms that signaled precisely his interests: *Einzelperson, naturlich Person*, or *Individuum*.[29] As Paul Ricoeur has demonstrated, there is no problematic of the primal or fundamental subject in Freud.[30] The term *subject* occurs only once in Freud's work.[31] Étienne Balibar has argued that what Freud meant by *the individual* was inherited from the Kantian concept of a "free and autonomous subject," someone active in both the civic and political spheres.[32] In a significant portion of Freud's writings, the artist, such as Leonardo da Vinci, stands for this model individual.[33]

Our use of the word *subject* comes, then, not from the German philosophical term *Subjekt*, but primarily from the French tradition of *le sujet*, where it is found in Old French as *suget* or *soget*, the person *subject to* another, as a serf was to a lord. The term found its way into psychoanalysis in the 1930s, around the time of Jacques Lacan's fa-

mous 1936 essay, "The Mirror Stage as Formative of the Function of the "I" as Revealed in Psychoanalytic Experience." Lacan writes there: "We have only to understand the mirror stage *as an identification*, in the full sense that analysis gives to the term: namely, the transformation that takes place in the subject when he assumes an image—whose predestination to this phase-effect is sufficiently indicated by the use, in analytic theory, of the ancient term *imago*."[34] Here, perhaps for the first time outside of art history, we find an explicit linking of the concept of the subject, the action of identification, and the object of an image.

Lacan's use of the terminology that I have associated with portraiture was inflected by Kojève's critique of Hegel's philosophy of consciousness (*Bewusstsein*) in highly influential lectures given at the École des Hautes Études in Paris between 1933 and 1939, during the period when Lacan was formulating the ideas found in "The Mirror Stage."[35] *Bewusstsein*, the word for consciousness in German, is a significant term in this discussion. As Sartre later explained, "We shall, therefore, speak of the consciousness of the image, of the perceptual consciousness, etc., using the term in one of the senses of the German word *Bewusstsein*."[36] This term, so central to the idea of the image and to the work of the imagination, came to Sartre via Hegel, just as it had come earlier to Lacan for his explanation of *imago*. Hegel's *Phenomenology of Spirit* had provided the primary locus for the understanding of consciousness as being in action and related to issues of perception, but earlier Freud had elaborated on this concept of consciousness as an activity also in play with the unconscious. According to LaPlanche and Pontalis, for Freud, "consciousness is the function of a system—the perception-consciousness system . . . [It] lies on the periphery of the psychical apparatus and receives information from the outside and inside world and from internal sources."[37] In light of this genealogy, we might think of consciousness as the hinge on which the portrait hangs in the twentieth century—swinging between theories of the image and theories of the unconscious subject.

A major aspect of Kojève's lectures—and one that pertains to the present discussion of the term *subject*—was his translation of Hegel's German into contemporary French. These translations of key terms

in Hegel's philosophical discourse may be called idiosyncratic, but for Kojève and his audience of philosophers and psychoanalysts of the time, they were instrumental. The terminology of the subject—in its French translation—became extremely influential for both philosophy and psychoanalysis. French intellectuals whose thought has been central to our contemporary understandings of the image and the subject gathered around Kojève at this time.[38] According to Lacan's biographer, in 1936 he and Kojève envisioned a study called *Hegel and Freud: Attempt at a Comparative Interpretation*.[39] Although Kojève barely began this study, the themes that we find later in Lacan's investigation of the subject in the mirror stage gestated at this time as he considered Freud under the influence of Kojève's Hegel: "the *I* as subject of desire, *desire* as revelation of the truth of being, and the *ego* as the site of delusion and the source of error."[40] The "hermeneutical encounter," as Judith Butler termed it, between Hegel and Kojève continues in Lacan's understanding of the formation of the subject in the mirror stage with the concept of the imago playing a central role there.[41] Here, the image begins to be the visual link, or figure, to the philosophical discourse on consciousness.

In Kojève's interpretation of Hegel's master-slave dialectic, it is through the very unconscious and conscious processes of representation undertaken by the human that a form of subjection occurs. Kojève's focus on desire in the master-slave relationship allies consciousness with recognition, a key concept in the discussion of portraiture. Kojève wrote: "In order that the human reality comes into being as 'recognized' reality, both adversaries must remain alive after the fight. Now, this is possible only on the condition that they behave differently in this fight . . . Without being predestined to it in any way, the one must fear the other, must give in to the other, must refuse to risk his life for the satisfaction of his desire for 'recognition.' He must give up his desire and satisfy the desire of the other: he must 'recognize' the other without being 'recognized' by him. Now, 'to recognize' him thus is 'to recognize' him as his Master and to recognize himself and to be recognized as the Master's Slave."[42]

If recognition is the action that gives the consciousness to desire in Kojève's interpretation of Hegel, the function of the *imago* in Lacan's

essay on the mirror stage helps us to understand the centrality of the portrait to the concept of representation in later theorists. Just as there is no "absolute subject," according to Lacan, so, too, the beginnings of self-acknowledgment or recognition allow us to understand the fallacy of "any philosophy directly issuing from the *Cogito*."[43] Lacan's essay opposes *Cogito* to *imago*. The imago teaches us what the *Cogito* cannot. The mirror stage, "the specular *I (Je)*" as Lacan calls it, is the beginning of the process that culminates in "the social *I*." This imago is the most ancient or primordial essence, or "reduction" as Lacan terms it, of the socially constructed human. The end of the mirror stage comes with "the identification with the *imago* of the counterpart," in which self-recognition allows for recognition of the other.[44] The precedent mirror stage is "an identification" that is "the transformation that takes place in the subject when he assumes an image."[45] This psychoanalytic discussion of an image provokes much of the language present in Sartre's later theory of the role of the imagination in the construction of consciousness that relies so profoundly on the portrait as its exemplar, but his concept of the subject differs in significant ways from Lacan's.

In several different places in the essay Lacan equates *imago* and *imagines* with ancient meanings of the terms, even referring at times to works of art as metaphors for the role that the imago plays in the infant's apperception of the self: "for the *imagos*—whose veiled faces it is our privilege to see in outline in our daily experience and in the penumbra of symbolic efficacy."[46] In this regard it is useful to remember that the term *imago* refers to imitation, copy, image, likeness— as in pictures, statues, seals, effigies, masks, etc. The Latin *imagines* refers specifically to the portrait masks of Romans, which were signifiers of the family's prominence and kinship. We find the putative origins of the genre of portraiture in these funeral masks, "wax portrait-masks of Romans who had held the higher magistracies" which were "prominently displayed in shrines in the family mansion, with lines of descent and distinctions indicated."[47] In the late Republic only the *nobilitas*, including women, held the privilege of *ius imagines*, the right to have one's image preserved and displayed together with other ancestors by birth and marriage in the public funeral procession. As

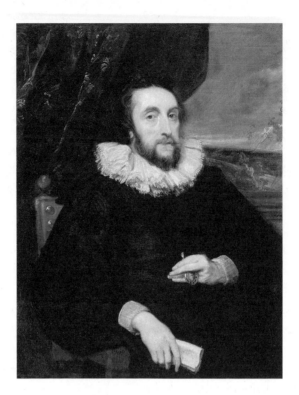

4 Anthony Van Dyck, *Thomas Howard,
2nd Earl of Arundel*, 1630.

I have stated, later European portraits give a similar visual guarantee
of the succession of the family and its attendant social status. This
is, for instance, a familiar aspect of seventeenth-century portraiture
of the nobility, as seen in Anthony Van Dyck's 1630 painting *Thomas
Howard, 2nd Earl of Arundel*, and it continues in family portraits of
the bourgeoisie in the centuries that follow (see figure 4).

Within Lacan's variations on the metaphor of the *imago*, he ad-
dresses aspects of visual representation, such as mimesis, replication,
and beauty. The essay on the mirror stage is shot through with a view
of the subject that articulates as the primordial image—a portrait
from the point of view of the analyst, or a *self-portrait* from the point
of view of the subject—of the nascent individual whose ego is not
centered on reality but rather on "a *method of symbolic reduction*."[48]
Rather than understanding this image as a "symbolic reduction"—

where the essential person is thought to be seen, the essential image is thought to reside, or the presocial event is thought to be represented—we should concentrate on the method of the reduction of the image to the action of portraiture.[49] Desire for the subject in art overcomes the Hegelian view of the autonomous human subject and the conditions of representation that surround it.[50]

Roland Barthes understood that Lacan's "le sujet" could not be considered a unified one, for example, a "whole individual," like the one found in Sartre. Here, Barthes writes about the subject as *le sujet* in literary criticism, but what he says may also be applied to the subject in art: "The subject is not an individual plenitude which one is or is not entitled to pour off into language (according to the 'genre' of the literature one chooses), but on the contrary, a void around which the writer weaves a discourse which is infinitely transformed (that is to say inserted in a chain of transformation), so that all writing *which does not lie* designates not the internal attributes of the subject, but its absence."[51] In this statement we find the aspects of the subject as *le sujet* that have become most familiar in the genre of portraiture: the subject's mutability, its inaccessibility, its inextricability from the discourse that surrounds it, its relationship to ethics (as in Barthes's "all writing *which does not lie*"). In the book *Subjects of Desire*, Judith Butler summarized this postmodern subject using the rhetorical terms of *figure* and *figuration*. Her recourse to the language of the visual or to the actions embodied by figures underlines the affinities between portraits, images, and subjects in contemporary thought.

The Subject in Art History

Art historians choose to address the subject of identity in regard to visual representations, rather than textual or oral ones. The subject in art is most often identified and identifiable in portraits, as a casual survey of the use of the term *subject* and its cognates in the interpretation of the figure portrayed in the portrait reveals.[52] The term's disciplinary usage, however, remains unclear, and in the main has little in common with the more precise use and examination of this termi-

nology in other fields. As I have argued here, *the subject*, which has become so common in art-historical usage, has an extremely complex, different, and often contradictory set of meanings, dependent on its etymologies in several European languages. These meanings remain unexpressed by the English word, as it is used in art history. In part, the reliance of the trans-European/American academic art world upon multiple linguistic proficiencies has contributed to this obscuration of the concept of the subject in art. Furthermore, a kind of procedure of transubstantiation adheres to the terminology of the subject in art because of the materiality of the portrait image as an artifact.

Again, the terms *portrait* and *portraiture* connote both material artifact and invested image. Raymond Williams's observation that "subjective is a profoundly difficult word, especially in its conventional contrast with *objective*" pertains acutely to the discipline of art history.[53] In art history the difficulty exists because subjects, as in the person portrayed, and objects, as in the work of art, are two sides of a naturalized and unexamined coin of the realm in the disciplinary terminology. As Williams explains, the object that he has in mind is that which is comprehensible through consciousness, while the subject, as in the "Self," is that which comes from within. In addition, we commonly understand *objective* to mean that which is reached through "rational" and exterior means, while *subjective* is that which is known through interior means. Yet even in this reductive explanation, the problems that the terminology brings to bear on an idea of the subject of portraiture remain manifest: the subject outside the self yet subject to the Self—as in the hand of the artist and the eyes of the viewer.

These difficulties in the perception of the location of subject and subjectivity in modern portraiture do explain, however, the continuing attraction of the simple view that the portrait is transparently just a picture of an individual. It may be useful here to think about the possibility of the revision of the history of portraiture, and of a new view of the subject in art, through Ferdinand de Saussure's statement concerning the sign as arbitrary. "No one disputes the principle of the arbitrary nature of the sign, but it is often easier to discover a truth than to assign to it its proper place."[54]

Portraiture describes identity, the "who," perhaps better than any other visual genre. Through both its material instantiation and the actions around it portraiture invokes identity. Mikkel Borch-Jacobson usefully describes the ways in which subjectivity becomes identity in representation: "But to say *who* I am—who thinks, who wishes, who fantasizes in me—is no longer in *my* power. That question draws me immediately beyond myself, beyond my representation, toward a point . . . where I am another, the other who gives me identity."[55] Issues of identity, which are raised by any singular portrait or in the genre of portraiture as a whole, cannot be located solely in artistic intention or with the patronage or commissioning of the portrait or with its reception. To say that through the visual representation of the portrait we know who once existed is to acknowledge that the genre actively works against anonymity. Concurrently, the representation of the known or named subject in the portrait prevents it from being understood as an autonomous creation of the "free" artist because the role of the sitter in relationship to the artist will invariably be known, or at least surmised. At every step in the experience of the portrait the function of consciousness plays a role.

In this important sense, the portrait is not "free," either for the artist, the portrayed, or the viewer.[56] The portrait entails less than the freedom of thought with action implied in general by works of art. If, as I and others have argued, an essential characteristic of the figure of the artist in Western culture is his comparative freedom in regard to other humans and their behaviors, then the artist will be most constrained from this freedom in regard to his actions around representations of historically situated people precisely because he is not *free of them*.[57] In addition, the portrait puts additional pressures on the critic "to know" the work of art because the expectation of the genre is already given: to recognize. If the goal of recognition in criticism is to produce interpretation and knowledge, portraits enhance the stakes in the operation of critical practices.[58] We shall see that the pressures to interpret or to know portraiture imposed by the Vienna School art historians on the genre are most apparent when the people represented could no longer be identified, or, when contemporaries, such as acculturated Jews, could not be named or named accurately. My investigations show that "the invention" of the genre of portraiture by

these art historians is, in part, the outcome of this pressure "to know" others—to be fully conscious of the portrayed.

If we emphasize the principle of the contingent nature of portraiture, as my genealogy of the subject suggests we should, it may still continue to be easier to speak of the truth claims of the representation of an individual than it is to speak about the mutable subject that the portrait represents. The social history of art has taught us to consider the location of all art making in the social sphere, but arthistorical methods and their attendant assumptions often privilege certain genres in order to maintain the order of the social imaginary. It can be said with some assurance that portraiture, with the important inclusion of photography, remains the visual genre in which the social imaginary has been most heavily invested throughout the modern period, precisely because it appears to present us with the assurance of our own identities. The seduction of this apparent assurance has proven problematic from the point of view of the theory of the subject. The connection in art history with other disciplines that have attempted to explain identity, identification, and the subject has, until now, remained mainly cursory or superficial. It stands to reason that if we open the discussion of the subject in art to these other explanations it will mean that our own complexities, and those of our forebears whom we have interpreted, will assert themselves in the future social imaginary. Accepting that the responses that portraiture provokes in the viewer occur along an axis perpendicular to the image's frame, rather than contained within it, means that all encounters between subjects will be understood as historical, dependent on a present and a past temporality; on both the visual artifact of the portrait and on the discursive realm in which the responsive actions take place.[59] While this prospect may provide fewer assurances regarding the lessons of history, it surely brings the subject in art closer to a historical reality.

THE BIRTH OF THE

SOCIAL HISTORY OF ART

Oskar Kokoschka's early portraits, painted in the early twentieth century, and contemporary writing on portraiture by Viennese art historians manifest a new, self-consciously modern concept of subjectivity. My investigation of these two interrelated approaches to the subject in the portrait places the birth of the "social history of art," at an earlier moment than previously thought.[1] According to the firsthand account of the art historian Julius von Schlosser, the aim of the Vienna School of Art History was a new, modernist art history.[2] This utopian goal must be seen as central to the formation of the approach to portraiture undertaken in Vienna.

I propose that Viennese artists and art historians theorized a genre of portraiture as preeminently social.[3] They explicitly placed portraits in relationship to a larger community of images—something art history had done for centuries. In addition, the individuals portrayed in portraits and their subjectivities were inserted into social relations that ran back into the past and forward into the present. Portraiture was considered socially constructed by the very relations that could be adduced for a given historical moment among a variety of indi-

viduals portrayed by the genre. This approach was revolutionary because it established portraiture as a genre by attempting to assimilate the differences between the individuals portrayed and those doing the viewing.

This first attempt at an explanatory system for the modern subject and subjectivity used a typological method—both a classification according to type and one with correspondences between past and present—to interpret the recognized visualized subject and subjectivities. Using such a method, the Viennese understanding of portraiture operated historically and ideologically. The method was used to discuss past and contemporary pictures of individuals in terms of the containment of the excess of individuality through representational strategies that insist on interrelationships and groups. This understanding of portraiture governs signification through the naturalization of difference in favor of a common subjectivity.[4] Today, the strength of this method may be found in the interchangeability of the terms *portrait* and *portraiture* to designate both a material artifact and a kind, or genre, of art.

The life of images from the past pertains to the present, as art historians have long known. From its beginnings in the fifteenth century, the early modern literature on art theorized a connection between contemporary art and the past. The discovery of ancient texts gave Renaissance historians and artists a written tradition on which to build their biographical and technical accounts of the art of their own time. Most obviously, this historical tradition endorsed the use of ancient sculptures as models for the modern painting and sculpture of the fifteenth to eighteenth centuries. At the beginning of the twentieth century, the German art historian Aby Warburg used vivid language to describe this visual phenomenon, calling it *das Nachleben der Antike*, or "the afterlife of classical antiquity."[5] Artists, too, were understood to be in relation with others, both of their own time and in history. Thus, in the prologue to the earliest treatise on painting, written in 1435, the Florentine architect and theorist Leon Battista Alberti could cite a number of his successful contemporaries who also self-consciously rivaled ancient artists.[6] By the nineteenth century the conceptual apparatus of exemplarity that underlies this "system of the

arts," as Paul Kristeller called it, led art history to regard the interconnection between images and artists both past and present as given.[7]

However ingrained in the discipline it may have been to understand that past and present images corresponded, Viennese art historians went further in regard to the subject portrayed in art. Their view entailed a conceptual leap of some magnitude and one with important consequences for the development of art history. This leap into the social history of art is characterized strikingly in the figurative language used by Hermann Bahr, the Viennese exponent of Expressionism, when he helped to create the notoriety of a portrait painter, Oskar Kokoschka: "The Expressionist, on the contrary, tears open the mouth of humanity; the time of its silence, the time of its listening is over—once more it seeks to give spirit's reply."[8] Bahr's writing also ensured the status of the "Vienna School" outside the discipline of art history.[9] As we shall see, the role of Viennese psychoanalysis must also be considered in the assessment of the ways in which Vienna School art history approached portraiture, particularly between the two world wars. Finally, we will find that a view of portraiture as a genre for sociality provided both a typology and a historical justification for an art criticism of the time, which sought in all portraits the power of recognition that belongs to the visualized subject.

The understanding of the portrait as a social document was originally articulated in three essays in German that appeared within four years of each other: one in 1898, published posthumously, by Jacob Burckhardt, the cultural historian from Basel, Switzerland; one in 1902 by Aby Warburg, the art historian from Hamburg; and, in the same year, one by Alois Riegl, the Viennese art historian.[10] Significantly, the study of portraiture as a social history of art knows no national boundaries, but the theory's linguistic location in the German language is clear.[11] This linguistic commonality may be attributed to the formation of the discipline of art history in Germany, Austria, and Switzerland in the second half of the nineteenth century. This social history of portraiture, found particularly in Warburg and Riegl, provides an example, perhaps the first, of the international integration of academic discourse, art criticism, and contemporary art practices. This convergence, a significant step in the development of the disci-

pline of art history and its historiographical methods, itself helped to determine the nature of the development of a new idea of the visualized subject.

The articulation of the genre begins with Burckhardt's writing on Italian portraits. He states that the genre of portraiture emerged in Italy ex nihilo, "only when painting has assumed a phase of full maturity, almost like an unexpected gift brought by a visitor no longer waited for."[12] Warburg wrote about the earliest Florentine manifestations of portraiture, which he found in the monumental quattrocento fresco cycles of narrative history painting. Riegl traced the genre north to Holland with an investigation of the group portrait from the fifteenth to the late seventeenth century, culminating with the canvases of Rembrandt and Hals. These essays, written on the cusp of the twentieth century, establish portraiture's historical, geographical, and ideological significance as a primary genre of visual representation.

Burckhardt considered portraiture the most successful of the representational arts because there art's capacity for mimesis achieved its most "obvious similitude" or "resemblance." Since the Renaissance, the pressure of an exacting mimesis had cast a shadow of ideality on the work of art as Burckhardt knew. In his words: "In a manner stronger than any of the other genres of art the portrait depends on the perfection of the given subject."[13] That perfect subject is not the individual portrayed in the portrait; it is the idea of portraiture. For Burckhardt the genre of the portrayal of the subject and the character of the subject portrayed achieve mimetic correspondence not only visually but also theoretically.

The portrait of an individual, whether recognizable by later viewers or not, demanded a purely artistic contemplation, according to Burckhardt. An example of such an object and portrayal would be Giorgione da Castelfranco's *Portrait of a Young Man* (see color plate 3). Here, the figure is shown in almost full face and half-length against a plain background; gesture and expression in the sitter are suppressed —Burckhardt preferred portraits without hands; costume is subordinate to the physical aspects of the figure that are portrayed. Burckhardt found that in later sixteenth- and seventeenth-century portraits, such as the *Portrait of a Halberdier* by Pontormo, the genre

degenerated into a more descriptive phase in which attributes, cloth-
ing, and settings related to the situation of the individual detracted
from the strength of pure representation (see color plate 4). With an
argument taken from his earlier book, *The Civilization of the Renais-
sance in Italy* (1860), Burckhardt related the development from an
early simplicity, or "purity," to a more ornate presentation of the sub-
ject to the demise of individual freedom and the rise of autocratic
rule in the Italian states, which he believed certainly had occurred by
1630. Thus, for Burckhardt, portraiture is related in its origin and in its
purest form to the documentation of a "free subject," expressed visu-
ally in paintings that exhibit no elaboration of context, nor an obvious
social engagement. To document simultaneously both an ahistorical,
mythic figure and a historical personage with a single painting pro-
duces a situation of irony in the beholder, a position not unfamiliar
to anyone who knows Burckhardt's rhetorical style.[14] For Burckhardt,
the free subject is signified by portraiture, the genre closest to "pure
representation," as he calls it. We can relate this freedom from subjec-
tion that the individual in the portrait represents to the contemporary
philosophy of Hegel, particularly to his *Phenomenology of Spirit*. For
Burckhardt, as for Hegel, the subject in the portrait may be under-
stood as a metaphysical being, a fictionalized paragon who nonethe-
less demonstrates in its visualization the meaning of consciousness.

 In the portraiture essay, Burckhardt's historical argument works in
reverse. Unlike other art forms or genres, portraiture does not acquire
perfection with the progression of time, in the way that Italian his-
tory painting, for example, is said by Giorgio Vasari and later critics to
have progressed from Cimabue to the High Renaissance perfection
of Michelangelo and Raphael.[15] Rather, for Burckhardt, the genre
of portraiture originates in a perfect state and degenerates over the
course of its history. This interpretation puts a burden on the origins
or beginnings of this genre and leaves the later history always less than
perfect, much like the parallel version of the history of man given in
the biblical story that begins with the Garden of Eden. Burckhardt
tells the story of a genre that begins with perfection, has no secure
antecedents, and incessantly declines. His ideal portraits represent the
idealized subject. Thus, in order to recapture the reality which por-

traiture's mimesis appears to convey, the unique capacity of the portrait to document the society *in which it was made* became primary in studies that followed Burckhardt's.[16]

There can be no doubt that in their essays Warburg and Riegl responded immediately to Burckhardt. In contrast to him, their essays expand both in theoretical terms and with visual evidence a social history of portraiture. Their essays, unlike his, may also be understood as an anti-Hegelian view of the history of representation. In his preface Warburg characterizes his work as a "supplement" to Burckhardt's.[17] Warburg's sense of following on the heels of Burckhardt obscured a contradictory tendency in Warburg's own work. On the one hand he affirmed that Burckhardt "undertook the labor of examining the individual work of art within the immediate context of its time, in order to interpret as 'causal factors' the ideological and practical demands of real life." But, on the other hand, Warburg also saw that Burckhardt's essay refused to locate the individual portrayed within his or her historical reality.[18] Warburg chose to locate the individual within his historical period. For example, in his examination of the frescos in Santa Trinità in Florence painted by Domenico Ghirlandaio in 1482–86 Warburg takes the genre of portraiture—the portraits of Lorenzo de'Medici and his household—into the context of early Renaissance history painting (see figure 5). There, the portrait can actively mediate between a present social reality, that of the families portrayed in the fresco, and past history, in this case, that of a saint.

So, too, Riegl responded directly to Burckhardt in his discussion of the Venetian group portrait, with which he began his essay on the history of the Dutch group portrait. Riegl acknowledged Burckhardt's characterization of Venetian painting "as an art of 'being' (*Existenzmalerei*) standing in sharp contrast to the kind practiced especially by the Florentines that focused on action and emotion."[19] Riegl proposed that "Italian figures lack the disinterested attentiveness that is a prerequisite of group portraiture," although he found it present to some extent in early Venetian group portraits.[20] Riegl regarded these Venetian examples of group portraits as particular exceptions to the general Italian predilection for portraits of singular individuals. However, he saw the "absence of emotion" in the Venetian group portraits

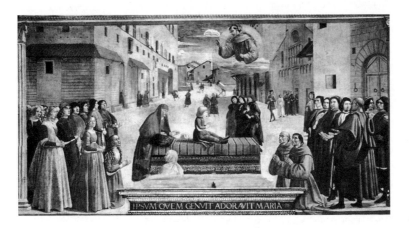

5 Domenico Ghirlandaio, *The Miracle of the Little Boy*, 1482–86.
Detail from Santa Trinità, Florence.

as typical of a "portrayal of being," in contrast to the "mood" found
in northern portraiture.[21] Riegl's goal in his essay was to demonstrate
how the work of art, specifically the Dutch group portrait, allowed
both the historical and the present viewers of the picture to see them-
selves: "Only intimate study by a viewing subject who takes the time
for self-discovery can truly do justice to their [the group portraits']
inner meaning and significance."[22]

Riegl expanded the sociality of portraiture to the psychology of the
past and present viewer. In the essay he repeatedly invokes the view-
ing and interpreting art historian, the audience both of his text and
of the group portraits he illustrated. Those who have attempted a cri-
tique of Riegl's essay have found it difficult not to be taken in by this
rhetoric of inclusion, whose effect is twofold. First, it permits a trans-
parency in the interchange between the present viewer, the historical
viewer, and the onlooker in the group portraits discussed. Second, by
insisting on the simultaneity of the interchange among the historical,
painted onlookers and contemporary viewers, it can elicit from the
interpreter a new view of portraiture.[23] This view of portraiture is not
a metaphysical or abstract portrayal in Riegl's understanding of the
genre. The critic escapes the constraints of a historicism that ties the
figures to one time and place by effecting identification in himself be-
tween different historical moments and their representations. When

the individuals portrayed address the viewer through gesture or expression Riegl find them moving from the past into his present. This identification between Riegl's interpretation and the past, present, and future viewers of the Dutch portraits elicits the very subjectivity desired by Riegl in portraits. By overcoming the notion of a fictionalized being in the portrayal this kind of identification also operates on a plane of historical reality.

Riegl took the history of group portraiture in Holland to be indicative of an increasingly democratic society—a society in which every individual gains an identity in relationship to others of equal status and freedom, as exemplified in the portraits he discusses. For him, the corporate organizations portrayed in the group portraits and their democratic spirit were mimetically reproduced in the genre of the Dutch group portrait itself; individual fulfillment was socially constituted by the group. In ways not seen in Burckhardt and Warburg, Riegl described an evolution of portraiture based on an interpretation of a specific political situation, which he used to account for the artistic success of the Dutch group portrait. The history of the corporation in Holland determined the fate of the genre of group portraiture.[24] When the practice of true democratic principles died in Holland, so too did the formal visual qualities Riegl associated with group portraiture.

Riegl's civic idea of portraiture brings the political consciousness of the critic into visual and imaginary alignment with the historical individuals of the past. According to Riegl, historical portraiture involves the viewer in acts of identification in the present. Riegl's view of the genre of group portraiture begins the assumption of the historical subject who is portrayed as in dialogue with the presently viewing subject. Riegl's radical departure from the self-contained image in the portrait that Burckhardt had insisted on inserts portraiture into a social reality, while at the same time providing the earliest history of the genre with two different concepts of portraiture, the interiority and exteriority discussed in the previous chapter. If we look beyond the history of the genre to the representation of the actual subjects portrayed, we may expect to find such ambiguities not only in strategies of representation—such as the contrast between the treatment of the

faces and the hands in Kokoschka's paintings—but also in the modes of identification found in different viewers.

Riegl read the gestures and gazes in particular paintings according to the dominant literary and philological approaches for which the Vienna School of Art History would later come to be known.[25] Riegl and his fellow art historians sought correspondences between the form of a text as determined by its linguistic structure and rhetorical figures and the overall structure of a work of art as determined by formal elements and their disposition according to a generic categorization of subject matter. In Riegl's study of the group portrait this protosemiotic approach meant that he could read each Dutch group portrait both according to its particular formal characteristics, and as part of a historically and geographically constituted genre. Contemporary art historians and artists found Riegl valuable because his "system" examined the individual syntax of each painting in relationship to the subjects portrayed and to the viewer's reaction to them, while simultaneously relating them to each other through a genre, for example, portraiture, which was constituted along a historical continuum.

To press the rhetorical and linguistic aspect of Riegl's argument, let us understand that the group portraiture of Holland "speaks" in order to be "heard" by both the viewer and the subjects portrayed in the picture. The interactions among the individuals in the portrait characterize the genre, and these are emphasized by the disjunction between the passive heads with directed gazes and the gesturing hands, as Joseph Koerner has noted.[26] The painting of 1529 attributed to Dirck Jacobsz called *A Company of the Civic Guard* appears at a key point in Riegl's essay (see figure 6). With this painting Riegl finds the first sustained manifestation of the dialogic aspect in portraiture, which would be more fully expressed in the later group portraiture of Rembrandt and Hals. Riegl terms the relationships set up by these gestures and gazes "attentive." The paintings are a place where "a depicted figure entertains a thought, or where men attend to each other's speech."[27] According to Riegl, the syntax of Jacobsz's *Company of the Civic Guard* is designed to evoke emotion in the viewer through the gestures and expressions of the figures who visibly entertain the

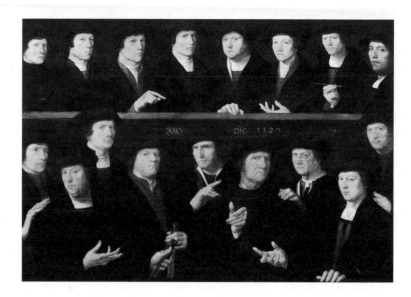

6 Dirck Jacobsz, *A Company of the Civic Guard*, 1529.

thoughts, speech, and actions of the others depicted. Riegl's argument asserts that the depicted figures are intentionally designed to evoke an emotional response in the viewer. As he would have known, in classical rhetoric such figures of pathos differ from figures of ethos, which are used to establish credibility, and figures of logos, which are used to appeal to the listener through reason. In the group portraiture of Holland certain classical figures of speech related to pathos may be translated into visual gesture and gaze. For example, apostrophe, or the turning of one's speech from one audience to another, occurs when one addresses oneself to someone absent, usually with emotion, as the figures in Jacobsz's painting appear to be doing. Anacoenosis, another classical figure of speech used to elicit emotion, asks the opinion or judgment of the audience, usually by implying a common interest with the speaker. In portraiture gestures of pointing or movement toward an imagined viewer must be considered the visualization of this figure of rhetoric. According to Riegl, the emotive, or pathetic, force of the portrayal of these figures allows the viewer to identify with the subjects in the portrait, making portraiture the most potentially "expressionistic" genre. These strategies of identification in portraiture surmised by Riegl found their way into the larger historiography of portraiture, particularly in Vienna.

The studies by Burckhardt, Warburg, and Riegl emerged at the end of the nineteenth century amidst a fluorescence of the study of portraits in German-speaking art history. By 1908, when the Berliner Wilhelm Waetzoldt published his comprehensive study, *The Art of Portraits*, he was able to list in his extensive bibliography thirty-seven books and articles on portrait painting, from Edelberg von Eitelberger's essay of 1884, "The Portrait" to Karl Westendorp's 1906 inaugural dissertation for Strasbourg, "The Development of French-Netherlandish Portrait Paintings."[28] In 1900, when Eugene Müntz wrote his massive study of Paolo Giovio, who assembled in the sixteenth century the first major collection of portraits, he linked "the preoccupation" of early Renaissance men in "leaving their likenesses [*traits*] to posterity" with a tendency to realism "that little by little penetrated all the other genres."[29] Müntz knew Burckhardt's study and relied on it for his understanding of the relatively late development of portraiture in Italy, a fundamental starting place for his study of Giovio's sixteenth-century collection. Müntz follows Burckhardt by accepting that Renaissance portraiture first provided the European visual imagination with its emphasis on exacting likeness, or mimesis.

It is important to keep in mind that this understanding of the portrait excluded a cult of the individual. If, as Martin Warnke has so persuasively argued, Renaissance portraiture, for Burckhardt, was not the beginning of "a continuous and historically ascertainable process of individuation," what was it?[30] Warburg and Riegl, too, resisted the definition of the early modern portrait as being mainly about the representation of individuality.[31] Burckhardt made the point that portraits of recognizable individuals are relatively rare in the early Italian Renaissance precisely because the strength of the group or societal context of painted representation was so strong. In his study of the portraiture of the Florentine bourgeoisie, Warburg regarded Burckhardt's late study of Italian art history, in which the portrait essay plays such an important part, to have been about "the individual work of art within the immediate context of its time, in order to interpret as 'causal factors' the ideological and practical demands of real life."[32] By making such claims for early modern portraiture, the art historians

Birth of the
Social History
of Art

35

erected a discourse for the genre that establishes the historical background for a social history of art based on the depiction of "reality," as Warburg put it, in the portrait.

Riegl's journal essay of 1902 on portraiture was published again in book form in 1931. Yet to this day art historians assume that the essay had no immediate impact on his contemporaries. Despite Riegl's untimely death in 1905, at the age of forty-seven, nothing could be further from the truth. Studies of portraiture proliferated in Vienna School art history. Riegl's book immediately stimulated his colleague Julius von Schlosser to publish his massive and important assessment of wax portraiture, *The History of Portraiture in Wax*, in 1910–11. Because they deal with the portrayal of the human being in death, the portraits that Schlosser studied mark the limits of a genre that sought a realistic, lifelike representation, while maintaining the signification of pathos. The wax portraits adhere to the norm of facial perfection, for example, without mobility or expression, established by Burckhardt as essential. Schlosser's study of portraiture in extremis takes the socialized subject into death. In addition, von Schlosser explored the history of the wax portrait and death mask throughout time, rather than in a more discrete period, such as Burckhardt's Renaissance or Riegl's seventeenth century. Schlosser characterized his contribution to the subject in the following way:

> It was, then, on the theme of the history of culture, in which the immensely important singular work of art was introduced as a "document"; but, at the same time, it was likewise a contribution to the "history of style" in general, and in particular to a very thorny problem of casts after nature and of their importance for so-called naturalism. Here we run up against "aesthetics" and "history." Already by the time of Kant the bugbear of the wax figures—old subsidiary to all of aesthetics and above all to normative aesthetics—impeded the way for history, which demanded a long series of carefully collected facts; and thus likewise the question of portraiture, in the aesthetic sense (in its oldest usage), was always a little suspect, because from the historical point of view it seemed directed to other values. Where did it [portraiture] overstep the realm of art and where did it not? As it is known, the problem of "art"—its criticism and its history—like every history in its generic form—

comes back again; from here flows all the old studies, the frequent labors centering on figuration itself and around the history of theories and historiography of the "arts." [33]

Schlosser's view of portraiture went well beyond Burckhardt's because he addressed "other values," such as the limits of life and exact representation, for example, reality in artistic representation. For him, portraiture always raises the issue of the value of art, thus playing an important role in the mediation between art and nature in the discussion of aesthetics. As von Schlosser's essay predicts, this mediating factor in the operation of the concept of the portrait caused the difficulties of obtaining a critical interpretation of the genre in the discipline of art history, which chapter 1 of this book explores.

The art historian most affected by Riegl's work on portraiture was the young Hans Tietze. Tietze adopted Riegl's terms of criticism for the genre of portraiture in all periods, particularly the baroque and the modern. Tietze's review of a 1909 book by Dumont-Wilden, *The Portrait in France*, demonstrates in succinct terms his synthesis of the views of both Riegl and Schlosser:

> The development of the portrait in a given period of time does not present a purely art-historical problem because it cannot be detached from more general stylistic events and seen as pure culture. Instead, it is deeply founded in the nature of the portrait in particular, that the artistic moment is supported by stronger cultural elements than it is in some other branches of art. The portraitist is, in any case, forced into a compromise between his own personal perception of the subject and conventions which may be of a more outward or more inward nature; he should not describe the individual in his severe isolation, but rather man in manifold social or spiritual contexts. He must, as the author of our book expresses, "saisir les ensembles." Which convention from case to case will govern the interpretation of a portrait is a predominantly cultural problem, and therefore the portrait history of a period is inseparably linked with the interpretation of that period's general culture. [34]

Here, in what could be called a manifesto for a social history of art according to genre, Tietze argued that portraiture relates to the social fabric of the culture to which both the portrait and the artist belong. [35]

Alfred Lichtwark, a Hamburgian art historian, museum director, and early connoisseur and collector of photography, wrote one of the longest studies of portraiture. His little-studied *The Portrait in Hamburg*, published in 1898, provided a history of portraits from 1400 to contemporary times based on various art collections, including collections of photographs, found at that time in Hamburg. This project, unlike those of his contemporaries Burckhardt, Warburg, and Riegl, cuts both diachronic and synchronic swaths through the genre and the life of a city. This metropolitan view of portraiture deals with all media and may also be considered a social history of Hamburg as seen through the portrayals of its inhabitants. As we shall see, Lichtwark's later study of photography presented an ideal culmination of his historical survey of the portrait genre as the "real life" of the city. He argued that art photography, also called pictorialism, was a continuation of a venerable portrait tradition in Hamburg that went back to the Renaissance. Lichtwark's work reveals an important aspect of the social history of art being established at this time through the study of portraiture in the German context: considerations of genre supersede issues of medium. He studied photography, Riegl dealt with panel and easel painting, Schlosser examined sculptured wax portraits, etc.

Portraiture Painting Modern Life

While we do not find a thoroughgoing art-historical discourse on portraiture in France at the end of the nineteenth century, Colin Bailey, writing about Renoir, has recently established the overwhelming desire for portraits among the bourgeoisie of the time.[36] Using *Marie-Thérèse Durand-Ruel Sewing* Bailey makes the case that the genre, while conventional to the extent that it had existed for a century or more, nonetheless transformed and was transformed by the "new painting" of the impressionists (see figure 7). Painterly innovations, such as gestural brushwork, stippling, the juxtaposition of pure colors, and contrasting of hues, abound in Renoir's portraits, as do changes in the conventional relationships of the figure to its background and costume. At times the portrait figures and, indeed,

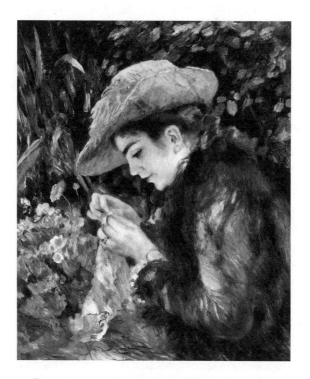

7 Pierre-Auguste Renoir, *Marie-Thérèse Durand-Ruel
Sewing*, 1882.

the genre itself stood for an expression of "modern life," as the critic
of the 1877 impressionist exhibition admitted when he wrote: "Yes
or no, must we allow art to effect its own naturalization of the cos-
tume whose black and deforming uniformity we all suffer? In other
words, must we paint the stovepipe hat, the umbrella, the shirt with
wing collar, the waistcoat, and the trousers?"[37] These attributes of the
modern portrait of the typical bourgeois apparently gave the genre its
distinctive claim to modernity. Historians agree both that the portrait
enjoyed increasing popularity in nineteenth-century France and that
critics and artists complained about the prevalence of the genre in the
Salons.[38] In France in the 1870s and 80s this complaint may have been
against a genre considered less "academic" than history painting; or
it may have been directed at the rise of the bourgeoisie represented
so formidably by the genre. Yet, the complaint made little impact.
In France the Impressionist portrait fulfilled the desires of those it

represented, whether in the style of the "new painting," or, as I discuss in chapter 4, in commercial or art photography. However, in the Germanic context, while French Impressionism made itself felt up until the beginning of World War I in other kinds of painting, in the social history of portraiture the Austrian artists turned to Post-Impressionism.

I have already indicated that when Expressionism was first recognized as a critical and artistic style in Vienna and Germany, portraiture stood as its primary visualization because portraits portrayed a kind of subject central to the ideal looked for by modernist critics. The critic Bahr wrote in 1916: "The Impressionist represents that something more in the Object and suppresses it in the Subject; the Expressionist knows only 'something more' of the Subject and blocks out part of the Object."[39]

My examination of the archival records of exhibitions that took place in Vienna in the first two decades of the twentieth century reveals the overriding interest in French Post-Impressionist painting. The influence of the Viennese Secession artist Carl Moll on younger artists and on dealers was particularly significant in this regard. Moll was not a portrait painter. He mostly painted interiors and landscapes, but his curatorial innovations caused sea changes in the new style of portraiture ushered in by Kokoschka at the end of the first decade of the century. Beginning in 1904, Moll collaborated with Othmar Miethke, owner of the Galerie Miethke on Vienna's Dorotheergasse, in order to organize a number of large exhibitions, many of them by artists known mainly for their portraits.[40] Some of these exhibits were by the well-established and conventional painters of the Austro-Hungarian upper classes. For example, the first of these, which took place in late 1904, showed the work of Ferdinand Georg Waldmüller, whose portrait paintings provide excellent examples of the style of the older and traditional painters. However, other exhibitions at Galerie Miethke were much more radical. In February and March of 1905 photographs by members of the Viennese Camera Club were exhibited, giving contemporary gallery goers an understanding of the interrelationships between the media of painting and photography in portrait studies. In January 1906, Galerie Miethke

showed forty-five works by Vincent van Gogh, and in March and April 1907 works by Paul Gauguin were shown. Moll's own collection and his exhibitions at Galerie Miethke must have influenced a number of contemporary Viennese artists.[41] The linkages are particularly strong between Kokoschka's early portraits and the portraits of van Gogh, Gauguin, and Renoir, for example, the French Post-Impressionists favored by Moll.

Moll himself owned an important portrait by Gauguin: the *Tahitian Woman and Boy* (1899) (see color plate 5). The French dealer Ambrose Vollard had sold this painting to Moll.[42] This unusual double portrait, not previously related to Kokoschka, is clearly based on conventions found in commercial photographic portraiture of the 1880s. It calls to mind the format of the *Portrait of Hans Tietze and Erica Tietze-Conrat* painted by Kokoschka in late 1909 (see chapter 1). In fact, the Gauguin portrait may have been exhibited at the same time as some of Kokoschka's earlier portraits in the 1909 *Kunstschau*.[43] Gauguin's use of a flat, highly coloristic, and mostly abstract background against which the figures are delineated using a strong outline also has much in common with Kokoschka. In Kokoschka's paintings of this period, such as *Portrait of Felix Albrecht-Harta* (1909), the variations in the thickness of the paint, from deep impasto to thin stains through which the canvas leaks, owe much to the manner of late Gauguin (see color plate 6).[44] Kokoschka's use of deeply saturated color recalls the audacious palette of Gauguin, and to some extent that of Renoir in the 1880s. Other paintings from 1909–10 that should be associated with the influence of the Post-Impressionists include: *Portrait of Wilhelm Hirsch* (Berlin, Neue Nationalgalerie); *Child in the Hands of the Parents* (Vienna, Österreichische Galerie); *Portrait of Adolf Loos* (Berlin, Neue Nationalgalerie); *Portrait of Peter Altenberg* (New York City, Neue Galerie); *Portrait of Bessie Bruce* (Berlin, Neue Nationalgalerie); and *Portrait of Auguste Forel* (Mannheim, Städtische Kunsthalle).

The French Post-Impressionist influences on the early portraiture of Kokoschka indicate a wider context for his early paintings than that of metropolitan Vienna, something not usually admitted by art historians. Kokoschka's use of extra-Austrian visual sources made available

to him in Vienna through contemporary exhibitions helped to define his highly original style, which now, on the basis of this evidence, must be considered both cosmopolitan and knowledgeable about the history of portraiture in late-nineteenth-century France. This style, found in portraits with the same rhetorical gestures that Riegl interpreted as so significant to Dutch group portraiture, set Kokoschka apart from his immediate Viennese contemporaries. His work can be cast as part of the intellectual context of Viennese art history and criticism.

Kokoschka's Early Portraits

In 1908–12 Kokoschka was not alone in choosing the portrait as the major vehicle for his painterly expression, but his approach to the subject contrasts with that of his contemporaries. Kokoschka contested the kind of portraiture aspired to by the "Imperial bourgeoisie" of Vienna, to use a term coined later by the critic Walter Benjamin.[45] The localized Biedermeier style and the later work of moderns such as Gustave Klimt stood for an approach to portraiture that distanced, or abstracted, the subject from others in society and from the viewer. Klimt's portraits, such as the *Portrait of Margarethe Stonborough-Wittgenstein* present women who are self-absorbed and removed from the viewer (see figure 8). These figures ultimately derived from early baroque portraits of nobles, such as Anthony Van Dyck's 1622–27 *Portrait of a Genoese Noblewoman* (see figure 9). The aristocratic figures are presented upright, wearing formal and decorative garments, and set against backgrounds notable for their grandeur. This empirical style and format creates a distanced representation of the person, emphasized by the treatment of the surface of the paintings with their densely applied brushstrokes in rhythmic, rather than gestural patterns. The color, particularly when Klimt uses gold or other reflective tones or finishes, is as radiant as the clothing is opulent. Klimt's portraits from this period represent the idea of an elite being, separate from others.

In contrast, Kokoschka's *Portrait of Lotte Franzos* from 1909 portrays a young artist and intellectual who went on to study art history,

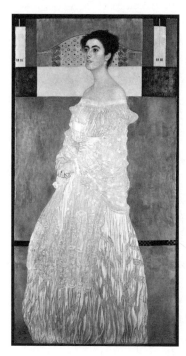

8 Gustav Klimt, *Portrait of Margarethe Stonborough-Wittgenstein*, 1905.

9 Anthony Van Dyck, *Portrait of a Genoese Noblewoman*, 1622–27.

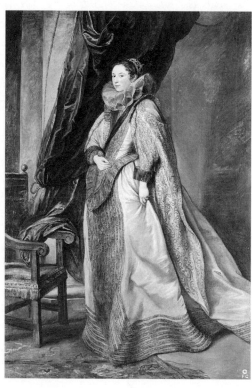

not a member of the aristocracy (see color plate 7). The figure is seated, seen in half-length, rather than an imposing full view. The hands cross and clutch in a way similar to those in the depiction of the art historian, Erica Tietze-Conrat, which Kokoschka painted in the same year. In addition, Kokoschka's critics recognized that in his early portraits the artist established a "new color," one that we have seen allied his style with French Post-Impressionism.[46] The critic Paul Stefan argued that the painter's use of color signified a new modality of painting that set him apart from his contemporaries. The acidic tonalities of the complimentary colors used by Kokoschka in the background create halos around the traditionally modeled faces and hands. These color tonalities set the face and the gesturing hands off from the surrounding clothing and background.

According to Stefan, another of Kokoschka's innovations in these paintings was the "unsophisticated, childlike quality of a half-tamed provincial" that his figures betrayed.[47] Referring to Kokoschka's children's book illustrations of 1908 and to his early portraits of children, such as *Child in the Hands of the Parents*, notable for the awkwardness and angularity in the treatment of the limbs, Stefan also makes a stylistic point here about the contrast between Kokoschka's early portraits and the more formally disposed portraits by the Secession artists, above all Klimt (see figure 10). Virtually every one of Kokoschka's early portraits show the figure truncated, in half-length, or, in the case of the portraits of children, lying down. Arms akimbo, gestures exaggerated, the figures relay an awkwardness that is never seen in Klimt's figures. In Kokoschka even subjects of the highest class are portrayed as if encountered in their own salon, in their favorite armchair. The *Portrait of Baron Viktor von Dirsztay* from 1911 provides an excellent example of a member of the nobility treated no differently from any other sitter (see color plate 8).

Stefan describes Kokoschka's fascination with the portrait in these years as deriving from the artist's discovery of the face as an "object of revenge."[48] Kokoschka's broad, gestural, and impetuous brushstrokes emphasize the paint and express in their form and thickness what Stefan means by "revenge." The expressivity of the artist in this case contrasts with the relatively expressionless faces, whereas expres-

10 Oskar Kokoschka, *Child in the Hands of
the Parents*, 1909.

sivity is enhanced by the gestures of the hands. With these contrasts,
Kokosckha finds a manner of distinguishing between the subject's
emotions and the artist's feelings about the subject. These contrasts
also call on the viewer to seek meaning in the incongruencies between
calm visage and agitated, painterly gesture. Stefan argues that this
conjunction pertains essentially both to Kokoschka's own situation
and to the characterization of his sitters: "The pictures of this period
are an experience of Kokoschka's suffering. Kokoschka's visionary eye
is an eye that does not see simply the individual he paints, still less
what the photography or society painter would see, but his [the sit-
ter's] own origins and family traits through two or three generations:
unacknowledged desires, ambitions and complexes. The artist repro-
duces the dissonant qualities. Thus, Kokoschka paints in another way
from what is seen by others; because he expresses himself and an un-
known essence, but also a fundamental reality."[49] Kokoschka's radical
mode of portrayal provides a space of intersubjectivity between him-

self and his upwardly mobile sitters, between the portrayals of various subjectivities at risk in their very recognition of each other.

The Subject of Caricature and the Vienna School

A younger generation of Viennese art historians were interested in the psychology of art as a result of their contact with the approaches to art of early psychoanalysis. They found other aspects of sociality in portraiture, which also relate to Kokoschka's psychological interests as defined by Stefan.[50] Their thinking on the topic, which came after World War I, exhibited both the intellectual inheritance of the first two decades of the century and the interdisciplinary research on the issue of resemblance and expression done in Vienna by psychoanalysis. Beginning in the early 1930s the art historian and psychoanalyst Ernst Kris and his assistant at the time, Ernst Gombrich, explored the kind of portraiture called caricature.[51] Kris's contribution to this work derived in the main from Freud's work on the joke and the investigation by other early psychoanalysts of the comic, wit, and humor.[52] These studies on caricature are important for the history of the discipline; they descend from the work on portraiture done in Vienna in the early decades of the twentieth century, and they make a significant contribution to the theory of resemblance in visual representation.

Resemblance or lifelikeness in the visual image remained the major interest of Kris and Gombrich, and it is the issue of resemblance that separates caricature from linguistic formations of comedy. Caricatures work through the deformation of resemblance to an individual's face or body, while wit works through the deformation of language.[53] Thus, Kris and Gombrich based their history of caricature on the issue of the gradation in the deviation from resemblance to a recognizable individual.[54] According to Kris, the ability to create caricature began in the seventeenth century, as aggression achieved a visual form that could affect the spectator: "Caricature indeed also tries to produce an effect, not however, 'on' the person caricatured, but on the spectator, who is influenced to accomplish a particular effort of imagination" — that of recognition.[55] According to this account, it is only through

recognition by another that caricature, as a subgenre of portraiture, maintains its distinctive power to annihilate. Caricature carries more of the magic that Freud and his followers associated with the image than does straight portraiture or any other genre of art, because "it gives the barest essentials required for resemblance while at the same time requiring recognition."[56]

The caricature, according to Kris, allows us to see that the resemblance in portraiture possesses a social and ethical dimension, which lies in recognition. In caricature the image is "transformed" from magic to art, and the figure portrayed lies one step away from apotropaion to portrait. For Kris, the identity in caricature could never be universal because it relies on resemblance to a particular individual for recognition. The remarkable number of illustrations (eighteen figures and sixteen color plates for only about twenty pages of text) in the 1940 book on caricature by Kris and Gombrich indicates the necessity of providing the visual proof for their argument that every caricature identifies a different individual. Quoting his earlier work with Otto Kurz on the related concept of the artist or the singular creator, Kris wrote: "Where the belief in the identity of a man and his image is on the decline, a fresh association occurs so that they may once more be united, namely, the factor of resemblance. At the stage of magical thinking, the features of the image are of minor importance; at that which corresponds to caricature, this resemblance is a prerequisite of the social function of the image. It is the result of a definite, but not easily determined measure of concern with the reproduction of reality; resemblance is a prerequisite of caricature."[57]

Kris was responding in this passage to the origin of the portrait, already made problematic by Burckhardt when he wrote of the genre as "an unexpected gift brought by a guest no longer waited for." How else to explain the emergence of a genre that relies so profoundly on the depiction of the recognizable figure than to tie it to the belief system of the entire society, and its previous absence to a lack of belief in such a system that privileges resemblance, or mimetic representation? In 1906 the art historian Karl Woerman had explained that the portrait put a unique pressure on the mimetic priorities of representation: "The struggle of art for the appearance of reality and higher

truths occurs most frequently, and particularly, in portrait painting—in which the representation of a countenance after the artist's will [or volition] is given." [58]

In a footnote to his first study on caricature, Kris states that the social image of the portrait entails a visual ethics: "The magical effect is replaced by one concerned with a particular order of values. This formula, 'value, not effect' appears, as we would further suggest, to enjoy a wider validity and to open one approach to the psychology of value in general." [59] We saw it earlier in the criticism of the expressionist values in portraiture. Kris argues here that the resemblance required for the portrayal of the individual in the portrait inserts the image into a space of social value that overrides the visual effect or reception of the work of art that it also is. Importantly, the portrait is theorized here as the place where the aesthetic and emotive qualities in the work of art diminish in contrast to the ethical concerns that the genre raises.

In their later study on caricature, written at the height of World War II and after both were forced to leave Vienna, Kris and Gombrich devoted the last, page-long paragraph of their short book to an elaboration of the kinds of ethical lessons which caricature could provide. In this passage we find echoes of the recent wrenching departure of Kris from Freud and his Viennese home, which would later be remembered by Gombrich. [60] In 1940 Kris and Gombrich wrote: "There are hopes, moreover, that caricature will remain a living art as long as civilisation persists, because it meets an urge which is bound up with the very achievement of civilisation. Civilisation has taught us to renounce cruelty and aggression which once ran riot in atrocious reality and magical practices. There was a time in all our lives when we enjoyed being rude and naughty, but education has succeeded—or should have succeeded—in turning this joy into abhorrence. We do not let ourselves relapse into that state again, and if ever such impulses break loose under the influence of passion, we feel embarrassed and ashamed. In caricature, however, these forces find a well-guarded playground of their own. The caricaturist knows how to give them scope without allowing them to get out of control." [61] It is not too much to think that Kris's and Gombrich's Jewishness was

where words and pictures, rules and values lose their well-established meaning, where the king may be changed into a pear and a face into a simple ball. And thus we are led back on a lightning excursion to the sphere of childhood, where our freedom was unhampered. In the eternal child in all of us lie the true roots of caricature.

THE POPE AND THE DEVIL

ACKNOWLEDGMENTS

Figs. 4, 9, 10, 13, 14 and 16 are reproduced by courtesy of the Trustees of the British Museum. The authors would also like to thank Messrs Klinkhardt & Biermann for Fig. 2 ; the Herzogliche Museum, Gotha, for Fig. 3 ; the Librarian, Windsor Castle, for Fig. 5 ; the National Museum, Stockholm, for Fig. 6 ; the Biblioteca Hertziana, and Messrs. Heinrich Keller for Fig. 7 ; the Graphische Sammlung, Munich, for Fig. 15 ; and David Low, Esq., for Fig. 17.

27

11 *Caricature of the Pope and the Devil,* in *Caricature,* by E. H. Gombrich and Ernst Kris, 1940.

at the heart of this explanation of caricature and civilization. Their recent escape from Vienna, together with what they must have felt to be the abandonment of the European Jews to their disastrous fate under the Nazis, comes across in the uncaptioned final illustration to their book. There, a caricature containing both the portrait of the current Pope Pius and the head of the devil demonstrates visually that the ethical choices made by "civilisation" and the Catholic Church weighed in the balance (see figure 11). An important chapter in the story of the subject in art emerges in this investigation of the work on caricature from the Vienna School art historians. Kris and Gombrich placed caricature in relation to portraiture by discussing it as a

subgenre, but this relationship can be maintained theoretically only if portraiture is understood as social and affective and if their work is put in the genealogy of their Viennese predecessors, artists and art historians. For Kris and Gombrich, caricature walks the fine line between art and magic and thus marks the significance of the portrait and its boundaries in reality and fiction. Finally, as a genre with deep ethical implications precisely because it calls identity into question with each image, caricature serves as the test case for the boundaries between the individual portrayed and the society invoked by the portrait. The limits of resemblance bring the ethical aspects of portraiture into view for art history, aspects which can either be engaged with or, as Kris and Gombrich suggested, ignored to the peril of the society that created the art of portraiture to start with.

Significantly, the view of a social understanding of the subject in the portrait that we find in the studies of caricature did not prevail in art history after World War II. Instead, mid-century German critics described the portraits of the early part of the century, particularly those by Kokoschka, Egon Schiele, and Max Oppenheim, as a decline from a more perfect style, epitomized by the earlier Biedermeier portrait. The "objective" painting of the 1920s and 30s, called in German *Neue Sachlichkeit*, exemplified what these critics valued and contrasted with the Expressionist style. This kind of painting was a contrary response to the earlier revolutionary subjectivity and sociality found in portraits by Kokoschka and in the Vienna School's theories, as contemporary criticism reveals. For example, in 1940 art historian Hanna Kronberger-Frentzen wrote on the German "family portrait" by elevating the singular human subject and "the deep human desire to have in sight a continued existence beyond existence in the present."[62] So, too, the German philosopher Hans-Georg Gadamer later wrote: "The portrait is only an intensified form of the general nature of a picture. Every picture is an increase of being and is essentially determined as representation, as coming-to-presentation. In the special case of the portrait this representation acquires a personal significance, in that here an individual is presented in a representative way. For this means that the man represented represents himself in his portrait and is represented by his portrait. The portrait is not only

a picture and certainly not only a copy, it belongs to the present or to the present memory of the man represented. This is its real nature. To this extent the portrait is a special case of the general ontological value assigned to the picture as such. What comes into being is not already contained in what his acquaintances see in the sitter."[63]

Gadamer's point elides in significant ways the historical situation of the social theories of portraiture that developed in Vienna before World War I. At the same time that he admits of the genre's reference to a universal idea of representation, its exteriority, he also removes the subject portrayed from the historical and social situation of his or her own time by insisting that the portrait signifies at a purely personal level. As we have seen, this is a view in opposition to a social history of art forged for and by the genre of portraiture in Vienna starting at the beginning of the twentieth century. As I argued in chapter 1, an important outcome of the conception of subjectivity formulated in Vienna for the portrait image came to be elaborated more fully in the fields of French psychoanalysis and philosophy, beginning in 1936 with Jacques Lacan's earliest formulation of a theory of ego development.

The "New" Social History of Art

Around 1968, provoked by current events and Marxist theory, art history sought to renew that promise of a social history of art that had been made in Vienna. Art historians, several of whom came under the influence of the Situationists at this time, called on the discipline of art history to speak about the subject without the baggage of individualism. The cover of the first American edition of Guy Debord's book, *Society of the Spectacle*, with its repetition of anonymous heads, eyes obscured by 3-D spectacles, illustrates the anti-individualism argued for by the Situationists and represents a visual instantiation opposite to the tradition of the portrait of the "known" individual (see figure 12). For a brief time in the early 1970s, particularly in Britain, France, and Germany, the history of art could be thought of as an aspect of sociology. The thinking of the philosopher and literary

12 Book cover. Guy Debord, *Society of the Spectacle*, 1972.

critic György Lukács (1885–1971) bears considerable weight in this later historiography.

Significantly for this historical chronology, the father of the social history of art is usually considered to be Arnold Hauser (1892–1978), not Alois Riegl, Hans Tietze, or Karl Marx. Hauser taught for many years in Great Britain, but his intellectual and cultural roots were in the Austro-Hungarian Empire, specifically as a member of the so-called Hungarian Marxist School. The best-known member of that group, Lukács, made a great impact not only on Hauser, but also on the young Oskar Kokoschka, although the relationship between the two has not been explored previously. On close examination, it can be shown that the congruencies in the thinking of Lukács and Kokoschka in the years from about 1909 to 1912 bear considerable weight in the post-1968 historiography of the social history of art. The bulk of Arnold Hauser's writing about art's social significance came just after World War II and, again, just after 1968. In his earlier book, *A Social History of Art* (1951), Hauser had relied extensively on the tradition of a socialist and Marxist aesthetics forged in Budapest and

Vienna by Lukács.[64] "Art as weapon in the struggle for life," as Hauser put it in 1974, could just as well have been the battle call of both the young Lukács and Kokoschka in the closing years of the Austro-Hungarian Empire.[65] The older Hauser revered the Marxist Lukács, but the art historian would have known better than anyone the essays on art and artists that formed the radical during his younger years. The Lukács that concerns us here is the "unripe" socialist of the first decades of the century.[66]

Lukács's early criticism on art and aesthetics opposed the old "art for art's sake" and the precedent movements of Impressionism and the Secessionists, which, for him, stood for a misguided "new direction." In several early essays he gave the alternative for "the new, modern art," writing: "What is at stake is not the ascendancy of new art, but the rebirth of old art, of art itself, and the life-and-death struggle provoked by its rebirth against the new, modern art."[67] Similarly, in an early manifesto of 1912, Kokoschka wrote: "There is no more room for death; for though the vision disintegrates and scatters, it does so only to reform in another mode."[68] In "Aesthetic Culture," an essay from 1910, Lukács had spoken about the role of the artist and art in the same near-ecstatic terms that we find in Kokoschka's early lecture. Both men believed in the redemptive and social essence of art. Lukács wrote: "The essence of art is to formulate things, to overcome resistance, to bring under yoke the hostile forces, to forge a unity out of the diverse and divergent. To create form: to pronounce the last judgement on things; this last judgement redeems what is redeemable, and its near-divine power dispenses grace."[69] Two years later Kokoschka said: "If we will surrender our closed personalities, so full of tension, we are in a position to accept this magical principle of living, whether in thought, intuition or in our relationships. For in fact we see every day beings, who are absorbed in one another, whether in living or in teaching, aimless or with direction. So it is with every created thing, everything we can communicate, every constant in the flux of living; each one has its own principle which shapes it, keeps life in it, and maintains it in our consciousness. Thus it is preserved like a rare species, from extinction. We may identify it with 'me' or 'you' according to our estimate of its scale or its infinite nature. For

we set aside the self and personal existence as being fused into a large experience."[70]

Called by his contemporaries a "criminal" for this kind of social thinking, for his portrait paintings, and for his early action plays, Kokoschka offered opinions that resonate with Lukács's radical social awareness. Furthermore, Kokoschka's manifesto and Lukács's essays of the first decade of the century commingle an ideology of modernism and Expressionism around the very subject of portraits, exactly similar to the one we have already seen in the art history of the period. As early as 1907, Lukács had maintained that the French Post-Impressionist Gauguin represented the ideal artist in his struggle for life in art: "Gauguin provides an answer to a very general question which many people have without actually being conscious of it, and which ruined the lives of quite a few artists who thought deeply. It is an answer to that very general question: what is the relationship between the modern artist and Life?"[71] So, too, Kokoschka's essay seeks in its jejune way to come to grips with this level of philosophical thinking: "The life of the consciousness is boundless. It interpenetrates the world and is woven through all its imagery."[72] Gauguin's late Tahitian paintings, most of them portraits and some of them exhibited in both Budapest and Vienna at this time, moved Lukács more than any others because in them "Gauguin achieved an ever greater harmony and tranquility. More and more the details, reality itself disappeared from his pictures; there remained but a symphony of lovely surfaces and dazzling colours; the harmony of undulating horizontal lines and planes. What we have here is not so much painting, as a decorative art."[73] Kokoschka also admired Gauguin at this time, particularly making use of Gauguin's color harmonies.

These early writings by the artist Kokoschka and the philosopher Lukács present neither a completely coherent nor a systematic body of thought on the social significance of art. The language is dense, and particularly in the case of Kokoschka, often unclear. Perhaps this was due to his rather inept attempt at synthesizing a point of view that was not originally his own and an ideology that he could express satisfactorily only in visual terms in his portraits. Nonetheless, both artist and philosopher insist on the fundamental role of art as the means

for the integration into society at-large of both the subject portrayed and the artist.

Some Conclusions

In Hauser's later book, called *The Sociology of Art*, which first appeared in German in 1974, he depended explicitly on an idea of sociology that derived from a serious engagement with the Frankfurt School, particularly the late work of Theodor Adorno.[74] Now that Adorno's final lectures on sociology have been published, it is possible to gain greater insight into the commensurate thinking about sociology and culture that he and Hauser held around 1968.[75] Indeed, it is difficult now to think of Hauser's "Totality of Life and the Totality of Art," the title of the first chapter of *The Sociology of Art*, without Adorno and without the theory of portraiture put forward by the Vienna School at the beginning of the century. If you substitute *portraiture* for *sociology* in the following sentence of Adorno's, you pretty much have the view developed by art historians in Vienna for the genre: "If you asked me what sociology really is, I would say that it must be insight into society, into the essential nature of society. It is insight into what is, but it is a critical insight, in that it measures that which 'is the case' in society, as Wittgenstein would have put it, by what society purports to be, in order to detect in this contradiction the potential, the possibilities for changing society's whole constitution."[76]

But what of those important years between the *Anschluss* in Austria and the immediate aftermath of 1968 when the social history of art appears to have been reborn, at least in Britain, France, and Germany? If we cannot find a social history of portraiture, or indeed of art, within the discipline itself during this interregnum, we may certainly trace the influence of the Vienna School views on the conception of subjectivity formulated for the portrait image, outside of the Germanic context and outside of art history, particularly in the fields of French psychoanalysis and philosophy, as I have argued in chapter 1. The radical political agenda theorized for art history and visual culture came forward only in the aftermath of 1968.[77] Following the

Situationists, we can recognize this action within the discipline of art history as a call to the individual without the attendant baggage of individualism. For a brief time in the early 1970s the history of art could be thought of as an aspect of sociology, specifically a sociology inflected by the Marxism of the Frankfurt School. However reliant it was on Frankfurt School ideology and the Hegelian dialectic, with this methodology also came the recuperation of an earlier possibility for art that had been established in the Viennese context of the early twentieth century. An examination of Kokoschka's portraits in their critical context reveals that the art-historical discourse on portraiture in Vienna cannot be regarded as a purely disciplinary matter pertaining to the relatively small academic field of the history of art, or to the biography and oeuvre of a single artist. In the twentieth century, the context for the investigation of the subject in art lies both in painterly practice and in critical discourse before it finds its way into psychoanalysis and philosophy, to reemerge in the post-1968 social history of art as a utopian project of historical significance.

3

THE SUBJECT AT RISK

Jewish Assimilation and Viennese Portraiture

What have I in common with Jews? I have hardly anything in
common with myself and should stand very quietly in a corner,
content that I can breathe.

—FRANZ KAFKA, 8 January 1914

Let Kafka's statement in his diary, written ten years before his death
(3 June 1924) stand for the conflict that the assertion of Jewish identity
manifests in the assimilated and cosmopolitan citizen in the former
Austro-Hungarian Empire.[1] When he asks what he has in common
with Jews, Kafka denies his relations with them by denying his re-
semblance to them. But in so doing he understands that a reflection
on the lack of resemblance to them also places him in a position of
alienation from himself. So much so that it is all he can do to breathe,
in a corner by himself like a bad schoolboy: without any group what-
soever with whom to identify. Max Brod, Kafka's lifelong friend and
biographer, interprets Kafka's last novel, *The Castle*, as a metaphor for

the dilemma of alienation encountered by Jews struggling to assimilate: "But the riddle as to why K. cannot make himself at home is not solved. He is a stranger, and has struck a village in which strangers are looked upon with suspicion. More is not said. One feels at once that this is the general feeling of strangeness among men, only it has just been made concrete in this one special case. 'Nobody can make the companion of anyone here.' One can take this making-concrete a step further. It is the special feeling of a Jew who would like to take root in foreign surroundings, who tries with all the powers of his soul to get nearer to the strangers, to become one of them entirely—but who does not succeed in thus assimilating himself."[2] The inability to identify with Jews gives Kafka no solace, other than the sense of being simply alive, breathing, in solitude. He writes on the same day in his diary: "Uncertainty, aridity, peace—all things will resolve themselves into these and pass away."[3]

Kafka's statement leads us to suppose that identification with a group, the Jews, would provide him with more: others with whom he could identify, without whose identification as a group he would be alone. Today, we commonly understand identification as referring both to our individual self, and to another or others with whom we feel significant affinities. In Kafka's formulation the process of identification precedes identity. The other must be recognized in order to know the speaker or in order for the speaker to know himself. Identity is not a solo performance, nor does it promote the singular individual. The assertion of a lack of identity or an inability to identify, then, would be a position of either extreme individualism or alienation.

Kafka's elegantly simple formulation of the complicated network of associations that Jewish identity raises in Prague in 1914 serves as a coda to the problem of the subject in the visual culture of Vienna circa 1900. The alienation that an assimilated subjectivity brought about in the Austro-Hungarian Empire concerns me here, for assimilation, identity, and identification were interrelated concepts at this time in history, as Kafka's diary indicates. These issues are particularly strong in discourses on art and the artist. The strategies used to understand the visual representation of the assimilated subject in early-twentieth-century Vienna form the backbone of this chapter.

In his diaries Kafka appears to seek an aggressive physical distance, evoking not only an inability to identify with others, but provoking on the part of the reader a desire for connection, such as that seen in Kafka's commentator Max Brod and others. This vacillation between physical and emotional distance in both author and readers may be seen as indicative of the historical situation in which Jews in the late Austro-Hungarian Empire found themselves.

Identification in Early Viennese Psychoanalysis

The most striking example of the assimilationist tendency in the arts occurs in the early work of Sigmund Freud's younger associate, Otto Rank (1884–1939). Freud himself edited Rank's study, *Der Künstler* (The Artist), written in 1905 and published in 1907.[4] Freud based his influential study of the artist Leonardo da Vinci, written in 1909 and published in 1910, on Rank's study of the artistic personality.[5] In Freud the historical artistic personality, Leonardo, served as a demonstration for how an individual overcomes his family history to become a productive creator. Freud's essay on Leonardo, and other essays of the same period, proposed the psychoanalytic concept of "identification," which prevailed in early psychoanalysis: "Psychological process whereby the subject assimilates an aspect, property, or attribute of the other and is transformed, wholly or partially, after the model the other provides."[6]

According to Rank's study, the artist overcame the situation of his birth and early upbringing, which resulted in a suppression of neuroses, so that "the creative hero" could be born. This served for Rank as a model for the contemporary Jew, who sought to overcome anti-Semitism and to achieve acceptance in mainstream culture. The figure of the artist theorized by Rank offered him the model of how to construct a positive Jewish identity at a time and in a place of both assimilation and anti-Semitism, his contemporary Vienna.[7] Rank's essay on the Jew, "The Essence of Judaism," was written on 13 December 1905, just after completion of *Der Künstler*.

Rank begins this essay by recalling his view of the role of sexual

repression in the development of culture from the primitive to the civilized, for example, from an "unconscious state of total sexuality to the conscious state of isolated sexuality," to the "state of hysteria," or "anti-sexuality, a disturbance of consciousness."[8] In this cultural evolution the Jew, like the artist, remains at a primitive, "favorable stage of the repression process."[9] Rank goes on to give a brief, and unsubtle, psychoanalytic history of Jewish assimilation. Repression "mounted among the 'cultivated Jews,'" but they were able to achieve the outcome of artistic personality "suddenly and without transition."[10] "Culture-less" Jews, on the other hand, used their creativity to lead the people to progressively more valued professions: from journalists, to matchmakers, and finally to physicians. Rank understands the physician to be close to the classical dramatic actor, for him the primary example of "the creative hero." He writes: "For, the Jews thoroughly understand the radical cure of neurosis better than any other people, even better than the artistically and sublimely talented Greeks with their powerful tragedies."[11] The short essay by Rank on Jewish assimilation echoes the conclusion of *Der Künstler*: at the present stage of cultural development Jews are responsible for curing the neuroses of mankind, just as the artist also will with the help of psychoanalysis.

No documentation exists to show a link between Freud's thinking and Rank's essay on Judaism. But the concept of identification proposed by Freud at this time arose from his study of the artist, which was influenced by Rank, and in that essay the process of assimilation that occurs with the unconscious recognition of the individual by another is of great significance for the concept of identification.[12] In his essay on the artist Rank wrote: "Slowly he prepared for his own creativity which, so to speak, occurs when the attempted remedies are not successful enough; intuitively then he recognizes the nature of the great artists whose works have attracted him and tells himself unconsciously; if they have cured themselves through their works, I can cure myself in a similar way: he himself becomes an artist by way of identification."[13] While Freud and his followers may have theorized identification through the figure of the artist and based it on the processes of recognition and assimilation, a questioning of the

dominant model of the individual that was used by Freud, based as it was on earlier philosophical concepts, occurred outside of the field of psychoanalysis.[14]

We have already seen that portraiture was invariably the term or figure around which explications of a new subjectivity were made. Portraits of the early twentieth century, and the writing about them, present the subject in ways that troubled the prevailing understandings of the individual. Rank's and Freud's discussion of Jewishness in relation to the art and the artist may then be taken as a symptom not only of the anti-Semitism prevalent in Vienna at the time, but also as a sign of the disciplinary location of art history, in which a complex renegotiation of identity could take place and be accepted. The early portrait by Oskar Kokoschka of two art historians who themselves contributed to the discussion of subjectivity in historical portraiture provides a starting point, or case study, for our discussion of the negotiation of assimilated Jewish identities in the visual arts in early-twentieth-century Vienna. As I've already noted, this portrait also provides an excellent visualization of the concepts raised by the invention of the genre of portraiture at this time.[15]

Portraiture and Assimilation in Vienna: The Case of Hans Tietze

Oskar Kokoschka painted the assimilated Jewish subjects Hans Tietze (1880–1954) and Erica Tietze-Conrat (1883–1958) in Vienna in 1909. The Museum of Modern Art in New York has owned the portrait since 1940. The painting in oil on canvas is signed on the lower right by the artist. The painting presents a particularly important example of the absence of overt signification of Jewish subjectivity, but Kokoschka's other portraits of assimilated Viennese Jews of the same period also exhibit this characteristic. In the main, the portrait of the Tietzes has been offered in the art-historical literature as an outstanding example of the work of a major avant-garde modernist. This signification of the painting can be traced to the association of it with other works by Kokoschka that were exhibited in several highly controversial shows at the end of the first decade of the twentieth cen-

tury. These one-man shows solidified his reputation as one of the first avant-garde masters of the century—as the first Expressionist. However, until the time of its purchase by the Museum of Modern Art this picture had been seen only over the mantelpiece in the Tietzes' home in the suburb of Heiligenstadt. There, according to Kokoschka's own view of his portraits of this period, it carried another meaning: "Most of my sitters were Jews. They felt less secure than the rest of the Viennese Establishment, and were consequently more open to the new and more sensitive to the tensions and pressures that accompanied the decay of the old order in Austria. Their own historical experience had taught them to be more perceptive in their political and artistic judgements."[16]

According to the curatorial files of the Museum of Modern Art, the Tietzes brought the portrait in its original frame from Vienna to New York City when they were forced to emigrate.[17] The painting was approved for purchase by the museum's acquisition committee on 8 December 1939, not long after the Tietzes' arrival. The sale appears to have been brokered through the New York dealer D. Hugo Feigl. The purchase stemmed from the Tietzes' need for funds in their new home. Prior to the sale of the painting, Feigl wrote to Alfred Barr on 26 September 1939 that "Kokoschka estimated [sic] especially this painting very much that [sic] hitherto the picture never was exhibited nor was taken a photograph of it, because Mr. and Mrs. Tietze have been extraordinarily anxious and superstitious in connection with all actions concerning their picture."[18]

No doubt for these same reasons, the Tietzes had refused to let the artist display this painting in his early exhibits, including the one at the Hagenbund in February of 1911 in which he exhibited twenty-five other paintings, most of them portraits.[19] We might attribute this to a desire not to be associated with the group whom Kokoschka sought to identify. This same desire on the part of others portrayed by Kokoschka can also be discerned in the catalogue of the Hagenbund. Most of the portraits were not identified by the *name* of the sitter but rather by *gender* or by the *initials* of the sitter: portrait of a man, portrait of a youth, children at play, Portrait of Frau Dr. L. Fr. This absence of the identification of the portrait to the named

individual has great significance both for the history of art and for the history of these subjects who were portrayed. The glaring absence of the Tietzes' portrait in the exhibition, where the other portraits were seen but not identified, registers an even stronger signification based on a lack. What power did this picture have, that only after the threat of genocide and bankruptcy, and their exile from Vienna with it, could the Tietzes bring themselves to part with and, perhaps, to cease to identify with it? This painting had never hung as part of a group of early works by Kokoschka, most of them portraits of assimilated Jews. Interpretations subsequent to the acquisition of the painting by MOMA, including its incorporation in numerous exhibitions elsewhere, have failed to address the identity of the sitters in their specific historical context. In the late twentieth century, when this painting hung at MOMA in a room devoted to modernism next to a post–World War II portrait by Kokoschka, it affirmed a social standing of *fully acculturated*.

The documentation of Hans Tietze's religious affiliations encapsulates the possibilities and failures of Jewish assimilation in the Austro-Hungarian Empire and in Vienna between the wars.[20] Hans Tietze was born Jewish in Prague in 1880, the son of Siegfried Taussig and Auguste Pohl. In 1893, when Hans was thirteen, his family moved to Vienna, converted to Protestantism, and changed their name to Tietze. Hans attended the elite Schottengymnasium in Vienna and received his doctorate in philosophy in art history at the University of Vienna in 1903, at the age of twenty-three.[21] Two years later Tietze married Erica Conrat, also a converted Protestant and an art historian who had studied at the University of Vienna. Their first son, Christopher, was born in 1908. Kokoschka made his portrait in December of the following year. In 1930 Tietze declared himself religiously "unaffiliated." In 1933, by now a prominent historian of Austrian and Venetian art, he published the book *The Jews of Vienna: History/Economics/Culture*, with a striking title-page illustration of the prophet David. This book shows that Tietze never entirely separated from his Jewish identity (see figure 13).[22] Indeed, a comparison of the drawing of David to Kokoschka's portrait of the Tietzes suggests echoes of a young Israelite prophet in Tietze himself. Tietze once again declared

HANS TIETZE

Die Juden Wiens

Geschichte — Wirtschaft — Kultur

Mit 30 Tafeln, Bildern und Plänen

1933
Leipzig / E. P. TAL & CO. / VERLAG / Wien

13 Title page. Hans Tietze, *Die Juden Wiens:
Geschichte-Wirtschaft-Kultur*.

himself Protestant in 1934, and in 1938–39 in order to emigrate to
the United States he declared himself Jewish. The *International Bio-
graphical Dictionary of Central European Émigrés* lists his religion as
"unaffiliated." [23]

At the time that Kokoschka painted this portrait, Tietze was twenty-
nine and Erica Tietze-Conrat was twenty-six. They had been mar-
ried for four years. In 1953 Kokoschka wrote to the Museum of Mod-
ern Art that this "exceptional" portrait, as he called it, "was meant
as a symbol of the married life of the two sitters and as such com-

missioned."[24] In the context of portraits of "worthy husband and equally worthy wife," Kokoschka's painting differs significantly by placing the sitters in the same frame, on the same canvas. This format is found in some Netherlandish, Dutch, and French painting. The Tietze portrait may derive from the first and most famous example: Jan Van Eyck's 1434 *Arnolfini Wedding Portrait* now in London at the National Gallery, pictured in chapter 1. Closer comparisons can be found elsewhere, particularly in later Dutch and French examples, such as Rembrandt's *The Mennonite Preacher Anslo and His Wife* from 1641, certainly known to both sitter and painter (see color plate 9). Married couples painted by Jacques-Louis David should also be mentioned: the 1788 *Portrait of M. & Mme. Lavoisier*, painted at the time of the artist's so-called Flemish style, and the very differently conceived *M. and Mme. Mongez*, painted in 1812. Closer in date to the Kokoschka portrait, Edouard Manet's 1860 portrait of his parents, today in the Musée d'Orsay, Paris, must also be cited (see color plate 15). However, unlike in most of the earlier double portraits of married couples, the Tietzes have no attributes, other than their clothes, to indicate their place in a society of the bourgeoisie, and no background elements to situate them in a particular location. The picture's lack of ornamentation, such as furnishings or landscape, is historically significant. In order to understand the meaning of this portrait the historical and physical contexts of the artifact are important, because signification occurs *outside* the overt symbols used in the image. The Tietzes' own insistence that this painting's rightful place was hanging over their mantelpiece and not in a public exhibit makes the topic of context particularly apposite.

In the earlier examples of portraits of married couples the active stance and/or foregrounding of the male figure contrasts with the modest pose of the female figures. According to Erica Tietze-Conrat's recollection, Kokoschka said sometime after World War I: "I have not painted you maliciously . . . The doctor looks like a lion and madam looks like an owl."[25] Whereas the married couple provides the ideal occasion for the depiction of conventional social values, Kokoschka's interest in something more, in the opposition of the sexes and their psychosexual traits visible in the contrasting gestures and physiog-

nomies of the Tietzes, came, so he said many years later, from the influential studies of Johann Jacob Bachoven.[26] His portrayal of the male as energized activity and the female as figure of quietude can be discerned in the opposition of the poses of the figures. Carl Schorske saw the "crackling light" behind Tietze and the "sharpened, fin-like scorings" behind his back as suggestive of a male sexual energy.[27] We see the same sort of active gesturing and strong scoring in the paint in the *Portrait of Felix Albrecht Harta*, pictured in chapter 2. To be sure, gender oppositions are overtly sexualized in Kokoschka's early work. The artist's illustrations for the 1908 children's book *The Dreaming Boys*, where "boys" take on feminized gestures, reveal that psycho-sexual attributions occurred in many of his images, not exclusively in the portraits (see figure 14). In contrast to the male figures, Kokoschka's early portraits of women show hands crossed over the breast or abdomen, a gesture of modesty as seen in the figure of Erica Tietze-Conrat. The 1909 *Portrait of Lotte Franzos* (see color plate 7) is a good example of what becomes at this time a convention peculiar to the work of Kokoschka.

Despite these conventions of differentiation between male and female sitters, in their home, as well as in this painting, Hans Tietze and Erica Tietze-Conrat were more than simply—if such a word can be used to describe the relationship—husband and wife, man and woman. They were both art historians who often published together and who sat at the same desk everyday for years to write about works of art, architecture, and art theory. As a sign of respect for Tietze-Conrat's standing in the field, in a letter to the director of the Museum of Modern Art, Julius Held, art historian and friend of the Tietzes, demanded that Erica Tietze-Conrat be named on the wall label of the portrait in the gallery because "she has made sufficiently important contributions to lend additional interest to a painting in which she is portrayed and identified by name."[28]

Since the Renaissance, scholars, men of letters, and writers had been shown in portraits at work in their libraries with their books. Kokoschka's portrait differs significantly from this tradition, as the comparison with Manet's *Portrait of Emile Zola* (1869), a writer and critic, demonstrates (see color plate 10). As a portrait of two art his-

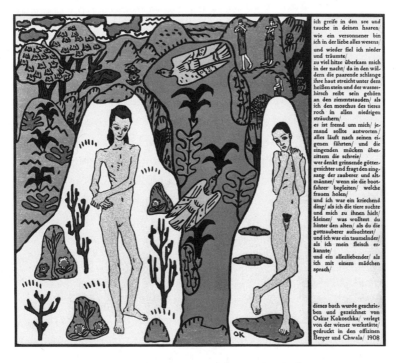

ich greife in den see und
tauche in deinen haaren/
wie ein versonnener bin
ich in der liebe alles wesens/
und wieder fiel ich nieder
und träumte/
zu viel hitze überkam mich
in der nacht/ da in den wäl-
dern die paarende schlange
ihre haut streicht unter dem
heißen stein und der wasser-
hirsch reibt sein gehörn
an den zimmtstauden/ als
ich den moschus des tieres
roch in allen niedrigen
sträuchern/
es ist fremd um mich/ je-
mand sollte antworten/
alles läuft nach seinen ei-
genen fährten/ und die
singenden mücken über-
zittern die schreie/
wer denkt grinsende götter-
gesichter und fragt den sing-
sang der zauberer und alt-
männer/ wenn sie die boot-
fahrer begleiten/ welche
frauen holen/
und ich war ein kriechend
ding/ als ich die tiere suchte
und mich zu ihnen hielt/
kleiner/ was wolltest du
hinter den alten/ als du die
gottzauberer aufsuchtest/
und ich war ein taumelnder/
als ich mein fleisch er-
kannte/
und ein allesliebender/ als
ich mit einem mädchen
sprach/

dieses buch wurde geschrie-
ben und gezeichnet von
Oskar Kokoschka/ verlegt
von der wiener werkstätte/
gedruckt in den offizinen
Berger und Chwala/ 1908

14 Oskar Kokoschka, *The Dreaming Boys* (book illustration).

15 Henri Fantin-Latour, *The Studio at Batignolles: Otto Schoelderer, Manet, Renoir, Zacharie Astruc, Zola, Edmond Maitre, Brazille and Monet*, 1870.

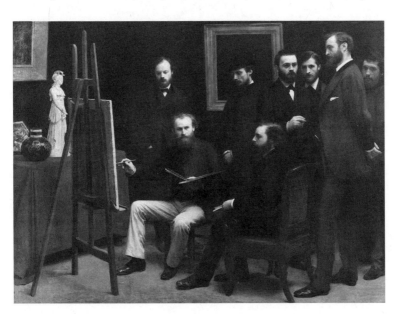

torians, Kokoschka's painting might be understood in the context of another category of portraiture, the group portrait of intellectuals and artists which became popular in nineteenth-century France. For example, Fantin-Latour's *An Atelier in the Batignolles* (1870) depicts a group of artists and writers — all associates of the painter Manet who sits at the easel (see figure 15). Fantin-Latour's paintings of artists and intellectuals differ significantly from Kokoschka's double portrait inasmuch as these portray full-length figures grouped around and focused on the main figure, whereas Kokoschka's early portraits invariably present the figure half-length, with a gaze which encounters the viewer, or someone not in the painting. In the case of the Tietzes' portrait, the figures interact both with each other and with the viewer. The historical model for the Fantin-Latour painting, based on an earlier image by the Dutch painter Joos van Craesbeeck (*Painter Doing a Portrait*, Louvre), reveals that the actual source for the group portrait in the studio derived from Dutch group portraits of the early modern period.[29] Kokoschka's portrait of the Tietzes can also be associated directly with this tradition of portraiture, specifically with the theory of the Tietzes' famous teacher, the Viennese art historian Alois Riegl (see chapter 2). In addition, with this association, the issue of subjectivity in the Tietze portrait can be more precisely historicized.

As already noted, the *A Company of the Civic Guard* by Dirck Jacobsz depicts half-length figures in a relatively anonymous, undecorated space, causing the viewer to focus on the figures, particularly the faces and the hands, which in both paintings emerge from the surroundings (see figure 6). In the Tietzes' portrait Kokoschka's sitters appear against a nonfigurative background. The curatorial file at MOMA reveals the intense interest taken by both the Tietzes and the artist in the edges of this double portrait, precisely relating their concerns about this space empty of figuration.[30] In both Kokoschka and the Dutch example, the heads press at the upper margins of the painting while the torsos are cut off by the lower edge of the painting. After purchasing the Tietzes' portrait, MOMA removed the painting from its original stretcher and framed it with the canvas edges folded out to increase the margins between the figures and the edges, to the distaste of Erica Tietze-Conrat. In the original framing, the limits of the

painting would have been even closer to the Dutch example, causing the hands and heads to be seen as more prominent than they are now.

In 1953 Kokoschka wrote that what impressed most in this and other portraits of his "early period was [that he was] the only one to render the vision of people being alive, due to the effect of an inner light, resulting technically from layers of thinly painted colour and fundamentally from a creative approach which in stressing the sense of vision, as the act of seeing, is dramatically opposed to all fashionable theories on art asserting the human being to be seen as a kind of *nature morte*."[31] Like the Dutch painters, Kokoschka desired a mode of energized representation—or, to use a term taken from Greek rhetoric, *enargia*. This liveliness characterizes all of Kokoschka's portraits and separates them from portraits by his immediate contemporaries, such as Gustav Klimt (see chapter 2). The "liveliness" of Kokoschka's early portraits is enhanced by the intervention of the artist's own gestures of incision and manipulation of the paint. In all of these portraits gesture and gaze mutually support an interaction between the figures portrayed and also between them and the viewers of the painting, with no subsidiary background distraction. The prominent gestures, expressions, and movements in the painting evoke a reaction from the viewer. As I have already discussed, the figures in Kokoschka's paintings do not appeal to reason, nor does he seek in his depictions to establish a highly credible likeness based on an absolute fidelity to a mimetic schema. Here we understand that he also refuses another dominant convention of the genre, for example, to provide a locus, or a readable background, for his figures. Kurt Varnedoe called Kokoschka's portraiture a "performance," understood as the artist's performance on behalf of those he represents.[32]

Again, the issue of subjectivity in Kokoschka's early portraiture can be historicized more precisely through the rhetorical terminology of *pathos*, a term used by Hermann Bahr in 1920 to define "Expressionism."[33] In his essay Bahr named Kokoschka and the art historian Alois Riegl as the primary proponents of the Expressionist movement in literature and art. Riegl's "The Group Portrait of Holland," an essay published in 1902, surely influenced his student Tietze as much as it did Kokoschka, and he also wrote on modern art in the essay. He

was particularly critical of modern portraiture for ignoring the reciprocation between subject and viewer. He wrote: "One must always proceed from the assumption that the portrait figure turning directly toward the beholder served exclusively as an emphatic demonstration of the Baroque dualism of object and subject. Classical antiquity avoided this turn, for it recognized only objects. Modern art can likewise dispense with it, but for the opposite reason. It recognizes only the subject, since according to its view the so-called objects are entirely reduced to perceptions of the subject."[34] In her book on Riegl, Margaret Olin argues that with his theory of portraiture Riegl addressed himself to the problem of subjectivity in modern times. Riegl sought a "reconciliation of a new 'subjective' element with the respectful separation which unites subject and object while preserving their individual identities."[35] Riegl's theory of portraiture speaks to the assimilation of subject and object through communication between the portrayed and the viewer. It is entirely possible that an aspect of

the transaction of portraiture embodied in the picture at MOMA concerned the explanation of the theories of Riegl, the recently deceased teacher of the subjects, to the young artist, Kokoschka. In his obituary of his friend, the art historian Julius Held wrote: "Hans Tietze took also a passionate—and lifelong—interest in modern art . . . becoming the spokesman of modern art in his country."[36]

Kokoschka's double portrait, as well as Tietze's later writings in support of Kokoschka, testify not only to Tietze's commitment to "modern art," but to a specific kind of radical art epitomized by Kokoschka's work in Vienna beginning in 1908, the date of the artist's public debut at the first Kunstschau exhibit.[37] The question of Kokoschka's political sentiments during these years has to be addressed in part through the violent reaction of Vienna against him after the first and second Kunstschau exhibits, and in terms of the political orientations of his closest associates at this time: Adolph Loos, the architect and critic from Brno, the capital of Moravia, and another émigré to Vienna, Karl Kraus, the satirist and journalist.[38] Both men were depicted by Kokoschka early in his career.[39] At this time both Loos and Kraus scorned the cultural and social backwardness of Austria-Hungary and championed the young artist. Kokoschka recalled the scene: "I always

sat at his [Kraus's] table in the café frequented by all the literary people in Vienna, and that was a great honor — certainly not everyone was allowed to. We made up a small circle — Peter Altenberg, Adolf Loos, Georg Trakl. Arnold Schoenberg came less frequently. For Karl Kraus correct mastery of the German language was proof that you belonged to the human race — his Bible was the grammar book." [40] Kraus's interest in language may well have caused Kokoschka to consider the overt rhetorical devices that I have identified in his portraits. So too, Loos's architectural theory, which called for a focus on essentials without ornamentation, could have influenced the lack of background figuration in the early portraits. Of Loos's famous essay, "Ornament and Crime," published in 1908, the architectural critic Reyner Banham wrote: "It brings the reader up with a jerk and sets his stock response jangling. It is probably the first appearance of that pugnacious moral tone that was to characterize the writings of the Twenties and Thirties, and the opening paragraphs fully sustain this bourgeois-bashing, damn-your-delicate-feelings attitude." [41]

No one sensitive to art and criticism in those years, as both of the Tietzes would have been, could have ignored the scandal and the political realities of Kokoschka's stand as "outsider," a self-presentation ostentatious in a contemporary poster that shows the artist with a shaved head, symbolizing at that time the appearance of a criminal (see figure 16). Like Loos, Kraus, and Kokoschka, Tietze was an "outsider" in Vienna; like them he had immigrated to Vienna, and he was a Jew. The many dimensions of the relationship between Kokoschka and the Tietzes established by the portrait contained within it the negotiation of multiple subjectivities. [42]

The portraits that Kokoschka painted in these years were predominately of assimilated Jews, many of them introduced to him by Loos. [43] According to the artist himself, before the Kunstschau most of the friends with whom he argued politics in the coffee house were Jewish bank clerks. [44] If we were to assemble all of the individual portraits of Jews painted by Kokoschka in the years 1908–11 into one imaginary group portrait this aggregate work would produce all of the qualities of representation and subjectivity addressed by Riegl in regard to the Dutch group portrait. As Riegl says, the figures in the

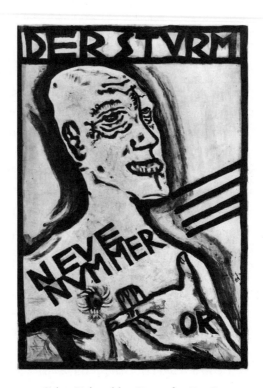

16 Oskar Kokoschka, Poster for *Der Sturm*.

Dutch group portrait maintain their individual identity but depend on each other for their collective identity. The specifics of that collective identity are seen in the portrait by the viewer. The gestures and gazes of the figures are the marks of identity that the group portrait so successfully conveys, according to Riegl. In our imaginary group portrait of Kokoschka's early portrait subjects, nothing points ostensively to a collective Jewish identity, even though he may have had this in mind if, as I suggest, he had discussed Riegl's essay with the Tietzes. Kokoschka disperses the collective identity among the individual portraits where it remains to be activated by the viewer. It is with the specificities common to this group of sitters and the artist that we can grasp the sense of a shared identity, which is gestured to by the artist's similar treatment of the figures in each of the separate paintings.

Portraits of Jews present particularly acute examples of the problem-
atic of the interrelationality of the subjects in portraiture. A brief ex-
amination of the history of the portrait of the European and American
Jewish subject allows us to understand why. In a chapter titled "The
Rabbi as Icon" in the book, *Jewish Icons: Art and Society in Modern
Europe*, Richard I. Cohen carefully describes the change in attitudes
of European Jewry toward portraits that coincided with an increas-
ing sensitivity toward the image in general.[45] To be sure, portraits of
Jews existed earlier, but in the main, until the eighteenth century they
"were deemed idol worship and emulation of a Christian tradition."[46]
The first "modern" portraits of Jews were portraits of rabbis, a com-
mon genre with clear references to Judaism in dress, attributes, and
attitude, such as pointing to Hebrew texts (see figure 17). In rabbi
portraits the subject is always depicted alone within the frame of the
painting or print. This is the case even when a number of representa-
tions occur together in one work, such as the broadside of rabbis from
Breslau. In the rabbi portrait the figure is truncated, and often holds
a book with visible Hebrew script, such as in the *Portrait of Tzevi Ash-
kenazi* of 1660–1718 (see figure 18). The gaze is invariably focused for-
ward. The clothes and hair distinguish the rabbi from others as a reli-
gious figure. These portraits appear to derive in their typology from
the Christian visual tradition, in particular from Flemish and Dutch
portraits of the Renaissance period, such as the *Portrait of a Carthu-
sian Monk* painted by the artist Petrus Christus in 1446 (see figure 19).
This portrait can be distinguished from others of this early period,
such as the *Arnolfini Wedding Portrait* pictured in chapter 1, by the
monk's dress, the tonsured head, and his truncated figure. Although
he does not tie it to the Christian tradition, as I do briefly here, Cohen
has demonstrated that the iconography of the rabbi portrait persists
into the twentieth century. Of equal importance to our understand-
ing of Jewish portraits in modernity are a large number of portraits
of Jews from the American colonial and federal periods. In number,
these portraits, such as *Portrait of Moses Myers* and *Portrait of Eliza
Myers* painted by Gilbert Stuart in 1803–4, reveal the strength of the

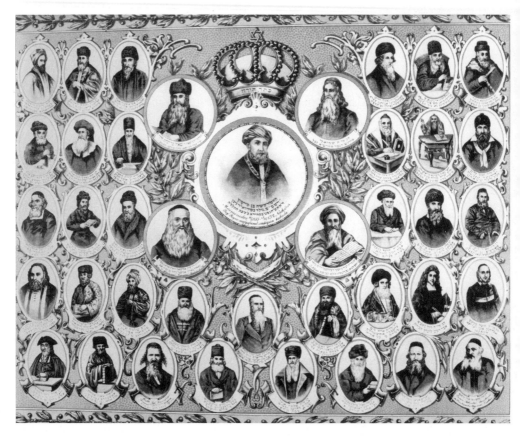

17 *Historic Rabbis*, broadside printed by the Graphische Kunstanstalt, Breslau, twentieth century.

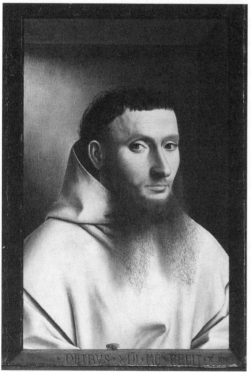

18 *Portrait of Tzevi Ashkenazi.*

19 Petrus Christus, *Portrait of a Carthusian*, 1446.

desire for portraiture among the propertied class of Jewish merchant-traders, shippers, and bankers (see figures 20 and 21).[47] Unlike in the rabbi portraits, there are no overt signs of Jewishness either in dress or attributes. Richard Brilliant found that such portraits presume a purely domestic context, evident first in the predominance of "paired portraits of worthy husband and equally worthy wife," as he put it.[48] Paired spousal portraits also derive from an early modern northern tradition, as the now unnamed 1520 portraits by Quentin Massys in the Metropolitan Museum of Art demonstrate (see figures 22 and 23).

The reception of the early American portraits in their original context, Jewish homes, must be understood in terms of the "semi-private function of the original display of the painted portrait itself."[49] Brilliant argued that these paired portraits would have been seen in the context of domestic Jewish religious practices and objects, yet they contain no religious iconography. The surviving examples of Jewish American paired portraits of the eighteenth and nineteenth centuries are comparable in composition and situation to the so-called "marriage portraits" commissioned by prosperous Jewish merchant families of Prague beginning in the first half of the nineteenth century. My examples here—portraits of Sara and Wolf Moscheles—were painted quite early, in 1790 (see figures 24 and 25). Like the American paintings of Moses and Elizabeth Myers these portraits were usually painted in pairs and reflect the strength of the Flemish or Dutch precedent and its importance for Jewish family portraits. A ceremonial significance—that of marriage—has naturally been attributed to these portraits, but the evidence for a specifically religious iconography is scanty.[50] These central European paintings should be read like the early American portraits, for example, as examples of social and economic aspirations made visible and recognizable only in their original domestic context as portraying Jewish individuals.

Without any visual references to religion or religious practices, the central European portraits of Jews in modernity, except those of the rabbis, contain no "Jewish semiotic," as Richard Brilliant has argued. When we look at these portraits out of their original context there is nothing to signify that they portray Jews. It is only when we venture outside the frame of the representation itself and into the history

20 Gilbert Stuart, *Portrait of Moses Myers*, ca. 1808.

21 Gilbert Stuart, *Portrait of Eliza Myers*, ca. 1808.

22 Quentin Massys, *Portrait of a Woman*, ca. 1520.

23 Quentin Massys, *Portrait of a Man*, ca. 1520.

24 *Portrait of Sara Moscheles.*

25 *Portrait of Wolf Moscheles.*

of the painting that we find a Jewish signification, or, if you will, a "Jewish identity."[51] The portrait's transactions with its responsible interpreters, those who seek a historically complete understanding of the object, press the topic of identity into consciousness. Once there, it can be examined as a legitimate aspect of the visual representation itself even if its presence, the identity of the acculturated Jew in historical context, has in the past, in the interpretation of art, not been allowed.[52] Or, to put the matter more directly in the hands of the art historians, because of the movements of these objects caused by the destructions of World War II, the portrait of the Jew has lost its original context, and therefore, the depicted Jewish subjects have lost their domestic identity through their public display in museums. Like the assimilated Jewry of modernity, unmarked by dress, no longer residents of the ghetto with boundaries clearly marked so that identity could be claimed and known by those both inside and out, these portraits require a historical discourse in order for the interpretation of subjectivity to take place. In addition, if the Jewish identity of the portrait becomes a subject through interpretation, then the interpreter's own subjectivity and the role of history writing, as well as that of museum politics, must be considered as integral to the transactions of subjectivity presented by portraits of Jews.

As representations the early portraits of Jews by Kokoschka appear to display the emancipatory ideal of assimilation held by bourgeois, urban Jews in the Austro-Hungarian Empire in the first decades of the twentieth century. This emancipatory ideal, born in the nineteenth century, became part of the modern, cosmopolitan Jewish material, literary, and performance culture found in many German-speaking cities of the time.[53] This was the ideal that Otto Rank had sought so assiduously with his essay on the Jew as healer and creator. The representation of these individuals by Kokoschka helped to promote such an ideal in Vienna, in the class of those being portrayed and among those who would have viewed the portraits in exhibitions and publications. Just as non-Jewish members of the urban bourgeoisie in Europe usually sought to identify through the portraits they commissioned with an economic and social class, rather than with a particular nation or ethnic background, so, too, the Jews portrayed in the portraits

sought to belong to a dominant social group. As art, the portraits of Jews in modernity signify a desire *not* to signify a religious identity pictorially. But in whom does that desire lie?

Recognizing these portraits as "Jewish," as I have done, means calling into question the very project of emancipation itself, but it also calls into question the role that recognition plays in the interpretation of the visually represented subject. Recognition of the individual portrayed, whether by a family member or by the later art historian, emerges as central to the discussion of portraiture from the Greek times onward, as I argued in chapter 1.[54] These concepts, one political and historical—Jewish emancipation—and one political and aesthetic—recognition—are mutually reinforcing through the very genre of portraiture itself. So, too, in a more historically specific case, the congruence of a concept of freedom and emancipation in a democratic society and a concept of recognition underlies Riegl's theories of Dutch group portraiture. What emerges from Kokoschka's early portraits and from the Vienna School's scholarship on the genre of portraiture is a form of political idealism based on emancipation—the freedom of the subject to be a subject to others. From this investigation of the subject, together with investigations into aspects of recognition and identification, explored by psychoanalysis at this time, it is clear that the congruence of aesthetic and political ideals theorized for the portrait places Viennese art and art history at a key juncture in the history of twentieth-century culture.

For the Tietzes, attentiveness to their subjectivities may not have been altogether optimistic in 1909, but a sign of an unstable place in a changing social order where acculturation may prove imperfect and the study of the art of the past no haven. In 1928 the Viennese Jewish émigré Salo Baron argued that the processes of assimilation had a far more ambiguous character than was usually recognized, particularly for the historiography of Jewish culture in modernity.[55] Once the portrait is removed from its place and the relationship of painter, sitter, viewer it initially invited—be it by physical removal or by the "remove" of an art-historical tradition that favors generic placement with the formal conventions of genre painting over the contextual relocation of the work—we are *ourselves* compelled to exercise an atten-

tiveness that confirms and paraphrases historical contexts. Our own context for the reception of the Tietzes' portrait and other portraits of Jews from Europe before 1938 includes a knowledge of the events leading up to the expulsion of the Tietzes from Austria. The effects on history writing of the Holocaust are part of its aftermath, which also pertains to our reception of the visual images of Jews associated with those times. The difficulties we may have today with the "Jewish identity" of the sitters in Kokoschka's early portraits are a strong part of the history of the sitters, the history of the object, and the interpretative tradition which we have inherited. Portraits of Jews in modernity are exemplary "sites of a new and tension-filled social contract," in which displacement(s) reveal identity only when the interpreter beholds the gestures toward identity, collectivity, and sociality that reach beyond the frame.[56]

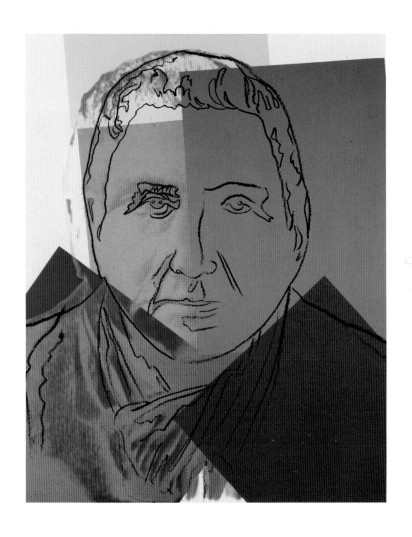

PLATE I Andy Warhol. *Ten Portraits of Jews of the Twentieth Century: Gertrude Stein*, 1980.

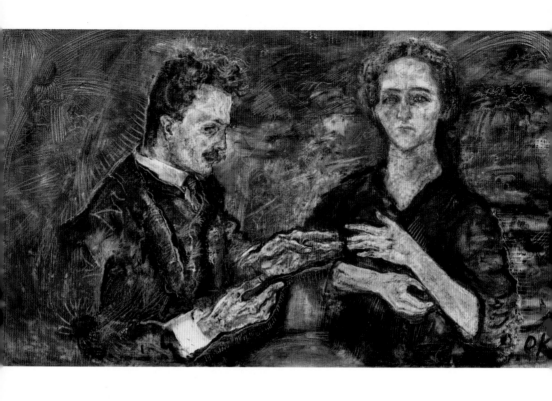

PLATE 2 Oskar Kokoschka, *Hans Tietze and Erica Tietze-Conrat*, 1909.

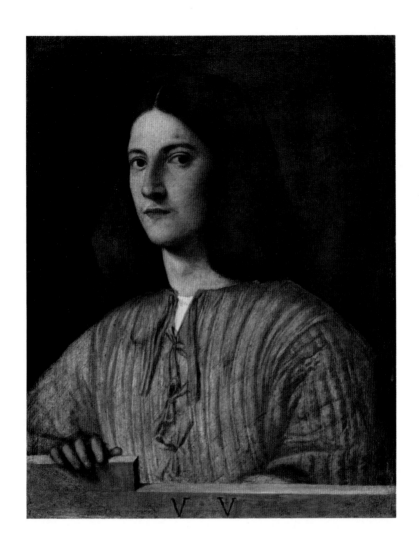

PLATE 3 Giorgione, *Portrait of a Young Man*, ca. 1505–6.

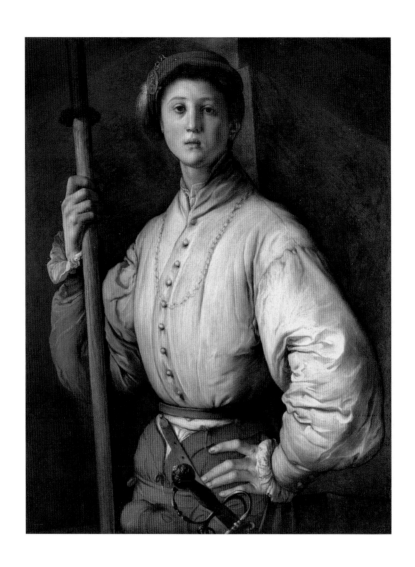

PLATE 4 Pontormo (Jacopo Carucci), *Portrait of a Halberdier*
(Francesco Guardi?), ca. 1528–30.

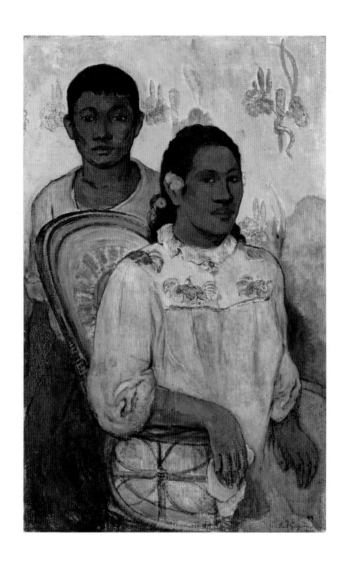

PLATE 5 Paul Gauguin, *Tahitian Woman and Boy*, 1899.

PLATE 6 Oskar Kokoschka,
Portrait of Felix Albrecht-Harta, 1909.

PLATE 7 Oskar Kokoschka, *Portrait of Lotte Franzos*, 1909.

PLATE 8 Oskar Kokoschka,
Portrait of Baron Viktor Von Dirsztay, 1911.

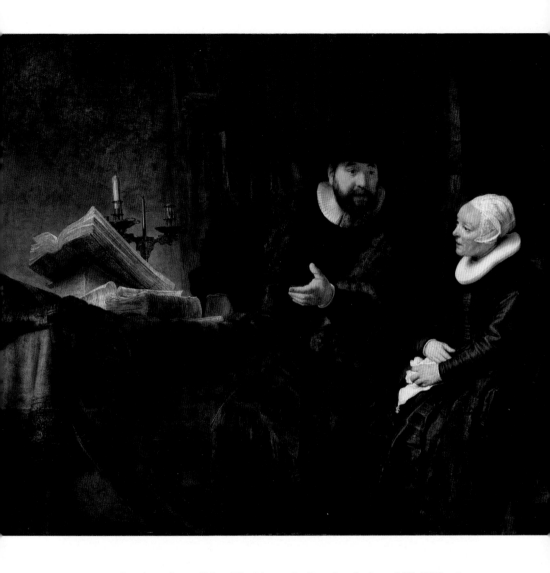

PLATE 9 Rembrandt van Rijn, *The Mennonite Preacher Anslo and His Wife,* 1641.

PLATE 10 Edouard Manet, *Portrait of Emile Zola*, ca. 1868.

PLATE 11 Heinrich Kühn, *Still-life*, 1895.

PLATE 12 Heinrich Kühn, *Walther and Lotte Kühn*, ca. 1910.

PLATE 13 Heinrich Kühn, *Portrait of the Artist's Children*, 1912.

PLATE 14 Heinrich Kühn, *Portrait of a Man Seated Beside a Supine Child*, 1900–10.

PLATE 15 Edouard Manet, *M. and Mme. Manet, Parents of the Artist*, 1860.

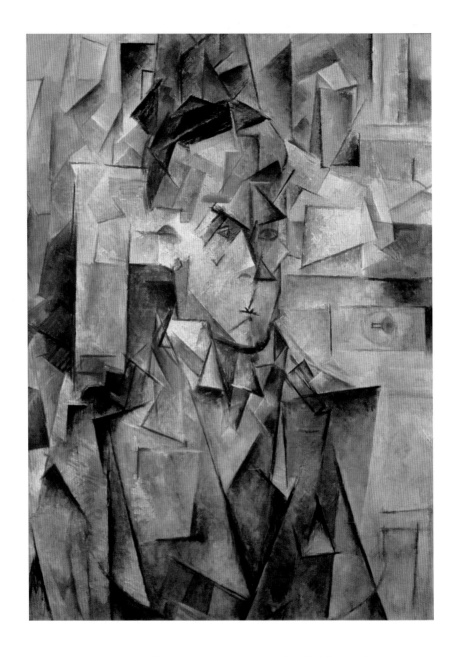

PLATE 16 Pablo Picasso, *Portrait of Art Dealer Wilhelm Uhde*, 1910.

4

ART PHOTOGRAPHY,

PORTRAITURE, AND MODERN SUBJECTIVITY

Issues of identity in art adhere preeminently to portraiture and pertain to processes of recognition, which occur between viewers of the portrait, the artist, and the subject because of resemblance and desire. Thus, it becomes necessary to confront the medium in which resemblance to the subject has traditionally been taken to be at its most concrete: portrait photography. This chapter addresses photographs and a group of texts that initially belonged to the historiography of German and Austrian art photography, also known as pictorialism. The artists discussed here manipulated photographic techniques in order to achieve the effects of the other graphic arts, particularly painting, in their portraits. The critics referred to here supported a discourse on photography that effaced its relationship to "the real" or to its historicist efficacies in the discipline of art history, where photography already possessed an evidentiary or documentary function.[1] The historical literature on photographic portraiture of this period in both the Austrian and German contexts will serve to amplify our understanding of the meaning of art photography for the representation of the subject.[2] It should be noted that in comparison with Great Britain, the United States, and France, Austrian and German fin de siècle

photography has been little studied, although it was a highly regarded international practice at the time. My argument will therefore revise the traditionally held view of the importance of art photography for the social history of art.

The practice known as art photography prompted a comparative approach in photographic criticism at the beginning of the twentieth century.[3] At this time and in this discourse alone photography was favorably compared to other artistic media. Although contemporary accounts are quick to say that neither the art photography movement nor the discourse on art and photography originated in the Germanic context, these visual and discursive practices nonetheless flourished in Vienna and Germany—as did the discipline of art history. With few exceptions, however, the later histories of both Viennese painting and Austrian art photography remain silent on the other medium.[4] It can be said, therefore, that the history of European portraiture remains incomplete because the relationships among media in the genre have not yet been examined. Why has this been the case? I suggest that after World War I in Germany a strategic history of photography developed, one that ignored the innovations of art photography and chose to return to an earlier moment of portrait photography. This post–World War I criticism by the German-speaking avant-garde has influenced profoundly the subsequent art-historical interpretation of both photography and other "new media," despite the strength of art history in Vienna and Hamburg, precisely those places where art photography had flourished. Yet, in the newer, postwar critical milieu, the comparative potential for the theorization of the medium offered by art photography was lost. The elision of Austrian and German art photography by the avant-garde critics should be viewed, in part, as a response on the part of an avant-garde seeking aesthetic criteria at odds with the early claims of art photography itself.

The Place of Art Photography in German-Speaking Europe

In order to place photography in its early historical and visual context, let us begin with an early example which advances the dominant view of art photography: C. Schiendl's *Artistic Photography* (*Die*

26 Frontispiece. C. Schiendl, *Die künstlerische Photographie*, 1889.

künstlerische Photographie) published in Vienna, Pest, and Leipzig in 1889 (see figure 26).[5] The full-page frontispiece for the series of publisher A. Hartleben's Chemical-Technical Library depicts the apparatus of a chemist's laboratory with the title of the book displayed in an open window at the top center of the image. To the lower left of the center of the image a portrait camera stands surrounded by and incorporated into the tubes, chemicals, and instruments of the chemist's laboratory. Symbolically indicated, artistic photography and chemistry, for example, art and science, are married by the medium of photography. This marriage transforms chemical substances into new forms, symbolized here by the distiller that fills the center of the lower part of the composition.

In the institutions founded to promote the technology and processes of photography a constant tension exists between the artistic and the scientific and industrial, or functional, aspects of the medium. Schiendl and others take this dual structure to be the essential char-

acteristic of the medium. The marriage of science and art, therefore, presents no conceptual problem in this view. Scientific processes of transformation, such as those caused by the chemical changes that occur when light produces an image, allow photography to be an art as well—an art with transformative powers. Schiendl's book deals a great deal with portraiture. It contains careful and prolonged discussion of the technical processes of lighting and negative manipulation required in portrait photography, in addition to the lengthy reminder that Rembrandt's printmaking techniques, with their striking manipulation of light and shadow, provide the perfect exemplum for the contemporary photographer.[6] This discussion of photography as both art and science found that the pressing issues for the definition of photography lay inside the medium's own borders.

By 1900, this discrete, noncomparative discourse on photography constituted the prevailing understanding of the medium. Sufficient unto itself, photography's epistemology refrained from engagement

with either social or aesthetic concerns. On the other hand, art photography, which arose at just this moment, invited historians and theorists to compare it with other visual arts. Proponents of art photography realized that the medium could be "aesthetic," as the title *A General Aesthetic of Photographic Art from a Psychological Point of View*, for a book on the new pictorialism originally published in German by Willi Warstat, attests.[7]

When photography came to be compared to other art forms, such as painting or printmaking, and was conceptualized solely in relationship to them, its justification as a medium was no longer self-contained. Photography now belonged to the institutions of art, such as art history and museums, which interpreted and displayed it. It would receive scrutiny, and its definition, from the institutions designed to address art rather than science or industry. In a discourse where photography vied with the other representational arts, comparisons between photography and the so-called fine arts began to offer the key to its definition. Photography submitted to aesthetic philosophy's regimes of definition as the other arts already had after the grounds for comparison between them had been established in the early modern period. Furthermore, in this critical strand, art pho-

tography could threaten the preeminence of other representational media. Comparisons between the arts worked to photography's advantage. Not only could photography represent the real better than the other representational visual arts of painting and sculpture, it could be said to achieve painterly effects, such as color and the obliteration or blurring of outline. Just as painting had threatened sculpture at an earlier historical moment, it was now photography's turn to threaten and to be threatened.[8]

From its earliest institutionalization in the photo clubs and international exhibits of America, England, France, Germany, and Austria, art photography insisted on the amateur's primacy over the professional photographer in the order of things.[9] Art photography questioned the industrial and capitalized hierarchy of portrait studios, photographic landscape postcards for sale to tourists, and even the scientific uses, such as in medicine, to which photography had been put since its invention.[10] Art photographers were not defined in the beginning solely by commercial interests, as portrait photographers, for example, had previously been. They were an international group who corresponded with each other, exchanged prints with each other; and read each other's magazines, where articles on techniques and theory were to be found.[11] Today, recent scholarship on the use of photography by Impressionist and Post-Impressionist painters can elucidate the intricacies of these connections among practitioners of painting and photography, although these will not be pursued here because they pertain for the most part to the extra-Germanic situation. However, in an exceptional article on Impressionist portraits, art historian Linda Nochlin regards the variety of solutions to portraiture found in French painting circa 1875 to be a response to the strictures on pose and position imposed in the photographic medium so as "to reconfigure human identity by means of representational innovation."[12] In this chapter, in a similar manner, I will explore the photographic portrait in Vienna at the turn of the century in order to understand the representational innovations in the marriage of art and photography. How did portrait photography by the pictorialists help to bring about the visualization of a new, modern subjectivity, such as we saw in contemporary paintings by Kokoschka? The exhibitions of European art

photography in which the Austrian artists figured prominently give a sense of the stakes involved in the depiction of the subject in fin de siècle Vienna.

Exhibition History

The exhibition history of art photography is available through illustrated catalogues published at the time (see figure 27). For example, the Paris Photo Club's *Première Exposition d'Art Photographique* was published in 1894 in a sumptuous edition of 500 copies intended for amateurs and connoisseurs of portraits, landscape, and *scènes de genre* photography, the last of which comprised a very small number of the offerings. The significance of portraiture, and its association with a tradition of representation based on the gaze at the face in the mirror, the same one we noted in Lacan's important essay on the mirror stage, can be seen immediately in the colored lithograph originally used as a frontispiece for the exhibition catalogue and presented in the volume as plate 1. The allegorical female figure rendered in the linear and elegant art nouveau style gazes at herself in a hand mirror. The figure that gazes at his own reflection, a Narcissus, had been used as a symbol of the origin of painting since the time of the famous treatise *On Painting* (1435) by Leon Battista Alberti.[13] The allusion to painting occurs in this representation in the small motif at the right side of the page. This book celebrated the Paris Photo Club exhibition held in January 1894: photographs by 113 photographers from all over Europe, of whom 17 were Austrian, and only one was German. The participants are listed ceremoniously in alphabetical order: the Austrians named included titled amateurs, such as Barons Albert and Nathaniel de Rothschild, and amateur artist-photographers, such as J. S. Bergheim and Hugo Henneberg. The rules for entry into the exhibit are listed prominently on one of the first pages of the volume, opposite the list of jurors. The rules state that the purpose of photographs submitted must be artistic. Original prints by all of the exhibitors are hand-tipped into the volume. The editor and one of the judges of the competition, Armont Dayox, writes in the preface that the purpose

27 Guillaume Dubufe, *Aquarelle*, 1894.

of the exhibition, one which it in fact shared with the many photo clubs represented in the exhibition, was to wrest photography from the hands of "professionals" where it had become semiautomatic, and return it to the labile amateurs in whose souls breathed the artist so that they "could translate with real emotion the diverse and fugitive aspects of nature—from the agitation of the heavens and the calm, limpidity of waters, to the charms of a woman and the smile of a babe."[14] Dayox's ponderous prose raises the amateur photographer to a new level, after a period in which the commercial photographer, that is, the photographer "in trade," had dominated.

It should be remembered that these professional photographers had made their living in two ways: 1) through the production of portraits, mainly in the form of *cartes de visite*; and 2) through the production of picture postcards of the major monuments of the European and Middle Eastern cities, designed as mementos of travel. Up until

the last decade of the nineteenth century, in Germany and Austria the norm in photography had been the professional portrait studio, a purely commercial establishment that could be found in every major American and European city. These studios were arranged in order to achieve formally posed, full-length portraits in which the elaborately dressed subject had to stand or sit for a long time. These photographs were used in the main on *cartes de visite*, but they also could be displayed in albums or perhaps on tables.[15] The work of the commercial portrait photographer most obviously promoted and constructed the interests and "look" of a newly enfranchised middle and upper middle class who flocked to the portrait studios for betrothal, wedding, and family portraits (see figure 28). In this portraiture appearances strictly conformed to current formal fashions and poses were rigidly conventionalized in order to display wealth and position. In the unpublished photographic stock albums of the Heinrich Graf firm of Berlin (circa 1861–90), a page from the 1860s illustrates this portrait type,

so prevalent in commercial portrait photography. Judging by their names, people from virtually every European country were photographed by the Graf firm, with no indication of a "national style" or aesthetic given to the representation. Careful notations are made in the album regarding the full names, and in the case of women, of their birth names. This documentation of family names emphasizes the individual genealogy of the portrayed, an important aspect of portraiture, as already noted. One can imagine that the Graf studio was not an uncommon stop on the tour of the city of Berlin by well-to-do visitors. When viewed as a group the portraits from the Graf firm convey a formulaic tone, predominantly full-length poses, and a crispness of detail in clothing, hair, and props.

In comparison, the portraits from the 1894 Paris exhibit adhere to a painterly aesthetic in pose, execution, and composition. Interestingly, the latest photographs from the Graf firm, those dated circa 1890, come closer to the artistic aesthetic promoted by the art photography camera clubs and photographic societies (see figure 29). While the poses and props remain the same, the background details are lost. Instead, the figures are set against a white backdrop, which has a fuzzier look, closer to a looser, more painterly quality. As a result the form

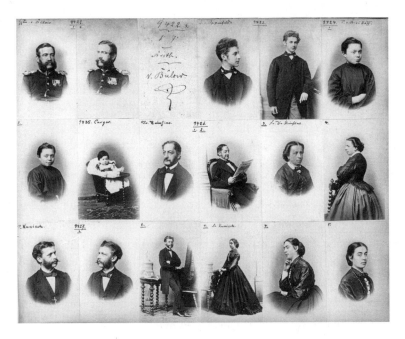

28 Heinrich Graf, photographic proofs, volume 1.

29 Heinrich Graf, photographic proofs, volume 4.

of the figure and the expression of the subject claim more attention from the viewer than was the case in the earlier *cartes de visites*. It can only be surmised that this change in taste in commercial photography from the 1860s to the 1890s reflects the influence of art photography on the genre of portraiture. Beginning around 1890 and lasting until World War I this newer style of photographic portraiture predominates among the same classes who had previously desired the typicality and formalism of commercial portraiture. The commercial photographers had used and reused props on which the figure could lean or sit, and against which the figure would be composed. So prevalent are these that a good way to identify the provenance of professional studio portraits from the period of 1860 to 1900 would be through the identification of the persistent items of furniture and props in the portraits. These items of furniture, ornamental urns, and backdrops were consistently present in the photographs, and their presence emphasizes technical requirements of photographing the figure at this

time. These requirements can be visualized well by contrasting the studio of the portrait photographer with that of the art photographer.

In his book on photographic practice of 1897, the famous Dr. H. W. Vogel, director of the Technischen Hochschule of Berlin, illustrates the required elements of the traditional, commercial photographer's atelier (see figure 30).[16] The entire studio is configured to obtain an ideal view of the human figure for the purpose of portrait photography. In the illustration, the marble portrait bust substitutes for the missing live figure. The concept of portraiture here depends on statuesque immobility and placement. The lighting of the studio, seen in the elaborate and changeable window treatments, which are depicted in the illustration, enhances the control that the photographer can exercise on the effects obtained in the final photograph. This is the staging of the portrait that depends on managing technical details prior to the click of the shutter or the printing of the image. In contrast, art photography often manipulated the image after it was developed, or used processes, such as the platinum print, in which the final effects were obtained after the photograph was taken. The studio of the amateur art photographer resembled that of a painter, as the photographs of the pictorialist Heinrich Kühn illustrate.

Fig. 2.

Das ältere Atelier der Kgl. Techn. Hochschule, Klosterstr. (jetzt Bakteriologisches Institut, Prof. Koch)
Gardinen nach Loescher u. Petsch.

Fig. 3.

Das neue Atelier der Kgl. Techn. Hochschule zu Charlottenburg. Gardinen nach Herrn Norden.

30 Illustration 5. H. W. Vogel, *Handbuch der Photographie: Die Photographische Praxis*, 1897.

Turning again to the discussion of art photography found in the Parisian exhibition catalogue, it should be noted that interpretations regarding the photographs rely first on distinctions according to national style and the subject. From the earliest moment art photography was tied to an idea of a national consciousness. Dayox argues that the true distinctions, which the exhibition brought out, were not between photography and painting, but between "the spirit of the subject and the national aesthetic of which the subject is a manifestation."[17] For Dayox, the subject of the portrait or the genre photograph manifests a national style. It is here that individual subjectivity and a typology of identity merge. Dayox regards both the subject and the artist in these typological terms. In this way both are tied to a national tradition and style of painting: "The Austrian exhibition also had its particular character, and those original proofs which I noticed at first made me think of the reproductions after the paintings [*tableaux*] of Rottenhammer, Kaulbach, and Hans Makart."[18] The photographs exhibited often support this nationalistic view of identity. For example, the photograph exhibited by Watzek, *A Tyrolean*, makes clear the national spirit of the subject in regard to dress and locale. But the pictorial effects of much of the portrait photography also depend on earlier precedents taken from the history of European painting, as some of the titles make clear. For example, the photograph by Baron Albert de Rothschild, *A Portrait Study in the Italian Style of the Seventeenth Century*, is clearly a quotation from earlier painting (see figure 31). Heinrich Kühn's later photographs of still lifes "in the style of" Dutch seventeenth-century painting refer to a tradition in Northern European art often allied by German and Austrian art historians to their artistic patrimony, as it was in Riegl's study of the Dutch group portrait (see color plate 11). Here, in the photograph the still life is tied to the Dutch grand manner. In this catalogue, as elsewhere, identity may also be noted in other, more complex ways by the artist-photographer, for example, the contribution by the Viennese J. S. Bergheim, *Portrait of a "Gazaleh,"* is obviously a picture of a European dressed to look like a native of Palestine (see figure 32). Here the orientalist impulse, and possibly a Zionist one, are conflated with the Austrian style.

With the example of this exhibit before us, the subject of portrai-

31 Baron Albert de Rothschild,
*Tête d'étude: Dans le style italien
du XVIe Siècle*, 1894.

32 J. S. Bergheim, *Portrait of a
"Gazaleh,"* 1894.

ture emerges as someone who can be identified with aspects absent in the earlier commercial photographs, where class and family, rather than national, ethnic, and subjective characteristics of the sitters were stressed. According to Dayox, the photographers themselves do not harbor the venal interests of the commercial photographer; rather their country of origin identifies them. Their calling is a higher one than money: aesthetics and national pride. Yet, and at the same time, the topic of the legitimacy of photography as an art form served as a way for the pictorialist photographers of the period to bridge national differences in style and tradition and unite under the umbrella of art. The sympathetic dialogue between the artist and the subject represented by the discourse on art photography rejects any commercial relationship and relies instead on the personality and qualities of the artist. Thus, Loescher writes: "Oh! What strength, what love one must have in order to dwell on that soul, for the power to reveal to he who searches and calls for it."[19]

The acts of identification that were assumed to have taken place between artist and subject inform much of the historical criticism on art photography. In some cases identification can even serve as the justification for the elevation of photographic portraiture above painting. For example, the English photographer Alvin Langdon Coburn wrote:

A photographic portrait needs more collaboration between sitter and artist than a painted portrait. A painter can get acquainted with his subject in the course of several sittings, but usually the photographer does not have this advantage. You can get to know an artist or an author to a certain extent from his pictures or books before meeting him in the flesh, and I always tried to acquire as much of this previous information as possible before venturing in quest of great men, in order to gain an ideal of the mind and character of the person I was to portray . . . To take satisfactory photographs of people it is necessary for me to like them, to admire them, or at least to be interested in them. It is rather curious and difficult to explain exactly, but if I take a dislike to my sitter it is sure to show in the resulting portrait. The camera naturally records the slightest change of expression and mood, and the impression that I make on my sitter is as important as the effect he has on me.[20]

These identificatory elements are visible in the photographs themselves, particularly in the proportionately large number of portraits of the artists' family and friends, people with whom we might expect any artist to have a vested sympathy.

International Art Photography

Alfred Lichtwark, art historian and director of the Hamburg Kunsthalle, did more than any other historian to promote art photography as an art form with social and aesthetic significance.[21] Lichtwark argued in a number of his writings that photography deserved to be included in the history of art—indeed that it was essential to an understanding of painting. In 1930 the German biographer of David Octavius Hill, the British "father" of art photography, wrote that "today Lichtwark's prophetic words are being fulfilled: 'When a future history which knows the facts shall deal with the painting of the nineteenth century, it will have to devote to photography a special detailed chapter embracing the period from 1840 to the end of the century.'"[22] Lichtwark had been responsible for establishing an important collection of David Octavius Hill's work in Hamburg. Under Lichtwark's influence, Hill's artistic portraits in the medium of the calotype were later promoted by a group of Austrian photographers who saw Hill's work as the precedent for their own.

As Richard Stettiner wrote in 1899, Lichtwark's view of photography's importance in the history of art rested on the genre of portraiture, transformed by art photography: "For Lichtwark Art Photography was a class in a great system . . . a life-making art, a rising above pure dilettantism."[23] Lichtwark expressed his views on artistic portrait photography a number of times between 1900 and 1907.[24] His examples of contemporary photographic portraiture were drawn in the main from the Austrian context, as he indicates in his introduction to an important book, *Kunstlerische Photographie* (Artistic Photography), published in 1907 by the major promoter of the Viennese school of art photography on the international scene, Fritz Matthies-Masuren.

In 1902 Matthies-Masuren had published in a sumptuous folio vol-

ume, *Gummidrucke von Hugo Henneberg, Wien, Heinrich Kühn, Innsbruck, und Hans Watzek, Wien,* the pictorial work of the three Austrian photographers known as "the trefoil" (*Die Kleeblatt*). In the introduction he promotes art photography and relates the power of its effects to technological advances in the medium, particularly the bichromate color process known as *Gummidrucke* in German, which, he says, can be manipulated to subjective effects by artistically inclined photographers, such as the three Austrians whom he discusses. Matthies-Masuren included forty-five black-and-white photographs of their work, which were pasted into the volume. These photographs are divided between landscapes, portraits, and still lifes. Just at the turn of the century Heinrich Kühn and the other Austrian pictorialists began using the complicated and innovative techniques in the manipulation of the photographic print to achieve color, so as to emulate contemporary painting. Kühn's large output of color slides, or diapositives, of this time has not been exhibited, but the collection of them in Vienna is testament to his commitment to color and pictorialist effects. Kühn's portrait of two of his children is a good example of the bichromate process, which had been perfected by amateur photographers in Vienna (see color plate 12). But even before gum bichromate these photographers had sought coloristic— specifically chiaroscuro—effects through the use of platinum prints. Kühn's photographic portrait made in 1907 of Eduard Steichen, one of America's best-known photographers and a leading proponent of art photography, deserves close consideration in this regard (see figure 33). In addition, like all of Kühn's portraits, this one illustrates the proximity of the practice of art photography to the theories of the modern subject that I am examining here.

The young Steichen, who is pictured at the age of twenty-eight, had exhibited with Kühn and visited Vienna, although at the time of the photograph he lived in Paris.[25] His dark-suited figure emerges from the deep shadow of the platinum print. Although Steichen, like Kühn, had been using the coloristic medium of the gum bichromate process to great effect by this time, he was still best known for his platinum prints. In this sense we can say that Kühn uses the medium distinctive to Steichen as a form of artistic identification in the por-

33 Heinrich Kühn, *Portrait of Eduard Steichen.*

trait photograph. Prints on platinum papers result in a painterly effect because the platinum print has a broad scale of gray tonalities without the contrast of other black-and-white processes, such as silver prints. Because there appears in the platinum print "to be a less mechanical, more organic, union of image and paper" Kühn's use of the medium relays a message about the image of the photographer produced in that medium. The portrait's technique reveals something of the subject.[26] Additionally, platinum prints allowed for multiple reproductions from the same negative, an important factor in a culture of the international exchange and exhibition of photographs.

The very thought that photography or a photographer could distinguish among media and medium techniques for expressive reasons emerged at this time as a result of the practices of the art photographers. Indeed, Steichen came to be best known for the experimental use he made of a wide variety of media and reproductive techniques.[27] Kühn uses the process of the platinum print—known for the softening of details and textures through its black, white, and gray

tonalities—to work up from the darkest area, which is the center of Steichen's body, to the lightest areas, the expressive features of the face and hands. Our information about the subject is gained by the separation of light from dark in the composition. White cuffs and collar emerge from the dark suit to frame the hands and face, much as they do in a Rembrandt portrait. Dressed like a gentleman, Steichen could be imagined seated in a gentleman's club, or an amateur camera club. He grasps the cigar in a clenched fist and his other hand flexes on the arm of the chair. These hand gestures, the locks of hair draped across the high brow, the diagonal of light across areas of flesh and fabric produce an overall haziness and a refusal of clarity in the photographic exposure. Yet, the figure possesses a presence that belies the surrounding obscuration. The formal aspects of the coloration and the composition insist on introspection and intensity. These traits are revealed by the hands and face as much as they must be but no more than that. The usual markers of resemblance are purposefully suppressed, for example, we do not "know" Steichen by his eyes or his mouth, both of which remain for the most part concealed. Rather, we know him by the somberness and severity of his dress, the strength of the hold that he has on his cigar, the thrust of his hand on the chair. Momentarily captured by light, like the burning tip of the cigar, Kühn's portrait obliterates the clarity of surface details so common in commercial photography that would have distracted from the subjectivity of this portrayal. Nonetheless, this photograph remains identifiable as a portrait of Steichen. Kühn gives us a portrait of a fellow photographer in total sympathy with his own artistic credo: a man most emphatically of his time, but also a man with a history in art. Like Kühn, Steichen is a gentleman artist, in the tradition of the old masters of similar reputation, such as Rembrandt.

Kühn, Steichen, and the other art photographers relied on the precedent of painting, but in Austria at this time we can also say that painting learned much from photography. The early portraits by Kokoschka that we have examined owe much to both earlier and contemporaneous photographs. As I noted in chapter 3, these portraits exhibit a striking absence of naturalistic background elements and of attention to surface details such as the texture of fabric and

clothing. The hand of the artist is emphasized in the gestural application of paint, with its alternating thin layers of color worked over the entire canvas without regard to whether the passage represents figure or background. Painterliness predominates, keeping portraiture in painting close to the aims of the photographers of the time, such as the *Portrait of Steichen*, with its coloristic effects. The format of the photograph, too, indicates the affinity between photography and easel painting at this time. Kühn uses the horizontal rectangle of an easel painting, a tableau, rather than the vertical format far more common for portraits. Notably, several of Kokoschka's portraits of this period are also horizontal.

My point is not that photography copies a particular painting or school of painting, or that Kokoschka copied one or another photograph, but rather that art photography and Kokoschka's portraits share perceived empathies between the artist or photographer and his subjects. Like all pictorialist portraits from this period, Kühn's *Portrait of the Artist's Children* and *Portrait of Steichen* exhibit something I have already called intersubjectivity. In pictorialist portrait photography, this may be characterized in the following ways: 1) the faces of the figures are obscured, lost in shadow, with lowered gazes; 2) the outlines of the figures merge with the background or into the other figures; 3) the delineation of superficial effects of skin and features remain subsidiary to the overall effect of luminosity, reflections off the hair of the figures, and softness of flesh; 4) the figures are enclosed by light and color in a shared space or world; 5) the scale of the print is large, and often, the format is tableau. These effects define a subjectivity that depends on the whole composition for articulation.

The kind of subjectivity found in the art photographers' portraiture must be considered new to photography. In the Paris Photo Club's journal of 1904, the German Loescher describes the pains to which the professional Hamburgian photographer Rudolf Dührkoop went in 1899 in order to change his studio over from a professional photographer's studio to a more "personal" one in keeping with the aesthetic of art photography. According to Loescher, a desire for a better "knowledge of the subject" drove the conversion to an art photography studio.[28] This method, which involved a "simplification of the

means," and "the absence of artifice in execution" allowed for a new kind of portraiture.[29] Loescher describes the difference in the following way: "The old atelier, bound to accessories, achieved the continual reproduction of a mass of uniform images more than the making of personal works. It is there that one finds that division of work, which, in our times, kills genius and makes of man a machine . . . The portraits made in these conditions may well be identifiable and correct, but they are not personal works of art."[30] Loescher also says the new portraiture results in nothing but "the natural essence of man, whether bad or good."[31]

In his later book *Photographic Portraiture*, Loescher develops his views on art photography and contrasts it with "conventional" or commercial portraiture.[32] He does not consider technology to be the basis of the differences between the older and newer photography, although he spends much time on practical aspects of photography, such as coloristic techniques and innovations in photographic apparatus and lighting. As far as he is concerned, however, "the tools are basically the same; on the one hand they are used to produce a boring and superficial copy of a momentary natural phenomenon—on the other, to create an inspired picture, pulsing with life."[33] As it was for Lichtwark, the differences that Loescher sees in art photography reside in subjectivities: the photographer's view of himself as an artist; the viewer's sense that a picture of a person now "pulses with life," whereas the older portraiture presented a formal and lifeless representation of the exterior of being.

This kind of photographic criticism separates art photography from earlier commercial photography and scientific views. Loescher rejects the idea, still prevalent today, that all photographs are "mechanically produced, without human intervention and interpretation, and thus objective."[34] The earlier noncomparative discourse, dependent, in part, on photography's technological base and scientific uses, did not regard photography as art. Instead it stressed its objective potential and therefore its remove from the affective areas of human making considered by aesthetics. In the art photograph both the pose and placement of the figure emphasize the possibility of movement and the interaction between figures, as Kühn's portraits demonstrate.[35] In *Portrait of the Artist's Children*, a platinum print of 1912, the pho-

tographer has positioned his two children in the artist's atelier (see color plate 13). As in a painted portrait, they are seated so that they are viewed in a slightly foreshortened way as half-length figures. This foreshortening gives a plasticity and movement to the figures. The direct comparison to painting is further emphasized by having the boy in the foreground gaze at a half-length painted portrait displayed on an easel. The figures are facing each other and may have looked away from each other only momentarily, or their "gazing" may imply the internal reveries of each child. Here, subjectivity, interiority, and the artistic context of the figures portrayed give a new kind of approach to the depiction of the individual. The lighting in the photograph indicates a reversal from the commercial photographs of the previous century: the background wall is lit while the foreground remains in shadow. The features of the boy's face in the front of the picture are in shadow while the girl's profile receives the greater light. Kühn's work displays many examples of sympathetic treatments of children, most of them his own. For example, the double portrait misleadingly titled *Portrait of a Man Seated Beside a Supine Child* displays the engagement between the two figures in terms of the interchange of gaze and expression (see color plate 14). The child's skin is softly modeled by the light in contrast to the starker white of the sheet which lies against it and the white starched cuffs and collar of his companion, imparting to the flesh a softness not found in the more crisply rendered details of clothing and cloth. In contrast to this treatment of the child's skin the man's hands and face are more mottled and the features of knuckles and nails are delineated more clearly than the child's individual characteristics. Such distinctions between youth and age, or between sickness and health, reveal a photographer and a photography with sensibilities that push portraiture far outside the commercial studio.

Walter Benjamin's Revision of the History of Germanic Photography

Attitudes toward art photography changed significantly in the literature on photography after World War I. Even Steichen, formerly a proponent of subjectivity in photographic portraits, wrote in 1923:

"No progress has been made in photography since the daguerreo-type . . . A photographer is supposed to take things as they are, without injecting his personality into the picture."[36] The new aesthetic sought a photography that would uphold "realistic" or "social" values. In America, Stieglitz no longer championed art photography, saying he desired a photography of reality and simplicity. In this view photography no longer aspired to create the effects of painting; it had surpassed the medium of painting. Later, just after World War II, André Bazin, basing his views on the critics of the 1920s and 1930s, equated the medium with a social practice and explicitly opposed it to an aesthetic one. In what would become the first chapter of his book *What Is Cinema?* Bazin wrote: "In achieving the aims of baroque art, photography has freed the plastic arts from their obsession with likeness. Painting was forced, as it turned out, to offer us illusion and this illusion was reckoned sufficient unto art. Photography and the cinema on the other hand are discoveries that satisfy, once and for all and in its very essence, our obsession with realism."[37]

Walter Benjamin's 1931 essay, "A Small History of Photography," has been particularly influential in regard to a view that a social portraiture is supported by a preference for the "objective" or for a realist aesthetic. Well before Benjamin, the term *objective* appears in the German-speaking context of photographic history, particularly in regard to art photography and theory.[38] There, it is opposed to *subjective*. Benjamin's essay explicitly concerns itself with the history of photographic portraiture, but ignores the historical and theoretical precedents for the sake of his own argument regarding the radical social and political potential of photography of his own time.

Benjamin writes of "the unresolved tension" between art and photography, using portraiture as one of his major topics of consideration and the source of many of his examples.[39] Benjamin understands the extreme fidelity to appearance found in mid-nineteenth-century photographs to be an exact congruence between the mimetic capabilities of the technology and the taste of the clientele for this genre, "whereas the photographer was confronted, in every client, with a member of a rising class equipped with an aura that had seeped into the very folds of the man's frock coat or floppy cravat."[40] Benjamin

regards the technological potential of the medium as supporting his taste for early- and mid-nineteenth-century commercial photographic portraiture where, according to him, the bourgeois subject was portrayed for the first time in complete detail. Benjamin sees in these portraits the subject of capitalism exposed.

Benjamin was not alone in extolling this view of the history of photography based on the depiction of the bourgeois subject. The relation of this essay to Siegfried Kracauer's essay of 1927 has often been noted.[41] Other German writing of this period on photography also understood the interconnections between technology, genre, and class in early commercial photographs in the same way: "The burgher's picture of the world had been small and narrow. Now at once he expanded it on every plane of his middle-class existence, in a great, wide circle that spread from his spiritual focus and mental attitude. And with this expansion the need of pictorial witness to his newly awakened sense of life began to grow prodigiously. He felt a pressing desire to have the novel aspects of the new life expressed plastically in some new, unique, and especially appropriate medium. For, when the wide front of middle-class society took over the privileges and ambitions of the old dominant class, even the old ways of expression no longer sufficed for the new cultural and economic demands."[42]

Benjamin and others of his generation had turned to Lichtwark's writing in order to support their idea of the importance of photography as a social indicator. In "A Small History of Photography," Benjamin writes: " 'In our age there is no work of art that is looked at so closely as a photograph of oneself, one's closest relatives and friends, one's sweetheart,' wrote Lichtwark back in 1907, thereby moving the inquiry out of the realm of aesthetic distinctions into that of social functions."[43] As we have seen here, Lichtwark had argued in a number of his writings that photography deserved to be included in the history of art—indeed that it was essential to an understanding of painting.[44] In addition, Lichtwark's view of photography's importance in the history of art rested on the genre of portraiture, although Benjamin does not note that Lichtwark's sense of the importance of portraiture is motivated by a clear preference for art photography, nor is there any evidence of the latter's preference for the Austrian photog-

raphers. By the end of the nineteenth century, according to Benjamin, photographers, particularly portrait photographers, had attempted in their techniques and styles to reproduce the aura which painting had lost due to the ascendancy of the new technologies of reproduction. For Benjamin, painterliness found its way into photographic portraiture to the detriment of both photography and the portrait. This position directly contradicts Lichtwark's appreciation of the possibilities of a painterly photography, while at the same time agreeing with his historicization of it: as we have seen, at the end of the nineteenth century Kühn and the other Austrian photographers began using the complicated and innovative techniques to achieve color which emulated contemporary painting.

Opposed to such ostentatious examples of color in art photography and to the silver nitrate portraiture by Dührkoop and other Germans, such as Nicola Persheid and Theodor Hilsdorf, Benjamin preferred an antecedent moment in the history of portrait photography, one exemplified by the format of the *cartes de visite* or the portraits of the mid–nineteenth century by Nadar. The French examples should not surprise us. By the time he wrote his essay on photography, Benjamin had been researching and writing about the Paris of Charles Baudelaire since the late 1920s. However, somewhat perversely, Benjamin chose exactly the sort of photography that Baudelaire despised, for example, the photography of his time, circa 1860, to promote. Baudelaire had protested against photographic portraiture in favor of the painting of modern life, such as that offered by Edouard Manet. This artist's 1863 portrait of his parents offers a prime example of painting's ability to supersede the photography of the day in terms of the visual complexity of the portrayal of the individual (see color plate 15). Manet used the rather unusual format of the double portrait to portray his parents, just as Kokoschka later used the same compositional type in his portrayal of the Tietzes. Manet's mother and father are placed at a table so that their bodies are foreshortened, in order to display the possibilities of a spatial presence, which would have been impossible in photography of the time. The still-life elements enhance the coloristic possibilities so dear to the proto-Impressionist Manet. The setting further suggests a domesticity not found in contempo-

rary photographic portraiture, dependent as it was on the commercial situation. The interrelationship of the figures can be suggested by gesture and their averted gazes, without a sense that one so often finds in contemporary photographic portraiture of the figure's gaze being frozen by the camera's eye.

In his writing on the poet that postdates "A Short History of Photography," Benjamin gave his views of the history of painting during Baudelaire's era: "The world exhibition of 1855 offers for the first time a special display called 'Photography.' In the same year, Wiertz publishes his great article on photography, in which he defines its task as the philosophical enlightenment of painting. This 'enlightenment' is understood, as his own paintings show, in a political sense. Wiertz can be characterized as the first to demand, if not actually foresee, the use of photographic montage for political agitation."[45] This account of the impact of photography on painting goes against an elevation of Baudelaire and of Manet's art and the Impressionists because it argues that they were motivated by the pressures of photography, the more "agitational" of the two media.

Contra Benjamin, however, by the end of the century and in an international context, photography was being praised for exactly what painting had been able to do in portraiture. Benjamin was aware of this turn, and he resisted it, wanting photography to remain true to its "social" origins and rejecting it on the grounds that it had become "aesthetic." As we have seen, early-twentieth-century photographic theory used the term *aesthetic* to characterize the aims of art photography.[46] Now the term was used against those very aims in photography. According to Benjamin, the European portrait photograph of circa 1900 fulfilled the function of painted portraiture in the "murkiness" of its style and surpassed it in popularity. This style was thought to be antithetical to the ontology of a medium considered avant-garde by the time Benjamin wrote. For example, in 1928 the Russian Alexsandr Rodchenko, who had recently exhibited his photographs in Germany, had written: "It is essential to clarify the question of the synthetic portrait, otherwise the present confusion will continue. Some say that a portrait should only be painted; others, in searching for the possibility of rendering this synthesis by photography, follow a very false path:

they imitate painting and make hazy by generalizing and slurring over details, which results in a portrait having no outward resemblance to any particular person—as in pictures of Rembrandt and Carrière."[47]

To denigrate the contributions made by Rembrandt and Carrière to the history of portraiture was to denigrate the respective national traditions on which German and French art were based. This was a radical and revisionist view to be sure, but not one that recognized the revisions to portraiture in terms of it subjective potential, which had been accomplished by art photographers in the early twentieth century. The sort of work done by Kühn in Austria or Steichen in Paris was superseded in the post–World War I period by a very different approach in painting and photography, known as *Neue Sachlichkeit* or "new objectivity."

Unlike the earlier Viennese modernist movement, which had embraced a photographic pictorialism, this postwar style in painting and photography flourished particularly in Berlin, the new art capital of Germany.[48] Represented by the works of Otto Dix, George Grosz, Christian Schad, Rudolf Schlichter, Georg Schrimpf, Georg Scholz, Anton Räderscheidt, and others, *Neue Sachlichkeit's* "objective" or "realistic" style has been identified with the political and social upheavals of the Weimar Republic. According to art historian Wieland Schmied, these artists "bore witness to their age either by indicting it or by seeking to hold up a pure and undefiled image in contrast to it."[49] The interpretative writing about *Neue Sachlichkeit* painting commonly ascribes to its artists a heightened political awareness and to its art a transparency to ideology. To strengthen such an interpretation, *Neue Sachlichkeit* is seen in favorable contrast both to the preceding Expressionism and to the art of the period of National Socialism that followed it. In post–World War II art criticism the desire to find a recuperative moment in visual culture before the Nazi regime appears justifiable, if not completely historical, and explains the emphasis even today on the period before the rise of Hitler and Nazism. But what of the period before World War I when Europe was still configured according to the political realities of the late nineteenth century? The political and "objective" painting of *Neue Sachlichkeit* has been seen as opposed to the Expressionism of the Austrian art-

ists Kokoschka, Oppenheim, and Egon Schiele in the first decades of the century. In criticism prejudiced toward a later "objectivity," such as that found in *Neue Sachlichkeit*, Expressionism and expressionistic styles were forced into a hermeneutic that criticized it as unrealistic and apolitical. The question of whether Kokoschka and others actually understood their work to be part of a radical political project, as I have argued they did, is usually ignored. When in rare moments they are understood as radical in the later literature, the character and personal style of Kokoschka or Schiele will be invoked, but the work will be understood as apolitical or interested in expression for expression's sake.[50] The result of the pressure of the interpretation of the later avant-garde photography and art has been that the social aspects of the art of the early twentieth century have gone unremarked or unrecognized.

This historiography has been most problematic in regard to the interpretation of early-twentieth-century photography. There is no reason that a pictorialist photography, any more than a painterly technique, should necessarily be thought of as unsocial or apolitical. Yet, later critics and photographers, who actively promoted "realism" and social photography, could only consider as unrealistic the subjective practices and effects acknowledged by art photography itself. For example, the photographer Albert Renger Patzsch wrote: "The secret of a good photograph—which, like a work of art, can have aesthetic qualities—is its realism . . . Let us therefore leave art to artists and endeavour to create, with the means peculiar to photography and without borrowing from art, photographs which will last because of their photographic qualities."[51] In this critical milieu, the medium of photography is opposed to the concept of art. With this prejudice subjectivity was swept under the rug by interpreters and practitioners alike.

From the evidence presented here, it obviously was important in the postwar avant-garde discourse to keep separate the two media of painting and photography. The attribution of distinct properties to each depended on distinctions between art and technology, and elided generic classifications that could transgress media boundaries.[52] Walter Benjamin best encapsulated these German avant-garde media distinctions when he wrote: "As the technique of communi-

cations increased, the informational importance of painting diminished. The latter began, in reaction to photography, first to emphasize the coloured elements of the image. As Impressionism gave way to Cubism, painting created for itself a broader domain, into which for the time being photography could not follow it. Photography in its turn, from the middle of the [nineteenth] century onwards, extended enormously the sphere of the market-society; for it offered on the market, in limitless quantities, figures, landscapes, events that had previously been utilizable either not at all, or only as pictures for one customer. And in order to increase sales, it renewed its objects by means of modish variations on camera-technique, which determined the subsequent history of photography."[53]

The tension between the presumed faithfulness to the appearance of things in the photograph and "the medium's capacity to express something beyond the surface appearance of things" can be found throughout photography's history.[54] However, the discourse on photography in the late nineteenth century and the early twentieth does not presume that realism prevails over other elements, such as expression or subjectivity. Nor does that criticism infer that that expressivity is less social than realism. These are the criteria of a later time which have prevailed along with their corollaries: that the technology of photography takes precedence over considerations of genre and that the image should not be manipulated in order to achieve painterly effects. If we today maintain that this style of painting and photography carry a social meaning, we cannot also maintain the silence about it found in Benjamin and the German avant-garde of the 1920s and 1930s. Thus, we could observe in the early twentieth century an art that acknowledged a new portrayal of the subject.

Picasso Responds to Pictorialism

A brief investigation of the response to the challenge of art photography portraiture by an important Spanish artist at the beginning of the twentieth century demonstrates that certain comparative methods may also have been kept out of the history of art of that period.

It is generally accepted that at this time Picasso moved toward the gradual effacement of the represented individual and away from an earlier sympathy with a "classical" portraiture, which had relied both on a mimetic fidelity to the subject and on the tradition of Spanish portraiture as found in Velasquez.[55] Picasso's 1905 *Portrait of Gertrude Stein* was the beginning of a suppression of the absolute, mimetic approach to the portrait while at the same time giving an acute representation of the individual subject in art. The great portraits of 1910— *Portrait of Ambrose Vollard*, *Portrait of Wilhelm Uhde*, and *Portrait of Daniel-Henry Kahnweiler*—may well be interpreted as the result of the pressures exerted by the amateur pictorialists who sought more than simple fidelity to a surface representation in their portraits at this time (see figures 34 and 35 and color plate 16).[56]

In assessing the abstraction of these portraits, William Rubin has argued that: "The high degree of abstraction of hermetic cubism was certainly not propitious in and of itself for the practice of portraiture . . . Picasso possessed completely the talent of a caricaturist which permitted him to isolate and emphasize a whole ensemble of revelatory details capable of remaining readable in the pictorial flow of analytic cubism: the pinched lips of Wilhelm Uhde, the heavy eye-lashes (*les paupières lourdes*) of Vollard and the distinctive traits of Kahnweiler, which the artist himself summarized as 'an undulation of hair, a hint (*un bout*) of an ear, crossed hands.' These notations give to the portraits, despite their very exaggerated abstraction, a suggestive resemblance with their subjects."[57] I have already discussed in chapter 2 the closeness to caricature of a theory of portraiture based on subjectivity, which originated in Vienna after World War I. Picasso's caricaturistic marks, if that is indeed what they are, predate this theorization of caricature that was based on the idea of the genre of portraiture. According to Rubin, these kinds of marks allow us to recognize the faces of Picasso's sitters, despite the abstraction of the figures as a whole. On the other hand, in the particular elements that give adherence to the resemblance to each of the individuals that these portraits represent, there are similarities to the strategies of portrayal that we found in the Viennese portraits of the same time. Picasso's portraits may be no more complete abstractions than are the portraits by Kokoschka

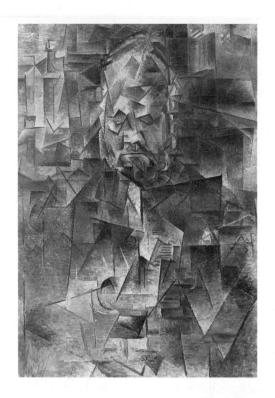

34 Pablo Picasso, *Portrait of Ambrose Vollard*, 1909–10.

35 Pablo Picasso, *Portrait of Daniel-Henry Kahnweiler*, 1910.

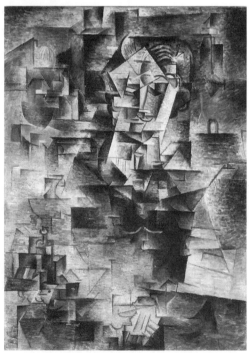

that we have examined. Given the ontology of the genre that I have argued for in this book, could these Picasso paintings indeed *be* portraits if they were abstractions? Given what we have learned of the centrality of recognition in the genre, abstraction itself cancels the activity of recognition. Even in Sartre, who insists that recognition occurs solely within us, for example, within our imaginations and not on the surface of the portrait, abstraction in our minds would not *give* us resemblance to the individuals we recognize as Uhde, Vollard, and Kahnweiler. Thus, while the coloristic qualities that we noted to be so important to Kokoschka's portraits are lacking in the subdued palette of cubism at this moment, we do indeed note in the Picasso portraits a similar gestural quality in the handling of paint. Furthermore, as Rubin noted, the emphasis on the eyes and hands, both in the handling of these areas of the paintings and in the more mimetic qualities of these physical attributes in the overall treatment of the sitter, correspond to similar emphases in the Viennese portraits. As we have seen in the pictorialist photographs of this time, an efface-ment of aspects of the face, and a lack of background detail, does not diminish the resemblance of portraits. Indeed, it is precisely these aspects of the portrait which give the other parts of the face, such as the eyebrows, and of the body, such as the hands, their emphatic subjectivity. In the portraits by Picasso and Kokoschka of the first de-cade of the twentieth century, the "analogical plentitude," as Roland Barthes called it, which had been expected of the genre of portrai-ture since the Renaissance and which invites recognition remains.[58] Our visual knowledge of the subject—that which is given to us by resemblance, even in fragmentary form—interacts with techniques designed to give us more. Even in the case of Picasso's abstraction, these techniques speak loudly of the artist's reactions and expressivity to the social situation of portraiture. They give us alternatives to the "objective" level of identification. They give us the subject in art.

Barthes warned that the photograph's appearance as a "perfect analogon" of reality would prevent interpretation, and, as we have seen in this chapter, in the case of art photography he has proven to be correct. He proposed a "specific method prior to sociological analy-sis" with which to interpret the photograph—mainly the portrait—

so that it could be provided with syntax, understood as a visual language, and given meaning beyond itself. Austrian art photography, painting, and art history aimed in a similar manner to provide those who experience the portrayal of others with meanings beyond the surface appearance of things. The belief that such a place can exist in a visual artifact or experience could be said to be the overriding faith in the human being that produced the historical situation of the subject in art in fin de siècle Vienna.

Chapter Four

5

REGARDING

THE SUBJECT IN ART HISTORY

An Epilogue

> I cannot classify the other, for the other is, precisely, Unique,
> the singular specialty of my desire. The other is the figure of my
> truth, and cannot be imprisoned in any stereotype (which is the
> truth of others).
>
> —ROLAND BARTHES, *A Lover's Discourse* (1978)

My account of the study and practice of portraiture in Vienna at
the beginning of the twentieth century in art history, psychoanaly-
sis, painting, and photography offers a new assessment of the subject
and subjectivity in modernity. An examination of the visually consti-
tuted modern subject, whose presence in painting and photography
arises simultaneously with the construction of a theory of the genre of
portraiture by art history, demonstrates the breadth and complexity
of the interconnections that cultural figuration implies. Over the last

thirty years, Carl Schorske, Marjorie Perloff, Peter Vergo, Kurt Varne-doe, Stefan Jonsson, and others have demonstrated the centrality of the early-twentieth-century context of Vienna and the Austro-Hungarian cosmopolitan culture found there for the construction of an idea of modernity in literature, politics, art, and criticism. My in-vestigation of portraits and portraiture in Vienna transforms this his-tory and transfigures the subject by placing the visualization of the subject, and the related issue of subjectivity, in a particularized his-torical context, and at the very center of the conceptual issues that have concerned both philosophy and psychology in the twentieth century. In the investigation of the visualized, modern subject — the subject in the portrait — in its relations to the world around it, the one from which it also takes its definition, we have found an ethics that depends on recognition, identification, and resemblance. So too, in this visual realm of the modern subject misrecognition, assimilation (or absence of identification), and illegibility create what I have ex-plained as the "functional dialectic" inherent to modern subjectivity and present in depiction.

As I have suggested both here and elsewhere, the later history of Germany and Austria in the twentieth century resulted in the sup-pression for over a generation of these original aims of "the disciplines of art" as they appeared at the beginning of the century in Vienna.[1] While it may be tempting to some to pursue the proleptic argument that would consider this history of the visualized subject as "erased" in order to be reborn again in a later era, it would be inaccurate, if not irresponsible, to do so. While not admitting of erasure, I would allow, as I have argued elsewhere, that a gap can be construed, in part due to the forced emigration of the younger generation of Vien-nese Jewish art historians, such as Kris, Kurz, Gombrich, and of some of their older colleagues, the Tietzes among them.[2] Kokoschka had already left after World War I, and returned, and left again. Other events, including the breakup of the Austro-Hungarian Empire fol-lowing World War I, resulted in a missed opportunity to construct a complete history whose tissue was still in the process of being formed at the outbreak of World War II. Thus, my project here has been one of retrieval, not as in finding that which has been lost, but rather

in constituting that which occurred but which was left unaddressed from the perspective that a history of this period requires. How can one erase that which was never fully seen? This book has been an attempt to see for the first time that which has remained unseen, even though it has been before our eyes.

After World War I, cultural criticism, psychoanalysis, avant-garde painting, art photography, and art history all underwent various forms of what could be called restrictions—some might even say, prohibitions—in theory, which also impacted the epistemological aims of these areas of study, so that it perhaps seemed better under the intellectual and political conditions then present to approach the subject in art differently, a point that Benjamin's view of photography supports most emphatically. Depending on the area of study, these restrictions established definitions and approaches to art based on media distinctions, disciplinary categories, and boundaries in art history according to period and national schools, and, famously, in the case of psychoanalysis, actual "splits" in the definition of the area of knowledge, in its practice, and amongst its practitioners. During this time, as the discipline of art history matured and expanded in the English-speaking universities of Great Britain, the United States, Canada, and Australia, the approaches to visual material that dominated consisted of iconography, connoisseurship, and critical formalism. For the most part, during the course of this maturation of a discipline, the major visual and mainly representational medium of photography would not have been taught in departments of art history. Consequently, when film or cinema studies arose as a separate area of academic study in the 1970s and 80s it first allied with departments of literature, mainly English or French, not art history.[3]

I sketch broadly here the histories of visual disciplines in the university of today in order to indicate the strength that a monodisciplinary approach to the visual arts has had in the modern university, despite the early history of the discipline of art history. Based on the historical research, we could say that this monodisciplinary approach was due in large part to the domination of an idea of art and art history *without the social subject*. By mid-century, the early-twentieth-century history of the construction of the subject in art through the genre of por-

traiture, including its conceptual and theoretical dimensions, which I have given here, came to be forgotten, even as both philosophy and psychoanalysis began to claim the subject, *le sujet,* as their own.

I have argued here that the goals of an interdisciplinary cultural project in regard to the subject in art came forward again in the early 1970s with the project of "the social history of art." This new social history of art did not restrict itself to investigations of subjectivity, or to the visualization of the subject in the portrait, but sought, indeed in a most ambitious and utopian way, to encompass with its methods the entire history of art, including visual interventions in mass media, publicity, and ephemeral material culture. In historiographical terms, this social history approach to the interpretation of art and visual culture—as broadly conceived as it must indeed be in order to be meaningful—represents the present-day inheritance from the Viennese at the beginning of the twentieth century. If we view the post-1968 social history of art as part of this genealogy then its strong impact on the discipline in the 1970s and 1980s can be understood historically and in strictly disciplinary terms. As it has come under attack, however, in more recent years from both conservative and progressive art historians, the continuing fragility of the social history of art and its approaches, among which the new visual culture studies must be included, has also proven evident, particularly in criticisms coming from cultural studies.[4]

Another way of stating the fragility of a social history of art would be to characterize the strengths and to measure the magnitude of the effects of traditional disciplinary methods found, in particular, in the post–World War II Anglo-American art history of the university and the museum, particularly in regard to the topic of portraiture. However, not unlike the Viennese at the beginning of the twentieth century, with their feet planted on a utopian landscape of politically motivated intellectual commitments for art in a social context, I have deliberately refrained from reinscribing this naturalized historiography of the discipline here. I have attempted in so doing to avoid a negative historiography. I am fully aware that approaches to art and to the subject in art that privilege their inevitable relation to the world as "other" put both the interpretation and the interpreter "at risk" in a discipline defined mainly according to other criteria and to an-

other history of the portrait. Thus, arguments for or against interdisciplinary visual studies in the university today continue, as if the history of the modern subject had nothing to do with its visualization in art.[5]

I have argued here that the modern subject, first visualized in Vienna, did not end or "die" with disciplinary changes brought on by the horrors of World War II and the years that preceded it in Europe. Indeed, it has been possible to trace or to "see," the earlier modern subject in art only as a result of its later reemergence in France at mid-century in the fields of philosophy and psychoanalysis. The idea of the subject developed there comes from a context different from the Viennese one. The idea of the subject in France derived from a history that French philosophy lacked, and which could only be found by returning to a Germanic context, leap-frogging, so to speak, the immediately preceding theories of the visualized subject. This philosophical and psychoanalytic theory of the subject has often been said to be synonymous with some aspects of French structuralism and with poststructuralism in its entirety, in particular with the work of Jacques Lacan, Jean-Paul Sartre, Roland Barthes, Michel Foucault, and Emmanuel Levinas.[6]

Significantly for my argument here, all serious historiographical studies of the work of these thinkers understand that the basis of their views of the modern subject lies in German and Austrian philosophy and psychoanalysis, including Hegel (as I outlined in chapter 1), Husserl, Buber, and Freud (whose importance for an idea of the cultural subject I suggested in chapter 2).[7] In the future studies of the historiography of the subject in the twentieth century that will amplify my findings here and which should be anticipated by many, the Viennese art historians, photographers, and painters will need to be reckoned with as preliminary to the later, better known, French philosophers and theorists.

Michel Foucault often used the surrealist paintings by René Magritte in which text and image are combined to illustrate his view of an ironic commentary on the inaccessibility of all images.[8] I have argued here that the theories essential to the knowledge of the discrepancy between the image and the referent existed already in Viennese theories of the subject in the portrait. Magritte's paintings of this type show us explicitly that when words and pictures do not match,

things can still be recognized. So too, as we have seen in portraiture, the recognition of the subject in art depends on *us* putting our *own* subjectivity into a direct and continuing, insofar as these material objects exist in historical time, relationship with the image depicted. This ethics of the modern subject in art cannot be historicized with accuracy, as I have attempted to do here, or understood in its exact theoretical dimensions, the other major goal in this book, without understanding the implications for the larger aesthetic and historical problem of the theory of the image.

Let us not forget that Aristotle understood the human being as a "representational animal" who makes signs, or, those things that "stand in for" or "take the place of" something else. My account of the history of the subject in art gives portraiture an important place in any concept of representation that situates the human being at its center, indicating that the portrait representation retains a particular hold on our visual imagination in the modern period. These paintings and photographs are not only fictions—inasmuch as any work of art is a fiction—nor are they only documents—inasmuch as they have traditionally been understood to give evidence of a particular person's appearance and existence. Portraits also demonstrate an engagement with representation as such at the most acute level of historical significance: the human, or subjective, level. For, portraits in the twentieth century have given us the ways that others have represented themselves to us, just as they show us ourselves in the world created by representations of others. The triangulated engagement with subjectivity—the viewer's, the artist's, the person's in the portrait—reveals a significant aspect of portraiture that puts it at odds with most views of semiotics. My investigation of the subject in art provides the portrait as a key distinguisher for the difference between visual and verbal in European culture since the Renaissance, as the early theorists of the genre often argued, even if at times only implicitly.

While semiotics argues that the visual is a language, the radical perspective of the subject in the portrait that we have found in Vienna argues that this form of visual representation is first a relationship between another and myself, prior to language. The face, the body, the gesture, the use of the paint and the brush, or the way that light diffuses in a photograph—all of these purely visual signs construct

the relationship between the viewer and the subject in art prior to language. In his theory of the image based on photography and his analysis of photographic portraiture, Roland Barthes, as versed as any critic in semiotic theory, created other terms, for example, *punctum* and *studium*, for the visual and psychological effects he perceived.[9] Ultimately, for Barthes, these efforts at understanding the portrait photograph relied on Sartre's philosophy of the imagination and psychoanalysis — on a concept of recognition. The history of modern portraiture itself reveals the significance of distinctions between visuality and language in regard to their knowledge systems. In my discussion of the theory of the subject in the portrait, therefore, I have preferred to use the terms *interiority* and *exteriority* in order to understand subject and subjectivity in art.[10] The power of the portrayal of subjectivities in Dutch group portraits without named individuals, or the controversy generated by displays of Kokoschka's early portraits that lacked labels with names, helps us to understand why the portrait image emerged so strongly and proliferated so widely in Europe beginning in the middle of the fifteenth century. As we have seen, Burckhardt provided an unsatisfactory explanation for this history, one that was disputed almost immediately by the Viennese. He believed that without a prior, or named history, the portrait could be only about itself. In the Viennese context I have found that the foundational concept of the visualized social subject in the portrait prioritizes the genre's theoretical potential in art history, but the topos of interactive sociality itself prefigures later work in other fields, such as psychoanalysis and sociology.[11]

This visual interactivity of the portrait cannot be understood as a narrative or a purely historical event, in ways that other, representational painting and photographs might be. While these implications of the sociality of portraiture may perhaps be disturbing for those who insist on the priority of language in epistemologies of the real, there existed already other genres and methods wherein effects did not rely on either chronologically progressive or narrative systems of representation and explanation. The most obvious among these, and also historically congruent with the period discussed here, may be found in the moving-image medium of film and the early technique of montage. Montage brings together separate shots so that the result is not

in any single shot but engenders a new idea, typically, according to the Soviet model, a heightened political consciousness. The movement in early avant-garde film, the back and forth of shot and countershot, the options available in point of view give us more than simply narrative positions of viewing. They illustrate how visual effects can maintain a transformation of the viewer, not just a fiction on the screen.

Portraits, therefore, may be considered the art form in which the still image most clearly demonstrates this knowledge or action of viewing. The theory of portraiture first put forward by the Viennese artists and historians in the early twentieth century provided then, and continues to provide even now, a way of understanding visual representation as dependent on a multiplicity of points of view, as mutable depending on context, and as contingent depending on viewer. This theory explained how portraits take us away from the passive statement "It is painted" to the complex action of "I see another."

Further, this expanded meaning of the portrait implies that the exchange between audience and the subject in art is ongoing with the history of the image. If there once could have been an originary or primary symbolic meaning of the visual object or form, such as we find posited in cultural anthropology for the ritual object, like a mask, or the ritual performance that the ethnographer tries to get as close as possible to, the portrait in European art gives through its form the visualization of the duration of representation, and thereby of the duration of humanity itself. For all of the reasons given here, portraiture plays an essential part in the epistemology of the visual image, which continues to fascinate us many ways, as it has throughout the history I have investigated.

Finally, but without conclusion, this book offers up a series of questions which follow on the historical argument constructed for the visualized subject in Vienna at the beginning of the twentieth century: on what basis, under whose authority, and with what genealogy does our own, present concept of the subject derive? From these questions, instigated by the subject in art explained here, may answers be given that will determine future actions involving the acknowledgment of the profound and continuing interrelationship of all human subjectivities.

NOTES

Introduction

1. Andreas Beyer's *Portraits: A History*—a recent and excellent survey of the history of the painted portrait—appeared after I had completed the research and much of the writing for my study of portraiture. Despite the book's comprehensiveness in regard to the history of the portrait image from the Renaissance to the present, and a sumptuous presentation in the form of large color reproductions of portrait paintings, Beyer's aims and views differ significantly from mine. As he writes in his introduction: "Art theory has occasionally tried to be more discriminating; nevertheless, it is still striking that there is in fact no real theory of the portrait. Only recently has Édouard Pommier, in a brilliant study of the history of portraiture theory from the Renaissance to the Enlightenment, presented evidence that such a theory can at best be pieced together from widely scattered positions and that even then it remains ephemeral" (15). My study argues that a theory of portraiture in and for art history can be established in Vienna in the first years of the twentieth century, and that its subsequent effects, to a great extent, may be felt more strongly and, indeed, traced, outside of the discipline. Beyer and I agree that a theory of portraiture entails the material objects, portraits themselves. Mention should also be made here of a very interesting little book that appeared just as the present manuscript was going to press: Bernard, *Le Portrait Anthologie.*

1. The conflation of thing and act may be most clearly expressed in the discussion by Brilliant: portraiture "directly reflects the social dimension of human life as a field of actions among persons" (*Portraiture*, 8). Harry Berger Jr.'s recent book on Rembrandt's portraits illustrates the approach to portraiture as action by taking up the performative aspects implied by a genre whose subjects (the sitters) and maker (the artist) acted in a relationship that resulted in artifacts, e.g., portrait paintings by Rembrandt, see Berger, *Fictions of the Pose*. I am grateful to Berger, my colleague, for his work on portraiture, begun long before my interest in Jewish identity led me to the topic. Over the last thirteen years I have listened to his lectures on the topic with interest. While acknowledging my debt to his work here, I recognize that much of my thinking about the historiography of portraiture, particularly its significance for twentieth-century art history and aesthetics, leads to conclusions with which Berger may not always be in agreement.

2. Louis Marin, in *Philippe de Champaigne*, noted two opposite poles in the meaning of portraits related to the Port-Royal school of seventeenth-century France: "Pour Port-Royal, toute représentation du moi, toute portraiturée de soi est en quelque manière prise entre deux pôles extrêmes, celui de la *Vanité* dont le crâne funèbre dans sa puissante frontalité est non seulement le signe d'un *memento mori* adressé à son spectateur, mais son authentique portrait, le portrait véritable de son universelle condition et celui de la *Vera Icona*, de la Véronique, du vrai portrait de l'universel singulier et de la singulière essence d'*imago Dei* de tout un chacun, portrait du Christ de la Passion dans la mesure même où, dans son humanité, il s'est chargé de la passion de vanité et d'amour propre, de la passion du péché de portraiture de tous les hommes" (205–6). [For Port-Royal, all representations of the "me," all portraitures of the self take place in some manner between two extremes: that of the *Vanitas* in which the funereal skull in its powerful frontality is not only a sign of a *memento mori* addressed to its viewer, but also the viewer's own authentic portrait, e.g., the genuine portrait of his universal condition; and that of the *Vera Icona*—of Veronica's veil—of the true portrait of the singular universal and of the singular essence of everyone's *imago Dei*; each and every portrait a portrait of the Christ of the Passion inasmuch as he took on, in his humanity, mankind's passion for vanity and pride, a passion for the sin of portraiture.] Marin's history of the Port-Royal portraits of Philippe de Champaigne reveals the roots of the idea of the portrait as of singular importance for a theory of visual representation in European art. My investigation of the theory of portraiture in this chapter may be traced back to

the Port-Royal views of the significance of the portrait as "sign," although the use of semiotics and its terminologies, such as *indexical* and *iconicity*, in contemporary art-historical theories of the portrait has not provided a satisfactory account of the significance of portraiture in the modern historical imagination because they sidestep important distinctions between the visual and language that were maintained in the modern theories of the genre explored here. See K. Silverman, *Subject of Semiotics*, 14–25, for an explanation that in Peirce's semiotic system the "icon" had within it already the mental image of thing represented or referred to, a point implicitly referred to in Marin's reading of Port-Royal philosophy. Finally, in my use of the terms *exteriority* and *interiority* I am extremely grateful to discussions with Debora Silverman, whose book, *Van Gogh and Gauguin: The Search for Sacred Art*, caused me to reconsider their meanings for the concept of portraiture.

3. In this discussion I will use the words *resemblance* and *likeness* interchangeably, although the term *resemblance* was historically the one used in discussions of portraiture. See Higgs, Killian, and Robbins, *Likeness: Portraits of Artists by Other Artists*.

4. In an argument about depiction, to which this chapter makes certain exceptions, Michael Podro stated recently that recognition "functions in a distinctive way within painting" (*Depiction*, vii).

5. Stein, *Picasso*, 8. There are numerous anecdotes about portraits from the early modern biographies of artists to postmodern criticism that convey the assumptions associated with the distinctiveness of the genre to portray lifelikeness and the uncanny effects that attend the perception of it in the portrayal of a historical individual.

6. Goldstein, "Andy Warhol."

7. See chapter 4 for an examination of the specific, historical role of photography in early-twentieth-century portraiture.

8. Breckenridge, *Likeness*, 14: "The 'true' portrait, therefore, is not only a work of art but a consciously conceived document of society."

9. Anderson, *Roman Portraits in Context*, 68.

10. A good summary of the literature on the meaning of this portrait may be found in Sayre, *Writing About Art*, 12.

11. A useful corrective to this view in the early modern period may be found in Simons, "Portraiture, Portrayal, and Idealization," 266.

12. In Peirce's semiological system the icon is the most elemental kind of sign, one which "represents its object mainly by its similarity to it" (Wollen, *Signs and Meaning in the Cinema*, 122). K. Silverman, *Subject of Semiotics*, 14–25.

13. I am grateful to Robert S. Nelson for his contributions to my think-

ing about icons with his thoughtful discussion and definitions of Byzantine icons.

14. Potts, "Sign," 27. Potts's definition of the modern work of art comes close to that of "icon" given by Charles Sanders Peirce.

15. Soskice, "Sight and Vision in Medieval Christian Thought," 35.

16. Bateson, "A Theory of Play and Fantasy," in *Steps to an Ecology of the Mind*, 183: "Finally, in the dim region where art, magic, and religion meet and overlap, human beings have evolved the 'metaphor that is meant,' the flag which men will die to save, and the sacrament that is felt to be more than 'an outward and visible sign, given unto us.'" This essay was first published in 1955.

17. See Pointon, *Hanging the Head*, 4: "In semiotic terms, portraiture is *langue* and portraits are *parole*. In so far as a linguistic model like this implies ahistoricity then it is unsatisfactory. It is none the less useful for suggesting portraiture not merely as a national language but also as an ideological mechanism."

18. Sartre, *Psychology of Imagination*, 5. Much of the current writing on portraiture, particularly photographic portraiture, appears to rely on Sartre's understanding of the role of imagination or consciousness of the image in the recreation of the image. See McCauley, *Likenesses*, 2: "The portrait's only justification, whether it be in oil or chemically altered silver salts, is that it recreate one human's experience of another, that it constitute a visual simile whose referent is recognizable and somehow present in the man-made recreation."

19. Sartre, *Psychology of Imagination*, 6.

20. Sartre, *Psychology of Imagination*, 6.

21. Sartre, *Psychology of Imagination*, n.p.

22. Sartre, *L'imaginaire*, 15–17.

23. Sartre, *Psychology of Imagination*, 8.

24. Danto, *Jean-Paul Sartre*, 45 and 58.

25. In 1980, Roland Barthes dedicated his book on photography *La Chambre Claire* (called in English *Camera Lucida*) to *L'imaginaire* by Jean-Paul Sartre. Significantly, the focus of this book is portraits of Barthes's relatives, particularly his mother.

26. Adorno, *Aesthetic Theory*, 236.

27. Adorno, *Aesthetic Theory*, 236.

28. Adorno, *Aesthetic Theory*, 243–51.

29. Copjec, "Introduction," xi: "For this reason, the devotion of this first volume to the concept of the subject is significant in that Freud does not himself use the term *subject*; it is under the word *unconscious*—and through

a conceptualization of it—that he will elaborate a theory of what we are calling 'the subject.' To state it somewhat differently: in psychoanalysis the subject is not hypostatized, but hypothesized—that is, it is only ever *supposed*: we never actually encounter it face to face." Some useful definitions from the *Eichborn German Dictionary* (1981) give clarity to this English situation of the subject: subjection=Unterwerfung; subjective=subjektiv; subjective judgment=subjektives Urteil; hysterical subject=hysterische Person; legal subject=Rechtssubjekt. Furthermore, in the *German Wortbuch* we find: subjective as in art=subjektiv, personlich, individuell, subjektiven Auschauungen; subject as in the subject of the painting=Vorwurf, Thema, Sujet (as in French); subject as in medicine or psychology=Versuchsperson.

30. Ricoeur, *Freud and Philosophy*, 419. All of chapter 2, "Reflection: An Archeology of the Subject," bears examination in light of my argument here.

31. Assoun, "The Subject and the Other in Levinas and Lacan," 102: "This very discussion presents the problem of passage from Freud to Lacan. Since, as we know, when it comes to the use of the term *Subjekt*, Freud is quite sparing; when it comes to "the Other," this term would explode within a discourse that makes of science its only semantic legitimacy . . . Lacan says of the "fact" of the psychoanalytic experience: that the subject *bears witness*, in the logic of his desire, to his relations with a certain Other (every clinical experience is aimed at the determination of the nature and function of this relation)."

32. Balibar, "Subjection and Subjectivation," 6–7.

33. I will return to this point in chapter 3 when I explore the issue of identity in the work of Freud's follower, Otto Rank. See also Soussloff, *The Absolute Artist*, 112–35.

34. Lacan, "The Mirror Stage," 2. The first version of this essay was delivered in Marienbad in 1936 (Roudinesco, *Jacques Lacan*, 513). Given the significance of terms here, it will be useful to provide the French version of this citation: "Il y suffit de comprendre le stade du miroir *comme une identification* au sens plein que l'analyse donne a ce quand il assume une image,-dont la prédestination a cet effet de phase est suffisamment indiquée par l'usage dans la théorie, du terme antique d'*imago*" (This, *Freud et Lacan*, 171). For further thinking about the linguistic alliances between Lacan and the Vienna School of Art History, see Soussloff, "Review of *The Vienna School Reader*," 230–32.

35. For the term as it is found in regard to Hegel's master-slave dialectic and the formation of modern consciousness in Continental philosophy, see Kojève, *Introduction to the Reading of Hegel*. For the Lacanian inheritance, see K. Silverman, *Subject of Semiotics*; for Michel Foucault's use of the terms

subject and *subjection*, which changes over time, see Foucault, *Discipline and Punish* and *Power/Knowledge*. For the most recent synthesis of these French traditions, see Butler, *Psychic Life of Power*, especially 1–30.

36. Sartre, *Psychology of Imagination*, n.p.

37. Laplanche and Pontalis, *Language of Psycho-Analysis*, 84.

38. Roudinesco, *Jacques Lacan*, 98.

39. Roudinesco, *Jacques Lacan*, 104–5.

40. Roudinesco, *Jacques Lacan*, 106.

41. Butler, *Subjects of Desire*, 63. I am grateful to Peter Hobbs, graduate student at the University of Rochester whose nuanced reading of the texts by Hegel, Kojève, Lacan, and Butler in my 2002 seminar "Subject, Subjectivity, Depiction" enhanced my understanding of the interconnections among them.

42. Kojève, *Introduction to the Reading of Hegel*, 8.

43. Lacan, "The Mirror Stage," 1.

44. Lacan, "The Mirror Stage," 5.

45. Lacan, "The Mirror Stage," 2.

46. Lacan, "The Mirror Stage," 3.

47. Hornblower and Spawforth, *Oxford Classical Dictionary*, 749. Thanks to Karen Bassi for this useful reference.

48. Lacan, "The Mirror Stage," 5.

49. Jung was the first psychoanalyst to use the term *imago*: "The imago evokes an imaginary residue of one or other of the participants in the situation" (cited in Laplanche and Pontalis, *Language of Psycho-Analysis*, 211). Jung wrote, "Here I purposely give preference to the term *Imago* rather than to the expression 'Complex,' in order . . . to invest this psychological condition, which I include under *Imago*, with living independence in the psychical hierarchy . . . *Imago* has a significance similar on the one hand to the psychologically conceived creation in Spitteler's novel and on the other hand to the ancient religious conception of *imagines et lares*." This definition, and a large number of other variations, may be found in the *Oxford English Dictionary Online*, Oxford University Press, 2002, <http://dictionary.oed.com>. In 1912 Otto Rank and Hanns Sachs founded the periodical *Imago* for non-medical research in psychoanalysis.

50. Butler, *Subjects of Desire*, 6.

51. Barthes, *Criticism and Truth*, 85.

52. See, for example, the use of the term in regard to self-portraiture in the study by Koerner, *The Moment of Self-Portraiture in German Renaissance Art*.

53. Williams, "Subjective," in *Keywords*, 308.

54. Saussure, *Course in General Linguistics*, 68.

55. Borch-Jacobsen, *The Freudian Subject*, 9.

56. On autonomy and efficacy in relationship to the subject, subjectivity, and subjection, see Butler, *Psychic Life of Power*, esp. 1–30.

57. See Soussloff, *The Absolute Artist*; "The Concept of the Artist"; and "The Aura of Power and Mystery that Surrounds the Artist." My argument in all of these studies about the freedom of the artist relied fundamentally on the still neglected book by Nahm, *The Artist as Creator*.

58. A discussion of these issues may be found in both Keller, "Warhol," and Buchloh, "Residual Resemblance."

59. See Ricoeur, *Le Temps et Recit*, vol. 3, 9: "Selon notre schéma de la triple relation mimétique entre l'ordre du récit et l'ordre de l'action et de la vie, ce pouvoir de refiguration correspond au troisième et dernier moment de la *mimesis*." [According to our schema of the triple mimetic relation among the order of the narrative and the orders of the action and of the life, this capacity of refiguration corresponds to the third and last moment of the mimesis.]

2 *Birth of the Social History of Art*

1. Recent assertions regarding the chronology of the social history of art, with which this chapter takes issue, may be found, for example, in Minor, *Art History's History*, 142–51; Preziosi, *History of Art History*, 581–82.

2. Schlosser, *La Storia dell'Arte nelle esperienze*, 40–41.

3. The best general discussion of the social dimensions of the genre of portraiture may be found in the introduction by Joanna Woodall to *Portraiture: Facing the Subject*. Woodall's excellent collection does not provide the historiography found in this chapter.

4. The theorization of the operations of genre per se by Jacques Derrida is particularly helpful here. See "La loi du genre/The Law of Genre," 221: "The question of the literary genre is not a formal one: it covers the motif of the law in general, of generation in the natural and symbolic senses, of birth in the natural and symbolic senses, of the generation difference, sexual difference between the feminine and masculine genre-gender, of the hymen between the two, of a relationless relation between the two, of an identity and difference between the feminine and masculine."

5. The complexity of this concept may be approached beginning with Gombrich, *Aby Warburg*, 16. Recently, Georges Didi-Huberman has called Warburg's *Nachleben*, "survival" (*L'Image Survivante*). Recent thinking on this problem in Warburg may be found in: Agamben, *Image et Mémoire*; Careri, "Aby Warburg"; Settis, "Pathos und Ethos" and "Kunstgeschichte al vergleichende Kulturwissenschaft."

6. Alberti, *On Painting*, 39: "I have come to understand that in many men,

but especially in you, Filippo, and in our close friend Donato the sculptor and in others like Nencio, Luca and Masaccio, there is a genius for [accomplishing] every praiseworthy thing. For this they should not be slighted in favour of anyone famous in antiquity in these arts."

7. Kristeller, "Modern System of the Arts." This essay was originally published in 1951–52.

8. Bahr, *Expressionism*, 85. The two sentences proceeding this characterization of the Expressionist artist read: "The eye of the Impressionist only beholds, it does not speak; it hears the question, but makes no response. Instead of eyes Impressionists have another set of ears, but no mouth, he is incapable of expressing himself, incapable of pronouncing judgement upon the world, of uttering the law of the spirit."

9. On the status of the Vienna School of Art History in the discipline, see Wood, *The Vienna School Reader*. See also my "Review of *The Vienna School Reader*."

10. Burckhardt, "Das Porträt in der italienischen Malerei"; Warburg, *Bildniskunst und florentinishches Bürgertum*; and Riegl, "Das hollandische Gruppenporträt." Burckhardt's essay has not been translated into English, but see the Italian translation, *Il Ritratto nella Pittura Italiana del Rinascimento*. For Warburg and Riegl, see the English translations (used here), "The Art of Portraiture and the Florentine Bourgeoisie" and *Group Portraiture of Holland*. Interestingly, given the argument in this chapter that the three texts must be read together, all three were republished in 1931–32. This congruence leads to speculations regarding the art-historical approaches of the editors of those volumes, Wölfflin, Bing, and Swoboda, in the early 30s that cannot be pursued here. In this chapter I am grateful to Shauna Finn of the Getty Research Institute for her assistance with the translations from the German.

11. In regard to portraiture the idea of a "national" school seems particularly problematic, although Burckhardt, in the last page of his essay, makes the point that no matter what happened in portraiture after the Italian Renaissance all conventions in the genre go back to that time and location ("Das Porträt in der italienischen Malerei," 294). Attempts to characterize the "expressionist" style of portraiture as distinctly Viennese or German have notoriously failed. For a discussion of these issues see Werkner, *Austrian Expressionism*, 246–53. Olin has argued more polemically that Alois Riegl desired "an ideology not of nationalism, but of an official internationalism, specifically, the embattled internationalism of the Hapsburg empire, then beginning to crumble before the onslaught of nationalist forces" ("Art History and Ideology," 153). On internationalism and Austrian art photography, see chapter 4 of this book.

12. Burckhardt, "Das Porträt in der italienischen Malerei," 146–294.

13. Burckhardt, *Il Ritratto nella Pittura Italiana del Rinascimento*, 32 (Pagliai citing Burckhardt's notes of 1863).

14. On the ironic mode in the historian, see White, *Metahistory*.

15. In 1925 Walter Friedlander's argument in *Mannerism and Anti-Mannerism in Italian Painting* regarding the degeneration of the High Renaissance style into mannerism rested on grounds in many ways similar to Burckhardt's argument in the portrait essay.

16. On the construction of a developmental and progressive model for the discourse on art, see Hazan, *Le Mythe du Progrès Artistique*.

17. Warburg, "The Art of Portraiture and the Florentine Bourgeoisie," 186, for all of the quotations that follow in this paragraph.

18. As far as I know, it was Podro who first recognized Warburg's conflicted relationship to Burckhardt in the study of the Sassetti Chapel (*Critical Historians of Art*, 167).

19. Riegl, *Group Portraiture of Holland*, 96.

20. Riegl, *Group Portraiture of Holland*, 96.

21. Riegl, *Group Portraiture of Holland*, 96.

22. Riegl, *Group Portraiture of Holland*, 80.

23. Harry Berger Jr. in *Fictions of the Pose* and Christopher Wood in *The Vienna School Reader*, 9–72, each in different ways, fall under this historicizing spell of Riegl's rhetoric, although each also presents valuable insight into the essay. As this chapter indicates, I profoundly disagree with Wood's characterization of "Riegl's radical formalism as *aestheticism without judgment*" (28). I do however understand Riegl's art history as radical (see Zerner, "L'Histoire de l'Art de Alois Riegl: Un Formalisme Tactique"). My view of Dutch group portraiture in its historical situation has been immensely aided by the work of Ann Jensen Adams in "Civic Guard Portraits" and "Three-Quarter Length Life-Sized Portrait." I am grateful to Henri Zerner for discussing some aspects of this chapter with me.

24. Here I disagree to some extent with Jonathan Crary's recent reading of Riegl in *Suspension of Perception*, 51–52: "But for Riegl, the dream of community, of a hushed moment of psychic communion, as figured, say, in Rembrandt's *Syndics*, existed as an aesthetic construction to be apprehended by the individual as a solitary observer. Without question, the new forms of collective reception, such as cinema, concretized in attentive mass audiences around 1900, would have disheartened Riegl, whose ideal could only be an elitist and regressive fantasy of a premodern and ethically charged attentiveness." While Riegl sought the position of the ethical viewer (and for this he should be praised) he also sought to understand the intersubjectivity of the

historical subjects portrayed in group portraiture and their political identifi-
cations. His reading of the Dutch group portraits was historical but what he
may have desired to find in contemporary portraiture would also have been
an intersubjectivity put in the terms of the political concerns of his own day.
On these matters, see also Scarrocchia, *Studi su Alois Riegl*.

25. On the Vienna School's method, see Soussloff, *The Absolute Artist*,
chapters 3 and 4.

26. Koerner, "Rembrandt and the Epiphany of the Face," 10.

27. Podro, *Critical Historians of Art*, 94.

28. Waetzoldt, *Die Kunst des Porträts*, 417–18. The study of portrait sculp-
ture begins at the same time; see Bode, *Italienische Porträtsculpturen des XV.
Jahrhunderts*.

29. Müntz, "Le Musée de Portraits de Paul Jove," 252.

30. Warnke, "Individuality as Argument," 81–83.

31. Zerner argues both that Riegl reversed the primacy of the individual
in art history, and that this revision has not proven easy for the discipline to
accept ("L'Histoire de l'Art de'Alois Riegl," 39).

32. Warburg, "The Art of Portraiture and the Florentine Bourgeoisie,"
186.

33. Schlosser, *La Storia dell'Arte nelle esperienze*, 40–41, my translation:
"Era quindi ancora in tema di 'storia della cultura,' nel quale la singola opera
dell'arte, spesso molto importante, era introdotta come 'documento'; con-
temporaneamente pero era pure un contributo alla 'storia dello stile' in gene-
rale, ed in particolare al tanto spinoso problema dei calchi su natura e della
loro importanza nel cosidetto naturalismo. Qui si scontrano 'estetica' e 'sto-
ria': lo spauracchio delle figure di cera, vecchio accessorio di tutte le estetiche
e sopratutto dell'estetica normativa, gia fin dai tempi di Kant, intralciava
la via allo storico, che dominava una lunga serie di fatti intimamente colle-
gati; e cosi pure la questione del ritratto, in senso estetico (all'uso antico),
sempre un po' sospetto, nel quale il punto di vista storico sembra indiriz-
zarci ad altri valori. Dove si sconfinava dal campo dell'arte e dove no? Come
si vede il problema dell''arte,' della sua critica e della sua 'storia,' come di
ogni 'istoria' in genere, risorgeva nuovamente; qui sfociavano tutti i vecchi
studi, le fatiche spese intorno alle figurazioni in se e intorno all storia delle
teoria e delle istoriografie dell''arte,' e cosi tutto si concluse in un capitolo su
quell''estetica storica,' alla quale io, da lungo tempo, per vie false o traverse,
tendevo."

34. Tietze, "L. Dumont-Wilden, *Le Portrait en France*," 209.

35. Riccardo Marchi's excellent work on the social aspects of style in the
writing of Hans Tietze amplifies what I have said here about his view of

portraiture. See Marchi, "Hans Tietze e la storia dell'arte." I am grateful to Marchi for bringing this study to my attention after this chapter had been completed.

36. Bailey, "Portrait of the Artist," 1.

37. Emile Bergerat, *Le Journal officiel de la République Francaise*, 17 April 1877, quoted and translated in Clark, *The Painting of Modern Life*, 22. I borrow rather simplistically here from what Clark has theorized as the complex idea of "the painting of modern life."

38. For a number of examples of critics' complaints and for statistical evidence of the popularity of the portrait, see Vaisse, "Between Convention and Innovation."

39. Bahr, *Expressionism*, 89.

40. See the excellent overview of the exhibitions held at the Galerie Miethke and of the importance of Carl Moll by Natter, "Austellungen der Galerie Miethke 1904–1912." Werkner also cites the importance of Galerie Miethke for the new style and a knowledge of French art (*Austrian Expressionism*, 4–5). Carl Moll's father, August Moll (1886–1918) was an apothecary and also a photographer, a significant point for the son's interest in photographic exhibits.

41. Both Werkner and Natter, cited above, note the possible influence of these exhibits on Kokoschka.

42. I am grateful to Lisa Griffin and the Norton Simon Museum for this information from their archives and to Monique Nonne for helping me to obtain it.

43. The catalogue of the *Kunstschau* lists portraits by Gauguin and Kokoschka, but in the vast number of cases the sitters in these portraits are not named. Instead the title is given simply as *Portrait of a Man*, *Portrait of a Boy*, etc. See chapter 3 for suggestions as to the meaning of this lack of nomination in Kokoschka's early portraits.

44. Winkler and Erling, *Oskar Kokoschka*, 16–17, n. 30.

45. Benjamin, "A Small History of Photography."

46. In his idiosyncratic account of the years 1903–13 titled *Das Grab in Wien* (Death in Vienna), the writer Paul Stefan grouped Adolf Loos and Kokoschka together, calling them "new artists" responsible for new styles in architecture and painting respectively. In the same year Stefan wrote an appreciation of the painter, from which the following quotations are taken (*Dramen und Bilder*, 1).

47. Stefan, *Dramen und Bilder*, n.p.

48. Stefan, *Dramen und Bilder*, n.p.

49. Stefan, *Dramen und Bilder*, n.p.

50. See Soussloff, *The Absolute Artist*, 112–37, for further background on the Vienna School of art history and early psychoanalysis.

51. Here it will be useful to give a chronological bibliography of Kris's and Gombrich's work on caricature because it has not been offered before: Kris, "The Psychology of Caricature" (1936); Kris and Gombrich, "The Principles of Caricature" (1938); Gombrich and Kris, *Caricature* (1940); Kris, *Psychoanalytic Explorations in Art* (1952, with reprint of "The Psychology of Caricature" and "The Principles of Caricature"); Gombrich, "The Experiment of Caricature" (1960). In this last essay, a revision of the work done earlier with Kris, Gombrich moves away from portraiture and resemblance toward a full-blown theory of expression. For this reason and since it falls long after the historical period which concerns me here, I will not be examining it in detail. However, it bears mentioning that Gombrich's revised views are less inflected by the psychoanalysis that continued to inform Kris's work and more oriented toward a history of the caricature image as a form of "mixing and matching" with reality. On Gombrich's view of caricature and its history, see Carrier, *The Aesthetics of Comics*, 11–25.

52. Gombrich, "The Experiment of Caricature," 356–58.

53. Kris, "The Psychology of Caricature," 290–91. Kris relates caricature to children's drawings and then makes the analogy to wit, i.e., to verbal forms of expression (grammar and syntax). Thus, portraiture is the analogy to grammar and syntax to wit. Here an interesting historiographical progression manifests: the social and rhetorical aspects of portraiture were first delineated by the second Vienna School to be followed by the grammatical theorization of portraiture in caricature. For Kris the models were syntactical and linguistic; for the earlier art historians of portraiture they had been philological. Concurrently with the collaboration with Gombrich on caricature Kris collaborated with Otto Kurz on a concept of the artist using philology, linguistics, and psychoanalysis. See Soussloff, *The Absolute Artist*, 95, and "The Aura of Power and Mystery that Surrounds the Artist," 481–93.

54. Gombrich and Kris, *Caricature*, 12.

55. Kris, "The Psychology of Caricature," 298.

56. Kris, "The Psychology of Caricature," 298.

57. Kris, "The Psychology of Caricature," 298.

58. Woerman, *Führer zur Kunst*, 1.

59. Kris, "The Psychology of Caricature," 298, n. 19.

60. Gombrich, "The Study of Art," 221–33.

61. Gombrich and Kris, *Caricature*, 26.

62. Kronberger-Frentzen, *Das deutsche familien Bildnis*, 7, my translation. In the English-speaking context at this time, a view of the history of por-

traiture entirely dependent on Burckhardt may be found, for example, in Alazard, *The Florentine Portrait*, first published in 1948.

63. Gadamer, *Truth and Method*, 131.

64. Hauser, *Social History of Art*.

65. Hauser, *Sociology of Art*, 11–12.

66. For this characterization, derived from Lukács's self-analysis, see *The Lukács Reader*, 3.

67. Lukács, "The Parting of the Ways," *The Lukács Reader*, 167.

68. Kokoschka, "On the Nature of Visions, 1912," 235 and 238, n. 3. This controversial lecture and essay by Kokoschka has not been satisfactorily explained in relationship to a wider context for his work until now.

69. Lukács, "Aesthetic Culture," *The Lukács Reader*, 156.

70. Kokoschka, "On the Nature of Visions, 1912," 235.

71. Lukács, "Paul Gauguin," *The Lukács Reader*, 160.

72. Kokoschka, "On the Nature of Visions, 1912," 235.

73. Lukács, "Paul Gauguin," *The Lukács Reader*, 163–64.

74. *The Sociology of Art* was published first in 1974 in German as *Soziologie der Kunst*. I consider Hauser's third famous book, *The Philosophy of Art History*, published both in English and German in 1958, to be the preliminary thinking about sociology developed more fully in the 1974 book.

75. Adorno, *Introduction to Sociology*. These essays were first delivered as lectures in 1968.

76. Adorno, *Introduction to Sociology*, 15.

77. The reestablishment of this approach in the latter part of the twentieth century begins with Clark, "Conditions of Artistic Creation."

3 The Subject at Risk

1. Kafka, *Diaries, 1914–1923*, 252. In the original German, the quote reads: "Was habe ich mit Juden gemeinsam? Ich habe kaum etwas mit mir gemeinsam und sollte mich ganz still, zufrieden dammit dass ich atmen kann in einen Winkel stellen" (*Tagebücher*, 622). The lines are also quoted in English in Mendes-Flohr, "Retrieval of Innocence and Tradition," 282, n. 9, where the wrong date and a slightly different translation are given. Adorno said that Kafka's "texts are designed not to sustain a constant distance between themselves and their victim but rather to agitate his feelings . . . Such aggressive physical proximity undermines the reader's habit of identifying himself with the figures in the novel" ("Notes on Kafka," 246). In contrast, as this quotation indicates, in his diaries Kafka appears to seek an aggressive physical

distance, evoking not only an inability to identify with others, but provoking on the part of the reader a desire for connection with the author, such as that seen in Kafka commentator Max Brod and others. This vacillation between physical and emotional proximity in both author and readers may be seen as indicative of assimilation itself.

2. Brod, *Franz Kafka*, 186–87. This biography was first published in Prague in German in 1937. Brod's interpretation of *The Castle* as "straight from his Jewish soul" and as having more to say "about the situation of Jewry as a whole today than can be read in a hundred learned treatises" may be overdrawn, but the impossibility of assimilation and a resulting alienation are Kafka's themes in the novel.

3. Kafka, *Diaries, 1914–1923*, 252.

4. On Rank, see Lieberman, *Acts of Will*; and Klein, *Jewish Origins of the Psychoanalytic Movement*. See also the invaluable *Journal of the Otto Rank Association*, which ceased publication in the early 1980s.

5. Freud's paper, "A Fantasy of Leonardo," and the remarks of those present, including Rank, can be found in Nunberg and Federn, *Minutes of the Vienna Psychoanalytic Society*, 2 (1908–10), 338–52.

6. Laplanche and Pontalis, *Language of Psychoanalysis*, 205. For a useful chronology of Freud's work on identification and its place in the Leonardo essay and its later revisions, see Jackson, *Strategies of Deviance*, 53–81.

7. Rozenblit, *Jews of Vienna*.

8. Rank in Klein, *Jewish Origins*, 170.

9. Rank in Klein, *Jewish Origins*, 171.

10. Rank in Klein, *Jewish Origins*, 171.

11. Rank, in Klein, *Jewish Origins*, 172.

12. Yosef Yerushalmi has mentioned the complex relationship between Freud's view of Jewishness and Judaism in *Moses and Monotheism* and Rank's *Myth of the Birth of the Hero* (1909) (*Freud's Moses*, 4–5). My analysis of the correspondences between Freud's essay on Leonardo da Vinci and Rank's book *The Artist* belongs to a similar modality of influence. Two points that Yerushalmi makes strike me as important in regard to my argument. First, the theorization of the Jew as an artist was intended as positive by Rank, just as "Freud's conviction that Judaism had its origins in the slaying of its founder will neither come as a surprise nor be perceived as a particular insult for anyone familiar with his *Totem and Taboo* where not only religion but the whole of human civilization is rooted in a prehistoric murder of which the slaying of Moses is, on an unconscious level, a repetition" (*Freud's Moses*, 4). Second, Freud was never consistent in his acknowledgment of the influences of even his closest followers. I would add that this statement is particularly true in regard to his thinking about Jews and Judaism.

13. Rank, *Der Kunstler*, 7.

14. Stefan Jonsson makes this same claim in regard to the Viennese writer Musil. See *Subject Without Nation*, vii: "Robert Musil's works projected a 'new human being,' one who would resist assimilation into imperialist, nationalist, or fascist communities." I am most grateful to Stefan Jonsson for allowing me to read his book in manuscript and for his insightful and helpful comments on my work in this chapter.

15. The literature on the Tietze portrait is large, but no attempt I know of has been made to understand the work in terms of the identities of the sitters as assimilated Jews. For the most complete bibliography, see Winkler and Erling, *Oskar Kokoschka*, 19–20. See also Krapf-Weiler, "Löwe und Eule"; and Kahr, "Erica Tietze-Conrat." An attempt has been made to discuss portraits of Viennese Jewish women by Kokoschka's older contemporary, the artist Gustav Klimt; see Brandstätter, "Schöne jüdische Jour-Damen."

16. Kokoschka, *My Life*, 35.

17. I am grateful to Glen Lowry, director of the Museum of Modern Art, for allowing me access to the curatorial file on this important painting. I have not seen the records on the financial transactions between the Tietzes and the dealer or MOMA. Much of what follows can be found in the curatorial file. According to an article cited in the file which records the memory of Erica Tietze-Conrat the portrait was started and completed in December of 1909: Hoden, *Bekenntnis zu Kokoschka*, 76. Other research indicates they may have emigrated in 1938.

18. D. Hugo Feigl to Alfred Barr, 26 September 1939, MOMA, Curatorial File.

19. The exhibit catalogue, *Sonderausstellung Malerei und Plastik in den Räumen des Künstler Bundes Hagen*, states that the paintings by Kokoschka numbered 36–60 were exhibited in rooms two and three. I am grateful to Patrick Werkner of the Kokoschka Archive in Vienna for giving me access to this information, not represented correctly in most of the later Kokoschka literature, i.e., Schroder and Winkler, *Oskar Kokoschka*, 70. See also Hoffmann, *Kokoschka*, 86–108.

20. Of particular interest for Tietze's family history is the situation of assimilation in Czechoslvakia; see on this Bergová, *Jews of Czechoslovakia*. See also the important study of émigré art historians by Wendland, *Biographischen Handbuch deutschsprachiger Kunsthistoriker*, vol. 2: 689–99 (on Tietze); 2: 699–703 (on Tietze-Conrat).

21. Beller, *Vienna and the Jews 1867–1938*, 53 and 53, n. 38, identifies the Schottengymnasium as "aristocratic."

22. Tietze's book on the Viennese Jews, *Die Juden Wiens*, is one of several studies from this period that examine the long history of the Jews in the city:

(in alphabetical order) Bato, *Die Juden im Alten Wien*; Frei, *Judisches Elend in Wien*, with photos of poverty and illness in Leopoldstadt, the Jewish quarter in Vienna; Grünwald, "Die Wiener Juden 1826–1926"; Husserl, *Grundungsgeschichte des Stadt-Tempels der Israel*; Pollak, *Die Juden in Wiener-Neustadt*; Rotter and Schmieger, *Das Ghetto in der Wiener Leopoldstadt*.

23. The majority of this information can be found in the *International Biographical Dictionary of Central European Émigrés 1933–1945*, II, vol. 2, L-Z, "The Arts, Sciences, and Literature," 1165.

24. Oskar Kokoschka to Dorothy Miller, 4 October 1953, MOMA, Curatorial File.

25. Hoden, *Bekenntnis zu Kokoschka*, 76.

26. Kokoschka, *My Life*, 76.

27. Schorske, *Fin-de-Siècle Vienna*, 141.

28. Julius Held to Mr. Alfred Barr, 29 November 1957, MOMA, Curatorial File.

29. Druick and Hoog, *Fantin-Latour*, cat. nos. 70–73, pp. 203–14, esp. 204–5.

30. In 1946 the painting was still in its original frame, according to a letter from Hans Tietze to Sweeney at MOMA. He based his assessment on a photograph; see Hans Tietze to Sweeney, 7 March 1946, MOMA, Curatorial File. See also 27 February 1946, MOMA, Curatorial File, where the painting is described as "looking as it had been meant by the artist and in the frame he had designed for it." This evidence may contradict statements by Tietze-Conrat.

31. Oskar Kokoschka to Dorothy Miller, 10 October 1953, MOMA, Curatorial File.

32. Varnedoe, *Vienna 1900*, 169.

33. Bahr, *Expressionism*. The depicted figures are designed to function in painting as certain figures of speech do in rhetoric: to move the viewer to *pathos*, or to feeling.

34. Riegl, "Excerpts from The Dutch Group Portrait," 20.

35. Olin, *Forms of Representation*, 168.

36. Held, "Hans Tietze—1880–1954," 68.

37. Held, "Hans Tietze—1880–1954," 68: "Such 'radical' views and activities, even though only in the field of art, were by no means without risks in the arch-conservative Austro-Hungarian monarchy, but Hans Tietze was never a man to shirk from unpleasantness." Kokoschka may have claimed in his autobiography, written many years after the fact, to have had no revolutionary intent during the years 1908–10, but that may have been a revision of the historical situation by the older and more conservative Kokoschka. Other than the artist himself, the person most responsible for the revisionist criticism of early Kokoschka, including a reconsideration of his relationship

to the radical Karl Kraus as essentially nonpolitical, was E. H. Gombrich. See *Kokoschka in His Time*. In light of my research here I do not accept Gombrich's views on either early Kokoschka or Kraus.

38. On Loos and the background of Vienna in the early years of the century, see Vergo, *Klimt, Kokoschka, Schiele and Their Contemporaries*. See also Münz and Künstler, *Adolf Loos*. On Kraus, see Timms, *Karl Kraus*.

39. The portrait of Loos, originally owned by him and dated 1909, is in the Neue Nationalgalerie, Berlin (Winkler and Erling, *Oskar Kokoschka*, cat. no. 28, 15–16). The portrait of Kraus, also dated 1909 and originally owned by him, was destroyed in World War II (*ibid.*, cat. no. 26, 14).

40. Fischer, "Kokoschka's Early Work," 5.

41. Banham, "Ornament and Crime," 17 (originally published in 1957). The essay by Loos is translated in Münz and Künstler, *Adolf Loos*, 226–31.

42. The related presentation of Kokoschka as a child and an enfant terrible in the critical press of the day has been explored by Shapira in "Interpretation of Children's Drawings."

43. These connections to the radical, artistic, business, and political Jewish community came in the main through Loos. The painting *Child in the Hands of the Parents* pictured in chapter 2, depicted the firstborn of the Goldmann family, for whom in the same year of 1909 Loos was to begin the Goldmann and Salatsch building on Michaelerplatz in Vienna. Besides the catalogue entries on the early portraits discussed here in Winkler and Erling, *Oskar Kokoschka*, see Frodl and Natter, *Kokoschka und Wien*. See also note 15 above.

44. Kokoschka, *My Life*, 23.

45. Cohen, *Jewish Icons*, 27. See my review of Cohen's book in *Central European History* 33 (2000): 122–25.

46. Cohen, *Jewish Icons*, 117.

47. Brilliant, "Portraits as Silent Claimants," 1.

48. Brilliant, "Portraits as Silent Claimants," 2.

49. Brilliant, "Portraits as Silent Claimants," 4–5.

50. See Altshuler, *Precious Legacy*, cat. nos. 224–25. These portraits have frequently been associated with a Jewish ritual, part of the wedding ceremony called "The Veiling" (Bedeckung). The chair or sofa back depicted behind many of the half-length portraits may refer to that particular part of the ceremony, as might the veil worn by the woman, which was put on when the figures were seated. See the portraits of Amalie and Karl Andrée which supposedly represent this event (*ibid.*, cat. nos. 229–30). A wedding couch originally from Danzig and today in the Jewish Museum in New York is dated 1838. It is the only example of this genre of furniture; see Mann and Gutman, *Danzig 1939*, cat. no. 10, 62.

51. Brilliant, "Portraits as Silent Claimants," 3.

52. On the topic of not allowing Jewish identity into art's history and interpretation, see my "Introducing Jewish Identity to Art History," in Soussloff, *Jewish Identity in Modern Art History*, 1–16. This situation is rapidly changing in the literature on art.

53. See the exhibition and catalogue Bilski, *Berlin Metropolis*, for an argument that art, such as Kokoschka's portraits of Jews, significantly altered the metropolitan context and contributed to a new order of culture, indicated by the fully acculturated Jewish subject.

54. Woodall, *Portraiture*, 1–23.

55. Baron, "Ghetto and Emancipation," 515–26. I am aided in my understanding of the significance of Baron for the Viennese context by the fine introduction by David N. Myers in Myers and Rowe, *From Ghetto to Emancipation*, vii–xv.

56. Myers and Rowe, *From Ghetto to Emancipation*, x.

4 Art Photography, Portraiture

1. For an expanded discussion of the history of photography at the turn of the twentieth century in light of the discipline of art history, with bibliography, see Soussloff, "Art Photography, History, and Aesthetics," 295–313.

2. The best history of German photography in the early periods, on which I have relied a great deal, remains Loescher, *Die Bildnis-Photographie: Ein Wegweiser für Fachmänner und Liebhaber* [Portrait Photography: A Guide for Experts and Connoisseurs].

3. The best discussion in English of pictorialism remains Naef, *The Painterly Photograph: 1890–1914*. See also Harker, *The Linked Ring*, 15–22. For German and Austrian art photography specifically, see Steinert, *Kunstphotographie um 1900*. For some interesting views of more recent art-photography practice and postmodernism, see Solomon-Godeau, *Photography at the Dock*, 103–23.

4. To take an example from photography and painting that represents the best of scholarship respectively, but in which the other medium plays virtually no role, see for art history Vergo, *Art in Vienna*; and for photography, see Hochreiter and Starl, *Geschichte der Fotografie in Österreich*.

5. Schiendl, *Die künstlerische Photographie*.

6. Schiendl, *Die künstlerische Photographie*, 207–215 ff. This characteristic in photography is now known as "the Rembrandt effect."

7. Warstat, *Allgemeine Ästhetik der photographischen Kunst*. See also Hundhausen, "Grundzüge der Photographischen Ästhetik."

8. On the end of sculpture in modernity, see Krauss, "Sculpture in the Expanded Field."

9. For one of the earliest examples justifying the amateur's location in art photography, see Paris Photo Club, *Première Exposition d'Art Photographique*.

10. These other genres of photography are too large a topic to address here, but for photographic postcards in the colonial context, see Alloula, *Colonial Harem*. The collections of early postcards owned by the Getty Research Institute, virtually each of which bears the stamp of the professional photographer's studio in the European city where the photographic souvenir was purchased, would form the basis of an interesting study. For a comparison of the use of photographs in medical and art photography contexts, see the work of the Austrian art photographer Heinrich Kühn who appears to have been trained in medical photography before he became an artist. Bibliography on Kühn can be found below.

11. The best sense of these interactions among art photographers can be gained from the contemporary literature cited here and from the excellent book by Naef, *Collection of Alfred Stieglitz*. The international aspects of this discourse are evident in the holdings of the libraries belonging to the camera clubs and photographic societies, although these have not been systematically studied. See, for example, the listing of books in English, French, and German held by the New York Camera Club in "Catalogue of the Photographic Library of the Camera Club, New York," *Camera Notes* 6 (July 1902): following page 82. All of the contemporary criticism makes clear distinctions based on national characteristics; see, for example, Loescher, "La Photographie Professionelle en Allemagne," 80; and Hinton, "Pictorial Photography in Austria and Germany," G2.

12. Nochlin, "Impressionist Portraits."

13. Alberti, *On Painting and On Sculpture*, book 2, #26. Grayson explains: "The implied sense is surely that painting is representing Nature faithfully through artistic means on a flat surface, just as Nature (Narcissus) is reflected truly in the flat mirror of the pool. In this sense the painter is, as it were, an imitator of reflections, and holds a mirror up to Nature" (114).

14. Dayox, Preface, n.p., my translation: "Il y avait également place pour la doctrine féconde de la libre interprétation et qu'un habile amateur, en qui vit l'âme d'un artiste, peut traduire avec une réelle émotion les divers et fugitifs aspects de la nature, depuis l'agitation du ciel et la calme limpide de l'eau, jusqu'au charme de la femme et au sourire de l'enfant."

15. The best study of the cartes de visite remains McCauley, *A. A. E. Disdéri*. I know of no such studies of the German or Austria context, but see the archival references below.

16. Vogel, *Handbuch der Photographie*, 5, figs. 2 and 3.

17. Dayox, Preface, n.p., my translation: "Et cette distinction était rendue bien moins frappante par la dissemblance des techniques que par l'esprit du sujet et la tendance d'esthétique nationale dont il était la manifestation."

18. Dayox, Preface, n.p., my translation: "L'exposition autrichienne a bien aussi sa caractère particulier, et telles des épreuves originales que j'y ai remarqués font songer, à première vue, à des reproductions d'après des tableaux de Rotenhamer, de Kaulbach, de Hans Mackart."

19. F. Loescher, "La Photographie Professionelle en Allegmagne," 88, my translation: "Oh! Quelle force, quel amour il faut pour agir sur cette âme, pour la forcer à dévoler à celui qui la cherche et l'appelle."

20. Gernsheim, *Alvin Langdon Coburn Photographer*, 24.

21. Lichtwark was an art historian, museum director, collection builder, connoisseur of photographs, and immensely interdisciplinary art historian. His work deserves more recognition in the accounts of the historiography of art history. For an excellent bibliography of his work and works on him, see Kayser, *Alfred Lichtwark*. See also Kempe, *Vor der Camera*, which I have not yet been able to consult. For Lichtwark's interest in portraiture and photography, see his *Das Bildnis in Hamburg*.

22. I use the English edition of the book here: Schwarz, *David Octavius Hill*, 8.

23. Richard Stettiner quoted in Goerhe, *Die Kunst in der Photographie*, 5–6.

24. Schwarz delineates the role of Lichtwark in the dissemination of Hill's work and its influence on art photography: "But it was the large exhibition organized in the year 1898 by the Royal Photographic Society in the Crystal Palace in London, bringing together nearly seventy of Hill's photographs, which first made his work widely known to the English public and gave him back the full measure of his importance. A year after the London exhibition, Ernst Juhl, stimulated by Alfred Lichtwark, showed in Hamburg a large collection of old and new photographs, the only collection outside England which at that time contained works by Hill. The Hamburg Museum fur Kunst und Gewerbe and the Department of Prints and Drawings of the Dresden museum thereupon began to make collections; and they are still the only public art collections in Germany—aside from the Berlin Staatliche Kunstbibliotek—which include a few of Hill's photographs" (*David Octavius Hill*, 48).

25. Smith's *Edward Steichen* gives a good account of Steichen's movements during these years.

26. Naef, *The Painterly Photograph: 1890–1914*, n.p.

27. Naef, *Collection of Alfred Stieglitz*, 443–44.

28. Loescher, "La Photographie Professionelle en Allemagne," 41–42.

29. Loescher, "La Photographie Professionelle en Allemagne," 42.

30. Loescher, "La Photographie Professionelle en Allemagne," 79, my translation: "L'ancien atelier, bondé d'accessoires, convient à la reproduction continue d'une masse d'images uniformes plus qu'à l'enfautement d'oeuvres personnnelles. C'est là qu'on trouve cette division du travail qui, à notre époque, tue le génie et fait de l'homme une machine . . . Les portraits livrés dans ces conditions peuvent bein être identique et propres, mais ce ne sont pas des oeuvres personnelles."

31. Loescher, "La Photographie Professionelle en Allemagne," 80.

32. Loescher, *Die Bildnis-Photographie*, ix.

33. Loescher, *Die Bildnis-Photographie*, x, my translation: "Wer sich mit den neuen Wegen des Lichtbildes publizistsch beschäftigt, wird immer dazu kommen, mehr über wesentliche Unterschiede in Empfindung und Auffassung, als über die neuen technischen Mittel zu reden. Das Handwerkszeug is ja im grossen ganzen dasselbe; der eine benutzt es, um den langweiligen und äusserlichen Abklatsch einer vorübergehenden Naturerscheinung herzustellen, der andere schafft mit ihm ein wesentliches, beseeltes Bild, in dem der Pulsschlag des Lebens geht."

34. Nelson, "Slide Lecture," 432.

35. Kühn's preeminence and his mastery were noted early: see Goerhe, *Die Kunst in der Photographie*, 38–39; and Hinton, "Pictorial Photography in Austria and Germany," G1–G8. Part of this fame was due to the efforts of Stieglitz on Kühn's behalf, indeed, on behalf of the entire school of Viennese art photography, see Naef, *Collection of Alfred Stieglitz*.

36. Naef, *The Painterly Photograph: 1890–1914*, n.p.

37. Bazin, "Ontology of the Photographic Image," 10. Bazin's argument turns neatly on itself so that he makes photography the medium responsible for liberating painting from realism, allowing "it to recover its aesthetic autonomy" (16). See also Tagg, *Burden of Representation*. Clarke is especially sensitive to the discrepant expectations of photographs in regard to both the documentary and artistic for which he relies on Roland Barthes (*The Photograph*, 19–20).

38. Warstat, *Allgemeine Ästhetik der photographischen Kunst*, 87–95.

39. Benjamin, "A Small History of Photography," 240–57; 253.

40. Benjamin, "A Small History of Photography," 248.

41. Kracauer, "Photography." On the relationship between Kracauer, Benjamin, and the avant-garde, see Buchloch, "Gerhard Richter's *Atlas*."

42. Schwarz, *David Octavius Hill*, 3–5: "In essence the discovery depended

upon a changed social order, upon an aesthetic attitude of man to his environment which was new and based on scientific assumptions. As at the close of the Middle Ages, so at the opening of the nineteenth century, a new mankind, a new social class, had sloughed the old world. With fresh and untried powers and agitated by new ideas, a submerged order had broken its way to the surface. The eighteenth century had laid the way for the great change, the French Revolution establishing the predominance of a middle-class order for the century to come. And the features of this period were to be moulded by the bourgeoisie and its cultural ideals . . . The tremendous widening of people's interests, as well as that increase in the size of the purchasing public which followed upon the rise to power of the middle classes, found adequate expression in lithography and, to an even greater extent, in photography . . . Here lay another cause for the invention of photography; it represented, even then, a symptom of the dawning technical age which was straining towards a new unity of artistic and technical creation."

43. Benjamin, "A Small History of Photography," 252–53. Note also p. 248: "Thus, especially in *Jugendstil*, a penumbral tone, interrupted by artificial highlights, came into vogue; notwithstanding this fashionable twilight, however, a pose was more and more clearly in evidence, whose rigidity betrayed the impotence of that generation in the face of technical progress."

44. Schwarz, *David Octavius Hill*, 48.

45. Benjamin, "Paris," 35–36.

46. Warstat, *Allgemeine Ästhetik der photographischen Kunst*.

47. Rodchenko, "Against the Synthetic Portrait," 239 (first published in *Novyi lef* in 1928). On Rodchenko's contribution to photography and theory, see the excellent essay by Galassi, "Rodchenko and Photography's Revolution," 101–37. Galassi writes: "But photography's prospects as an art had invariably been identified with the emulation of painting, thus foreclosing in advance the possibility that photography might tread an untrodden path. In consequence, the notion of photography as art had produced not an evolving tradition but a sequence of dead ends, of which the most recent—the turn-of-the-century 'artistic photography' movement—was the most vacuous" (102–3). Galassi's views support the predilection in art history for avant-garde photography, which has in part prevented the historicization and appreciation of art photography.

48. On the place of Berlin in the art culture before World War I, see the excellent catalogue Bilski, *Berlin Metropolis*.

49. Schmied, *Neue Sachlichkeit*, 7.

50. The literature on Schiele has become quite extensive in the last decade, but for a general assessment of the historiography and of his art, see Dabrowski, *Egon Schiele*.

51. Quoted in Eskildsen, "Photography and the Neue Sachlichkeit Movement," 86.

52. Although I will not be discussing it here, Moholy-Nagy's post–World War I theory of photography which relies on medium distinctions regarding the use of light, or technological justifications, for its differences from painting deserves consideration in a wider discussion; see Moholy-Nagy, *Malerei, Photographie, Film.*

53. Benjamin, *Charles Baudelaire,* 163.

54. Clarke, *The Photograph,* 20.

55. McCully, " 'Dans le piège du regard scrutateur de Picasso,' " 224–53.

56. On the Kahnweiler portrait, see especially Pointon, "Kahnweiler's Picasso; Picasso's Kahnweiler," 189–202.

57. Rubin, *Picasso et le Portrait,* 29, my translation. Interestingly, in regard to what I argue here, on page 35 Rubin questions "the extent to which our reaction to the portraits of Picasso lies in our knowledge of the identity of the model?"

58. Barthes, "The Photographic Message," 5–7.

5 Regarding the Subject

1. See Soussloff, *Jewish Identity.*

2. Soussloff, *The Absolute Artist* and *Jewish Identity.* In a recent book about anachronism in twentieth-century art history Georges Didi-Huberman reprises the important argument, developed in both of my earlier studies, that the historiography of the discipline was transformed as a result of the fate of Jewish German and Viennese art historians during the Nazi period, although he does not cite my books; see *Devant le Temps,* 49–55. He points, as I have both here and earlier, to the philological methods associated with Vienna School art history as being significantly productive of critical approaches to the image that did not persist in the discipline. If World War II "stopped this movement short," as Didi-Huberman states, then, he argues, postwar art history, having emigrated from German-speaking locations, denied itself the approaches of its teachers, resulting in what he calls a "burial." He also places the methods of Warburg in this category of "loss"; whereas I would not call the *Kulturwissenschaft* of Warburg philological in the ways that Schlosser intended the term when he wrote of the methods of the Vienna School; see Schlosser, *La Storia dell'Arte nelle esperienze.* In addition, Warburg's inheritance differs greatly from the Viennese, indeed from other Germans, too, for several, historically specific reasons: 1) he lacked students, although he had followers; 2) he died before the war in 1929; 3) his library was transferred to

England during the Nazi period where it and his work played a significant role in the lives and work of English-based art historians, including Gombrich, and many others who made their way first to England during the war years before moving on to the United States and Canada. Much of this story was first told by Colin Eisler, not cited by Didi-Huberman, who deserves a great deal of credit for arguing early on of the significance of these events for the discipline; Eisler, "*Kunstgeschichte.*" See also Wendland's important study, *Biographische Handbuch deutschsprachiger Kunsthistoriker in Exil* and, on Warburg, the study by Schoell-Glass, *Aby Warburg und der Antisemitismus*, translated in part in Soussloff, *Jewish Identity*, 218–230. A great deal of important work on Warburg has appeared in the last five years, but of particular significance for an understanding of Warburg in America are the remarks by Michael P. Steinberg in Warburg, *Images from the Region of the Pueblo Indians of North America*. My argument about the subject and portraiture here pertains to the work of Burckhardt and Warburg, as well as to Vienna School art history, painting, and photography. Although the Vienna School art historians responded to Burckhardt and Warburg, it should be noted that I strongly disagree that their approaches can be conflated with the Viennese, something Didi-Huberman appears to want to do. Importantly, for my arguments here and in contrast to Didi-Huberman, p. 54, Kris did not "renounce his theory" and it could be maintained that Warburg's theories on Renaissance art remained central to many art historians in England and America throughout the latter part of the twentieth century, just as did Burckhardt's, see my essay, "Art," of the latter. I do agree, however, with Didi-Huberman's views that the situation in France for art history was entirely different and that linguistic and nationalistic issues regarding theoretical proclivities between German and French psychoanalysis, for example, and the history of the discipline in Germany and France must be considered separately. I have tried in chapter 1 of this book to take these important historiographical nuances into account in my investigation of the theories of the subject in Vienna School art history, and in later French philosophy and psychoanalysis. I have also traced the genealogies of the theory of the subject in historically and geographically specific ways in order to arrive at a historiography that is meaningful.

3. On this history of film studies, see De Lauretis, "Special Topic."

4. These debates over the social history of art and visual culture may be most closely followed in the special issue of the journal *October* devoted to the "Visual Culture Questionnaire" (*October* 77 [summer 1996]) and the debates in two recent issues of the *Journal of Visual Culture*; see Bal, "Visual Essentialism"; and Bryson et al., "Responses to Mieke Bal's 'Visual Essentialism.'"

5. On a case study of such an argument in the institution of the research university, see Soussloff and Franko, "Visual and Performance Studies." I have argued elsewhere that the aims of a socially responsible history of art necessitate its formation and its continuing allegiance with other arts disciplines, including theater, dance, film, performance, etc.; see "Like a Performance" and "Jackson Pollock's Post-Ritual Performance." In regard to my thinking on interdisciplinarity in art history, I am especially grateful to the following authors and their unpublished essays on the topic, which are presently under consideration for publication in a volume to be edited by myself: Michael Roth, "What's the Good of Art History?," Thomas Da Costa Kaufmann, "The Problem of Disciplinarity and the Definition of Art History," Stephen Bann, "Beyond High and Low: From Visual Culture to the Visual Economy," Mark Franko, "Dance Performing Interdisciplinarity," Ernst Osterkamp, "Interdisciplinary Teaching, Scientific Communication, and Research: Some Personal Comments," Robert S. Nelson, "Interdisciplinarity: The Problems of the In and the Between and the Art History of the Present and Future."

6. I cannot do more here than to gesture to what should be a major historiographical project and one of great value: the history of the subject in French philosophy and psychoanalysis in the second half of the twentieth century. In the present study I have attempted to provide some of this history as it pertains to the visualized subject in portraiture, and as a result I have concentrated mainly on Sartre and Lacan. I have also attempted to suggest briefly the significance of Barthes in these discussions, particularly in regard to Sartre's views and to the issue of realism and "art" in photography. On these, see the bibliography here. However, I have not pursued the importance of Foucault for the history of the subject, because I do not find his theoretical "roots" in quite the same cultural and conceptual milieus as those of the other French thinkers named here. But this is admittedly arguable. For an argument concerning Foucault and the image see Soussloff, "The Trouble With Painting." On Lacan, Foucault, and the subject, see especially Ogilvie, *Lacan*. On Foucault, see especially Deleuze, *Foucault*; Butler, *Subjects of Desire* and *The Psychic Life of Power*, although neither of these especially addresses Foucault and the visual fields. On Foucault see also *Le Magazine Littéraire* 435 (October 2004), devoted to an assessment of his philosophy, with extensive bibliography. On some early and preliminary suggestions regarding Foucault's relationship to the new visual culture studies, see Soussloff, "Review Article: The Turn to Visual Culture." On Levinas and the subject, see Levinas, *Outside the Subject*. Of all of these French thinkers on the subject and the visual, Levinas remains the least explored, and the significant precedent views of Martin Buber's thought, particularly in its

Viennese context, remain to be defined, particularly in regard to the history of art.

7. Particularly useful in pursuing Hegel's genealogy in French historical thought is Roth, *Knowing and History*.

8. Foucault, *This Is Not a Pipe*. For a related argument concerning parody and representation in the paintings of Paul Klee in the interwar years, see Haxthausen, "Zwischen Darstellung und Parodie."

9. Barthes, *Camera Obscura*. On the issue of portraits and identification in Barthes's argument, see Olin, "Touching Photographs."

10. See here Debora Silverman's use of a concept of interiority in her book *Van Gogh and Gauguin*. While this terminology may ultimately derive from Bergson, it may be found employed elsewhere, significantly in my opinion, in the work of Derrida on mourning; see *The Work of Mourning*.

11. See here Adorno, *Introduction to Sociology*, based on lectures originally given in 1968.

Notes

BIBLIOGRAPHY

Adams, Ann Jensen. "Civic Guard Portraits: Private Interests and the Public Sphere." *Nederlands Kunsthistorisch Jaarboek* 46 (1995): 169–97.

———. "The Three-Quarter Length Life-Sized Portrait in Seventeenth-Century Holland: The Cultural Functions of *Tranquillitas*." In *Looking at Seventeenth-Century Dutch Art: Realism Reconsidered*, edited by Wayne Franits, 158–74, 234–38. Cambridge: Cambridge University Press, 1997.

Adorno, Theodor W. "Notes on Kafka." In *Prisms*, translated by Samuel and Shierry Weber, 243–52. London: Neville Spearman, 1967.

———. *Aesthetic Theory*, edited by Gretel Adorno and Rolf Tiedemann and translated by Robert Hullot-Kentor. Minneapolis: University of Minnesota Press, 1997.

———. *Introduction to Sociology*, edited by Christoph Godde and translated by Edmund Jephcott. Stanford: Stanford University Press, 2000.

Agamben, Giorgio. *Image et Mémoire*, translated by Marco dell'Omodarme. Paris: Hoëbeke, 1998.

Alazard, Jean. *The Florentine Portrait*. New York: Schocken, 1968.

Alberti, Leon Battista. *On Painting*, translated by John R. Spencer. New Haven: Yale University Press, 1966.

———. *On Painting and On Sculpture*, edited by Cecil Grayson. London: Phaidon, 1972.

Alloula, Malek. *The Colonial Harem*, translated by Myrna and Wlad Godzich. Minneapolis: University of Minnesota Press, 1986.

Altshuler, David, ed. *The Precious Legacy: Judaic Treasures from the Czecho-slovak State Collections*. New York: Summit Books, 1983.

Anderson, Maxwell. *Roman Portraits in Context: Imperial Likenesses from the Museo Nazionale Romano*. Rome: De Luca Edizioni d'Arte, 1988.

Assoun, Paul Laurent. "The Subject and the Other in Levinas and Lacan." In *Levinas and Lacan: The Missed Encounter*, edited by Sarah Harasym, 102–185. Albany: SUNY Press, 1998.

Bahr, Hermann. *Expressionism*, translated by R. T. Gribble. London: Frank Henderson, 1925.

Bailey, Colin. "Portrait of the Artist as a Portrait Painter." In *Renoir's Portraits: Impressions of an Age*, edited by Colin Bailey et al., 1–52. New Haven: Yale University Press, 1997.

Bal, Mieke. "Visual Essentialism and the Object of Visual Culture." *Journal of Visual Culture* 2 (April 2003): 5–32.

Balibar, Étienne. "Subjection and Subjectivation." In *Supposing the Subject*, edited by Joan Copjec, 1–15. London: Verso, 1994.

Banham, Reyner. "Ornament and Crime: The Decisive Contribution of Adolf Loos." In *A Critic Writes: Essays by Reyner Banham*, 16–23. Berkeley: University of California Press, 1996.

Baron, Salo. "Ghetto and Emancipation: Shall We Revise the Traditional View?" *The Menorah Journal* 14 (June 1928): 515–26.

Barthes, Roland. *A Lover's Discourse, Fragments*, translated by Richard Howard. New York: Farrar, Straus, and Giroux, 1978.

———. *Camera Lucida: Reflections on Photography*, translated by Richard Howard. New York: Farrar, Straus and Giroux, 1981.

———. "The Photographic Message." In *The Responsibility of Forms: Critical Essays on Music, Art, Representation*, translated by Richard Howard, 3–20. Berkeley: University of California Press, 1985.

———. *Criticism and Truth*, translated and edited by Kathrine Pilcher Keuneman. Minneapolis: University of Minnesota Press, 1987.

Bateson, Gregory. *Steps to an Ecology of the Mind*. Chicago: University of Chicago Press, 1972.

Bato, Ludwig. *Die Juden im Alten Wien*. Vienna: Phaidon, 1928.

Bazin, André. "The Ontology of the Photographic Image." In *What Is Cinema?* translated by Hugh Gray, 9–16. Berkeley: University of California Press, 1967.

Beller, Steven. *Vienna and the Jews 1867–1938: A Cultural History*. Cambridge: Cambridge University Press, 1989.

Benjamin, Walter. "A Small History of Photography." In *One-Way Street and Other Writings*, 240–57. London: Verso, 1979.

———. *Charles Baudelaire: A Lyric Poet in the Era of High Capitalism*, translated by Harry Zohn. London: Verso, 1976.

———. "Paris, the Capital of the Nineteenth Century." In *Selected Writings*, edited by Howard Eiland and Michael W. Jennings, and translated by Edmund Jepcott, et al., vol. 3, 32–49. Cambridge, Mass.: Harvard University Press, 2000.

Berger, Harry Jr. *Fictions of the Pose: Rembrandt Against the Italian Renaissance*. Stanford: Stanford University Press, 2000.

Bergová, Natalia. *The Jews of Czechoslovakia: Historical Studies and Surveys*. Philadelphia: Jewish Publication Society of America, 1968.

Bernard, Hélène. *Le Portrait Anthologie: Présentation, notes, choix des extraits et dossier*. Paris: Flammarion, 2005.

Beyer, Andreas. *Portraits: A History*, translated by Steven Lindberg. New York: Abrams, 2003.

Bilski, Emily D. *Berlin Metropolis: Jews and the New Culture 1890–1918*. Berkeley: University of California Press, 1999.

Bode, Wilhelm von. *Italienische Porträtsculpturen des XV: Jahrhunderts in den königlichen Museen zu Berlin*. Berlin: Reichsdruckerei, 1883.

Borch-Jacobsen, Mikkel. *The Freudian Subject*, translated by Catherine Porter. Stanford: Stanford University Press, 1988.

Brandstätter, Christian. "Schöne jüdische Jour-Damen: Gustav Klimt's Damen-Porträts und seine Auftraggeber-Ein verdrängtes Kapitel österreichische Sammlergeschichte." In *Gustav Klimt*, exhibition catalogue Kunsthaus Zürich, 325–37. Stuttgart: Gerd Hatje, 1992.

Breckenridge, James D. *Likeness: A Conceptual History of Ancient Portraiture*. Evanston, Ill.: Northwestern University Press, 1968.

Brilliant, Richard. *Portraiture*. London: Reaktion Books, 1991.

———. "Portraits as Silent Claimants: Jewish Class Aspirations and Representational Strategies in Colonial and Federal America." In *Facing the New World: Jewish Portraits in Colonial and Federal America*, edited by Richard Brilliant and Ellen Smith, 1–8. New York: Jewish Museum, 1997.

Brod, Max. *Franz Kafka: A Biography*. New York: Schocken, 1960.

Bryson, Norman et al. "Responses to Mieke Bal's 'Visual Essentialism and the Object of Visual Culture.'" *Journal of Visual Culture* 2 (August 2003): 229–68.

Buchloch, Benjamin H. "Residual Resemblance: Three Notes on the Ends of Portraiture." In *Face-Off: The Portrait in Recent Art*, edited by Melissa E. Feldman, 53–69. Philadelphia: Institute of Contemporary Art, University of Pennsylvania, 1994.

———. "Gerhard Richter's *Atlas*: The Anomic Archive." *October* 88 (spring 1999): 117–45.

Burckhardt, Jacob. "Das Porträt in der italienischen Malerei." In *Beiträge zur kunstgeschichte von Italien*, 146–294. Basel: G. F. Lendorff, 1898.

———. *Il Ritratto nella Pittura Italiana del Rinascimento*, translated by Daniela Pagliai. Rome: Bulzoni, 1993.

———. *Die Kunst der Renaissance in Italien*, edited by Heinrich Wölfflin. Stuttgart: Deutsche Verlags-Anstalt, 1932.

———. *The Civilization of the Renaissance in Italy*, translated by S. G. C. Middlemore. New York: Harper, 1958.

Burton, Gideon O. "Silva Rhetoricae," <http://humanities.byu.edu/rhetoric/silva.htm>.

Butler, Judith. *Subjects of Desire: Hegelian Reflections in Twentieth-Century France*. New York: Columbia University Press, 1987.

———. *The Psychic Life of Power: Theories in Subjection*. Stanford: Stanford University Press, 1997.

Careri, Giovanni. "Aby Warburg: Rituel, *Pathosformel* et Forme Intermédiaire." *L'Homme* 165 (January/March 2003): 41–76.

Carrier, David. *The Aesthetics of Comics*. University Park: Pennsylvania State University Press, 2000.

Clark, T. J. "The Conditions of Artistic Creation." *TLS*, 24 May 1974, 561–62.

———. *The Painting of Modern Life: Paris in the Art of Manet and His Followers*. New York: Knopf, 1985.

Clarke, Graham. *The Photograph*. Oxford: Oxford University Press, 1997.

Coburn, Alvin Langdon. *Alvin Langdon Coburn Photographer: An Autobiography*, edited by Helmut and Alison Gernsheim. New York: Praeger, 1966.

Cohen, Richard I. *Jewish Icons: Art and Society in Modern Europe*. Berkeley: University of California Press, 1998.

Crary, Jonathan. *Suspension of Perception: Attention, Spectacle, and Modern Culture*. Cambridge: MIT Press, 1999.

Dabrowski, Magdalena. *Egon Schiele: The Leopold Collection*. Cologne: Dumont Buchverlag, 1997.

Danto, Arthur. *Jean-Paul Sartre*. New York: Viking, 1975.

De Lauretis, Teresa. "Special Topic: On the Cinema Topic." *PMLA* 106 (May 1992): 412–18.

Deleuze, Gilles. *Foucault*, translated by Seán Hand. Minneapolis: University of Minnesota Press, 1986.

Derrida, Jacques. "La loi du genre/The Law of Genre." *Glyph* 7 (1980).

———. *The Work of Mourning*, edited by Pascale-Anne Brault and Michael Naas. Chicago: University of Chicago Press, 2001.

Didi-Huberman, Georges. *Devant le Temps: Histoire de l'Art et Anachronisme des Images*. Paris: Minuit, 2000.

————. *L'Image Survivante: Histoire de l'art et temps des fantômes selon Aby Warburg*. Paris: Minuit, 2002.

Druick, Douglas, and Michel Hoog. *Fantin-Latour*. Ottawa: National Gallery of Canada, 1983.

Eisler Colin. "*Kunstgeschichte* American Style: A Study in Migration." In *The Intellectual Migration: Europe and America, 1930–1960*, edited by Donald Fleming and Bernard Bailyn, 544–629. Cambridge, Mass.: Harvard University Press, 1969.

Eskildsen, Üte. "Photography and the Neue Sachlichkeit Movement." In *Neue Sachlichkeit and German Realism of the Twenties*, 85–97. London: Arts Council of Great Britain, 1978.

Fischer, Wolfgang. "Kokoschka's Early Work: A Conversation Between the Artist and Wolfgang Fischer." *Studio International* 181 (January 1971): 5.

Foucault, Michel. *Discipline and Punish: The Birth of the Prison*, translated by Alan Sheridan. New York: Vintage Books, 1979.

————. *Power/Knowledge: Selected Interviews and Other Writings, 1972–77*, edited by Colin Gordon. New York: Pantheon, 1980.

————. *This Is Not a Pipe*, translated and edited by James Harkness. Berkeley: University of California Press, 1983.

Frei, Bruno. *Judisches Elend in Wien*. Vienna: R. Löwit, 1920.

Friedlander, Walter. *Mannerism and Anti-Mannerism in Italian Painting*. New York: Schocken, 1957.

Frodl, Gerbert, and G. Tobias Natter. *Kokoschka und Wien*. Vienna: Österreichische Galerie Belvedere, 1996.

Gadamer, Hans-Georg. *Truth and Method*. New York: Continuum, 1975.

Galassi, Peter. "Rodchenko and Photography's Revolution." In Magdalena Dabrowski, Leah Dickerman, and Peter Galassi, *Aleksandr Rodchenko*, 101–37. New York: Museum of Modern Art, 1998.

Goerhe, Franz. *Die Kunst in der Photographie*. Berlin: Julius Buher, 1899.

Goldstein, Bluma. "Andy Warhol: His Kafka and 'Jewish Geniuses.'" *Jewish Social Studies* 7 (fall 2000): 127–40.

Gombrich, E. H. "The Experiment of Caricature." In *Art and Illusion: A Study in the Psychology of Pictorial Representation*, 330–58. Princeton: Princeton University Press, 1960.

————. "The Study of Art and the Study of Man: Reminiscences of Collaboration with Ernst Kris (1900–1957)." In *Tributes: Interpreters of Our Cultural Tradition*, 221–33. Ithaca: Cornell University Press, 1984.

————. *Kokoschka in His Time*. London: Tate Gallery, 1986.

————. *Aby Warburg: An Intellectual Biography*. Chicago: University of Chicago Press, 1986.

Gombrich, E. H., and Ernst Kris. *Caricature.* Harmondsworth: King Penguin, 1940.

Grünwald, Max. "Die Wiener Juden 1826–1926." *Menorah: Jüdisches Familienblatt für Wissenschaft/Kunst und Literatur* 4 (March 1926): 134–48.

Harker, Margaret. *The Linked Ring: The Secession Movement in Photography in Britain 1892–1910.* London: Royal Photographic Society, 1979.

Hauser, Arnold. *A Social History of Art.* New York: Knopf, 1951.

———. *The Sociology of Art,* translated by Kenneth J. Northcott. Chicago: University of Chicago Press, 1982.

Haxthausen, Charles W. "Zwischen Darstellung und Parodie: Klees 'auratische' Bilder." In *Paul Klee: Kunst und Karriere: Beiträge des Internationalen Symposiums in Bern,* edited by Oskar Bätschmann and Josef Helfenstein, 9–26. Bern: Stämpfli Verlag AG, 2000.

Hazan, Olga. *Le Mythe du Progrès Artistique: Étude Critique d'un Concept Fondateur du Discours sur l'art depuis la Renaissance.* Montreal: University of Montreal, 1999.

Held, Julius. "Hans Tietze—1880–1954." *College Art Journal* 14 (fall 1954): 67–69.

Higgs, Matthew, Kevin Killian, and David Robbins. *Likeness: Portraits of Artists by Other Artists.* San Francisco: CCA Wattis Institute for Contemporary Arts, 2004.

Hinton, Horsley. "Pictorial Photography in Austria and Germany." In *Art in Photography: With Selected Examples of European and American Work,* edited by Charles Holme. London: The Studio, 1905.

Hochreiter, Otto, and Timm Starl, eds. *Geschichte der Fotografie in Österreich.* Bad Ischl: Museum des 20. Jahrhunderts, 1983.

Hoden, J. P. *Bekenntnis zu Kokoschka.* Berlin: Florian Kupfeberg, 1963.

Hoffmann, Edith. *Kokoschka: Life and Work.* Boston: Boston Book and Art Shop, n.d.

Hornblower, Simon, and Anthony Spawforth, eds. *The Oxford Classical Dictionary,* 3rd ed. Oxford: Oxford University Press, 1996.

Hundhausen, J. "Grundzüge der Photographischen Ästhetik." *Photographische Mitteilungen* 43 (1906): 340–51, 363–70, 393–404.

Husserl, Sigmund. *Grundungsgeschichte des Stadt-Tempels der Israel. Kultusgemeinde Wien.* Vienna: Wilhelm Braumuller, 1906.

International Biographical Dictionary of Central European Émigrés 1933–1945. Munich: K. G. Saur, 1983.

Jackson, Earl. *Strategies of Deviance: Studies in Gay Male Representation.* Bloomington: Indiana University Press, 1995.

Jonsson, Stefan. *Subject Without Nation: Robert Musil and the History of Modern Identity.* Durham, N.C.: Duke University Press, 2000.

Kafka, Franz. *Diaries, 1914–1923*, edited by Max Brod and translated by M. Greenberg and H. Arendt. New York: Schocken, 1949.

———. *Tagebücher*, edited by Hans-Gerd Koch, Michel Müller, and Malcolm Pasley. Frankfurt a. M.: S. Fischer, 1990.

Kahr, Madlyn Millner. "Erica-Tietze Conrat: Productive Scholar in Renaissance and Baroque Art." In *Women as Interpreters of the Visual Arts 1820–1979*, edited by Claire Richter Sherman, 301–26. Westport, Conn.: Greenwood Press, 1981.

Kayser, Werner. *Alfred Lichtwark*. Hamburg: Hans Christians, 1977.

Keller, Judith. "Warhol: Andy Warhol's Photo-Biography." In *Nadar Warhol: Paris New York*, 133–44. Los Angeles: J. Paul Getty Museum, 1999.

Kempe, Fritz. *Vor der Camera: Zur Geschichte der Photographie in Hamburg*. Hamburg: Hans Christians, 1976.

Klein, Dennis B. *Jewish Origins of the Psychoanalytic Movement*. New York: Praeger, 1981.

Koerner, Joseph. "Rembrandt and the Epiphany of the Face." *RES* 12 (fall 1986): 5–32.

———. *The Moment of Self-Portraiture in German Renaissance Art*. Chicago: University of Chicago Press, 1993.

Kojève, Alexandre. *Introduction to the Reading of Hegel: Lectures on the 'Phenomenology of Spirit' Assembled by Raymond Queneau*, edited by Alan Bloom and translated by James H. Nichols Jr. Ithaca: Cornell University Press, 1969.

Kokoschka, Oskar. "On the Nature of Visions, 1912." Reprinted in *Oskar Kokoschka: Early Portraits from Vienna and Berlin 1909–1914*, edited by Tobias G. Natter, 234–36. New York: Neue Galerie, 2002.

———. *My Life*, translated by David Britt. New York: Macmillan, 1974.

Kracauer, Siegfried. "Photography," translated by Thomas Y. Levin. *Critical Inquiry* 19 (spring 1993): 423.

Krapf-Weiler, Almut. "Löwe und Eule: Hans Tietze und Erica Tietze-Conrat —eine biographische Skizze." *Belvedere* (1999): 64–83.

Krauss, Rosalind. "Sculpture in the Expanded Field." In *The Anti-Aesthetic: Essays on Postmodern Culture*, edited by Hal Foster, 31–42. Port Townsend, Wash.: Bay Press, 1983.

Kris, Ernst. "The Psychology of Caricature." *The International Journal of Psychoanalysis* 17 (1936): 285–303.

———. *Psychoanalytic Explorations in Art*. New York: Schocken, 1952.

Kris, Ernst, and E. H. Gombrich. "The Principles of Caricature." *The British Journal of Medical Psychology* 17 (1938): 319–42.

Kristeller, Paul Oskar. "The Modern System of the Arts." In *Renaissance Thought and the Arts*, 163–227. Princeton: Princeton University Press, 1980.

Kronberger-Frentzen, Hanna. *Das deutsche familien Bildnis*. Leipzig: Johannes Asmus, 1940.

Lacan, Jacques. "The Mirror Stage as Formative of the Function of the I as Revealed in Psychoanalytic Experience." In *Ecrits: A Selection*, translated by Alan Sheridan, 1–7. New York: W. W. Norton, 1977.

Laplanche, J., and J.-B. Pontalis. *The Language of Psycho-Analysis*, translated by Donald Nicholson-Smith. New York: W. W. Norton, 1973.

Levinas, Emmanuel. *Outside the Subject*, translated by Michael B. Smith. Stanford: Stanford University Press, 1994.

Lichtwark, Alfred. *Das Bildnis in Hamburg*. Hamburg: Der Kunstverein zu Hamburg, 1898.

Lieberman, E. James. *Acts of Will: The Life and Work of Otto Rank*. Amherst: University of Massachusetts Press, 1985.

Loescher, Fritz. "La Photographie Professionelle en Allemagne." *La Revue de Photographie* (January 1904), Paris Photo Club.

———. *Die Bildnis-Photographie: Ein Wegweiser für Fachmänner und Liebhaber*. Berlin: Gustav Schmidt, 1910.

Lukács, György. *The Lukács Reader*, edited by Arpad Kadarkay. Oxford: Blackwell, 1995.

Mann, Vivian, and Joseph Gutman, eds. *Danzig 1939: Treasures of a Destroyed Community*. New York: Jewish Museum, 1980.

Marchi, Riccardo. "Hans Tietze e la storia dell'arte come scienza dello spirito nell' Vienna del primo Novecento." *Arte Lombarda* 110/111 (1994): 55–66.

Marin, Louis. *Philippe de Champaigne, ou, La Présence cachée*. Paris: Hazan, 1995.

Matthies-Masuren, Fritz. *Gummidrucke von Hugo Henneberg, Wien, Heinrich Kühn, Innsbruck, und Hans Watzek, Wien*. Halle: Wilheim Knapp, 1907.

McCauley, Elizabeth Anne. *Likenesses: Portrait Photography in Europe 1850–1870*. Albuquerque: Albuquerque Art Museum, 1980.

———. *A. A. E. Disdéri and the Carte de Viste Portrait Photograph*. New Haven: Yale University Press, 1985.

McCully, Marilyn. "'Dans le piège du regard scrutateur de Picasso.'" In *Picasso et le Portrait*, edited by William Rubin, 224–53. Paris: Flammarion, 1996.

Mendes-Flohr, Paul. "The Retrieval of Innocence and Tradition: Jewish Spiritual Renewal in an Age of Liberal Individualism." In *The Uses of Tradition: Jewish Continuity in the Modern Era*, edited by Jack Wertheimer, 279–301. New York: Jewish Theological Seminary of America, 1992.

Minor, Vernon. *Art History's History*. Englewood Cliffs, N.J.: Prentice Hall, 1994.

Moholy-Nagy, Laszlo. *Malerei, Photographie, Film*. Munich: Langen, 1925.

Müntz, Eugène. "Le Musée de Portraits de Paul Jove: Contributions pour servir à l'iconographie du Moyen Age et de la Renaissance." *Mémoires de l'Academie des Inscriptions et Belles-lettres* 36 (1900): 250–343.

Münz, Ludwig, and Gustav Künstler. *Adolf Loos: Pioneer of Modern Architecture*, with an introduction by Nikolaus Pevsner and an appreciation by Oskar Kokoschka. New York: Praeger, 1966.

Myers, David N., and William V. Rowe, eds. *From Ghetto to Emancipation: Historical and Contemporary Reconsiderations of the Jewish Community*. Scranton, Penn.: University of Scranton Press, 1997.

Naef, Weston. *The Painterly Photograph: 1890–1914*. New York: Metropolitan Museum of Art, 1973.

———. *The Collection of Alfred Stieglitz: Fifty Pioneers of Modern Photography*. New York: Metropolitan Museum of Art, 1978.

Nahm, Milton. *The Artist as Creator: An Essay of Human Freedom*. Baltimore: Johns Hopkins University Press, 1956.

Natter, G. Tobias. "Austellungen der Galerie Miethke 1904–1912." In *Carl Moll (1861–1945)*, 151–93. Vienna: Österreichische Galerie-Belveder, 1998.

———. *Oskar Kokoschka: Early Portraits From Vienna and Berlin, 1909–1914*. New York: Neue Galerie, 2002.

Nelson, Robert. "The Slide Lecture, or the Work of Art History in the Age of Mechanical Reproduction." *Critical Inquiry* 26 (spring 2000): 414–34.

Nochlin, Linda. "Impressionist Portraits and the Construction of Modern Identity." In *Renoir's Portraits: Impressions of an Age*, edited by Colin Bailey, 53–75. New Haven: Yale University Press, 1997.

Nunberg, Herman, and Ernst Federn, eds. *Minutes of the Vienna Psychoanalytic Society*, translated by M. Nunberg. 4 vols. New York: International Universities Press, 1967.

Ogilvie, Bertrand. *Lacan: La Formation du Concept de Sujet 1932–1949*. Paris: Presses Universitaires de France, 1987.

Olin, Margaret. *Forms of Representation in Alois Riegl's Theory of Art*. University Park: Pennsylvania State University Press, 1992.

———. "Art History and Ideology: Alois Riegl and Josef Stryzgowski." In *Cultural Visions: Essays in the History of Culture*, edited by Penny Schine Gold and Benjamin C. Sax, 151–70. Amsterdam: Rodopi, 1999.

———. "Touching Photographs: Roland Barthes's 'Mistaken' Identification." *Representations* 80 (fall 2002): 99–118.

Paris Photo Club. *Première Exposition d'Art Photographique*. Paris: Paris Photo Club, 1894.

Podro, Michael. *The Critical Historians of Art*. New Haven: Yale University Press, 1982.

————. *Depiction*. New Haven: Yale University Press, 1998.

Pointon, Marcia. *Hanging the Head: Portraiture and Social Formation in Eigthteenth-Century England*. New Haven: Yale University Press, 1993.

————. "Kahnweiler's Picasso; Picasso's Kahnweiler." In *Portraiture: Facing the Subject*, edited by Joanna Woodall, 189–202. Manchester: Manchester University Press, 1997.

Pollak, Max. *Die Juden in Wiener-Neustadt: Ein Beitrag zur Geschichte der Juden in Österreich*. Vienna: Jüdischer Verlag, 1927.

Pollock, Elizabeth. "Biography of the Photographer Kühn." In *Heinrich Kühn*, 5–14. Cologne: Greven and Bechtold, 1981.

Pommier, Édouard. *Théories du Portrait: De la Renaissance aux Lumières*. Paris: Gallimard, 1998.

Potts, Alex. "Sign." In *Critical Terms for Art History*, edited by Robert S. Nelson and Richard Shiff. Chicago: Chicago University Press, 1996.

Preziosi, Donald. *The History of Art History: A Critical Anthology*. Oxford: Oxford University Press, 1998.

Rank, Otto. "Der Künstler: Ansatze zu einer Sexual-Psychologie," translated by Eva Salomon with E. James Lieberman from the 4th ed., Vienna: Hugo Heller, 1907. *Journal of the Otto Rank Association* 15 (summer 1980): 7.

Ricoeur, Paul. *Freud and Philosophy: An Essay on Interpretation*, translated by Denis Savage. New Haven: Yale University Press, 1970.

————. *Temps et Récit*. 3 vols. Paris: Seuil, 1985.

Riegl, Alois. "Das holländische Gruppenporträt." *Jahrbuch der kunsthistorischen Sammulungen des allerhochsten Kaiserhauses* 23 (1902): 71–278.

————. *Das holländische Gruppenporträt*, edited by Karl Maria Swoboda. Vienna: Österreichische Staatsdruckerei, 1931.

————. "Excerpts from The Dutch Group Portrait," translated by Benjamin Binstock. *October* 74 (fall 1995): 3–35.

————. *The Group Portraiture of Holland*, translated by David Britt. Los Angeles: Getty Research Institute for the History of Art and the Humanities, 1999.

Rodchenko, Aleksandr. "Against the Synthetic Portrait, For the Snapshot." In *Photography in the Modern Era: European Documents and Critical Writings 1913–1940*, edited by Christopher Phillips, 239. New York: Metropolitan Museum of Art, 1989.

Roth, Michael S. *Knowing and History: Appropriations of Hegel in Twentieth-Century France*. Ithaca, N.Y.: Cornell University Press, 1988.

Rotter, Hans, and Adolf Schmieger. *Das Ghetto in der Wiener Leopoldstadt*. Vienna: Burgverlag, 1926.

Roudinesco, Elisabeth. *Jacques Lacan: Outline of a Life, History of a System*

of Thought, translated by Barbara Bray. New York: Columbia University Press, 1997.

Rozenblit, Marsha L. *The Jews of Vienna, 1867–1914: Assimilation and Identity*. Albany: SUNY Press, 1983.

Sartre, Jean-Paul. *L'imaginaire*. Paris: Gallimard, (1940), 1986.

———. *The Psychology of Imagination*. Westport, Conn.: Greenwood Press, 1948.

Saussure, Ferdinand de. *Course in General Linguistics*, edited by Charles Bally and Albert Sechehaye and translated by Wade Baskin. New York: Philosophical Library, 1959.

Sayre, Henry M. *Writing About Art*. Englewood Cliffs, N.J.: Prentice-Hall, 2002.

Scarrocchia, Sandro. *Studi su Alois Riegl*. Florence: Nuova Alfa, 1986.

Schiendl, C. *Die künstlerische Photographie*. Vienna: U. Hartleben's Verlag, 1889.

Schlosser, Julius von. *La Storia dell'Arte nelle esperienze e nei ricordi di un suo cultore*, translated by Giovanna Frederici Ajroldi. Bari: Laterza and Figli, 1936.

Schmied, Erika, ed. *Neue Sachlichkeit and German Realism of the Twenties*. London: Hayward Gallery and Arts Council of Great Britain, 1978.

Schoell-Glass, Charlotte. *Aby Warburg und der Antisemitismus: Kulturwissenschaft als Geistespolitik*. Frankfurt-am-Main: Fischer, 1998.

Schorske, Carl E. *Fin-de-Siècle Vienna: Politics and Culture*. New York: Random House, 1961.

Schroder, Klaus Albrecht, and Johann Winkler, eds. *Oskar Kokoschka*. Munich: Prestel-Verlag, 1991.

Schwarz, Heinrich. *David Octavius Hill: Der Meister der Photographie*. Leipzig: Insel, 1931.

———. *David Octavius Hill: Master of Photography*, translated by Helene E. Fraenkel. London: George G. Harrap, 1932.

Settis, Salvatore. "Kunstgeschichte al vergleichende Kulturwissenschaft: Aby Warburg, die Pueblo-Indianer und das Nachleben der Antike." In *Kunsthistorisches Austausch-Akten des XIII Kongress für Kunstgeschichte*, edited by T. W. Goehtgens, 139–58. Berlin: Akademie Verlag, 1993.

———. "Pathos und Ethos, Morphologie und Funktion." In *Vorträge aus dem Warburg-Haus*, vol. 1, 31–73. Berlin: Akademie Verlag, 1997.

Shapira, Elana. "The Interpretation of Children's Drawings and the Reception of Kokoschka's Work at the Kunstschau 1908." In *Oskar Kokoschka-Aktuelle Perspektiven*, edited by Patrick Werkner. Vienna: Hochschule für angewandte Kunst, 1998.

———. "The Pioneers: Loos, Kokoschka, and Their Shared Clients." In *Oskar Kokoschka: Early Portraits from Vienna and Berlin, 1909–1914*, edited by Tobias G. Natter, 50–60. New York: Neue Galerie, 2002.

Silverman, Debora. *Van Gogh and Gauguin: The Search for the Sacred in Art.* New York: Farrar, Straus, and Giroux, 2000.

Silverman, Kaja. *The Subject of Semiotics.* New York: Oxford University Press, 1983.

Simmel, Georg. "The Aesthetic Significance of the Face." In *Georg Simmel, 1858–1918*, edited by Kurt H. Wolff, 276–81. Columbus: Ohio State University Press, 1959.

Simons, Patricia. "Portraiture, Portrayal, and Idealization: Ambiguous Individualism in Representations of Renaissance Women." In *Language and Images of Renaissance Italy*, 263–311. Oxford: Clarendon, 1995.

Smith, Joel. *Edward Steichen: The Early Years.* Princeton: Princeton University Press, 1999.

Solomon-Godeau, Abigail. *Photography at the Dock: Essays on Photographic History, Institutions, and Practices.* Minneapolis: University of Minnesota Press, 1991.

Soskice, Janet Martin. "Sight and Vision in Medieval Christian Thought." In *Vision in Context: Historical and Contemporary Perspectives in Sight*, edited by Teresa Brennan and Martin Jay, 29–43. New York: Routledge, 1996.

Soussloff, Catherine M. "Review Article: The Turn to Visual Culture." *Visual Anthropology Review* 12 (spring 1996): 77–83.

———. *The Absolute Artist: The Historiography of a Concept.* Minneapolis: University of Minnesota Press, 1997.

———. "The Concept of the Artist." In *The Encyclopedia of Aesthetics*, edited by Michael Kelly, vol. 1, 130–35. New York: Oxford University Press, 1998.

———. "The Aura of Power and Mystery that Surrounds the Artist." In *Rückkehr des Autors. Zur Erneurung eines umstrittenen Begriffs*, edited by Fotis Jannis et al., 481–93. Munich: Max Niemeyer Verlag, 1999.

———. "Like a Performance: Performativity and the Historicized Body, From Bellori to Mapplethorpe." In *Acting on the Past: Historical Performance Across the Disciplines*, edited by Mark Franko and Annette Richards, 69–98. Hanover, Conn.: Wesleyan University Press, 2000.

———. "Art Photography, History, and Aesthetics." In *Art History and Its Institutions: Foundations of a Discipline*, edited by Elizabeth Mansfield, 295–313. London: Routledge, 2002.

———. Review of *The Vienna School Reader: Politics and Art Historical Method in the 1930s*, edited by Christopher Wood. *Centropa* 2 (fall 2002): 230–32.

———. "Jackson Pollock's Post-Ritual Performance: Memories Arrested in Space." *The Drama Review* 48 (spring 2004): 60–78.

———. "The Trouble With Painting, the Image (less) Text." *Journal of Visual Culture* 4(2) (2005): 203–36.

———. "Art." In *Palgrave Advances in Renaissance Historiography*, edited by Jonathan Woolfson, 141–55. New York: Palgrave Macmillan, 2005.

———, ed. *Jewish Identity and Modern Art History*. Berkeley: University of California Press, 1999.

Soussloff, Catherine M., and Mark Franko. "Visual and Performance Studies: A New History of Interdisciplinarity." *Social Text* 73 (winter 2002): 29–46.

Stefan, Paul. *Das Grab in Wien: Eine Chronik 1903–1911*. Berlin: Erich Reiss Verlag, 1913.

———. *Dramen und Bilder: Oskar Kokoschka*. Leipzig: Kunst Wolff, 1913.

Stein, Gertrude. *Picasso*. Boston: Beacon Press, 1959.

Steinert, Otto, ed. *Kunstphotographie um 1900*. Essen: Folwangschule, 1964.

Tagg, John. *The Burden of Representation: Essays on Photographies and Histories*. Amherst: University of Massachusetts Press, 1988.

This, Claude, ed. *De l'Art et de la Psychanalyse Freud et Lacan*. Paris: École Nationale Superieure des Beaux-Arts, 1999.

Tietze, Hans. "L. Dumont-Wilden, *Le Portrait en France*." *Monatshefte für Kunstwissenschaft* 3 (1910): 209.

———. *Die Juden Wiens: Geschichte-Wirtschaft-Kultur*. Leipzig: E. P. Tal, 1933.

Timms, Edward. *Karl Kraus: Apocalyptic Satirist*. New Haven, Conn.: Yale University Press, 1986.

Vaisse, Pierre. "Between Convention and Innovation—the Portrait in France in the Nineteenth Century." In *Degas Portraits*, edited by Felix Baumann and Marianne Karabelnik, 118–34. Zürich: Kunsthaus Zürich, 1994.

Varnedoe, Kirk. *Vienna 1900: Art, Architecture, and Design*. New York: Museum of Modern Art, 1986.

Vergo, Peter. *Klimt, Kokoschka, Schiele and Their Contemporaries*, 3rd ed. London: Phaidon, 1993.

Vogel, H. W. *Handbuch der Photographie: Die Photographische Praxis*. Berlin: Gustav Schmidt, 1897.

Waetzoldt, Wilhelm. *Die Kunst des Porträts*. Leipzig: Ferdinand Hirt and Sohn, 1908.

Warburg, Aby. *Bildniskunst und florentinishches Burgertum*. Leipzig: Hermann Seemann Nachfolger, 1902.

———. *Die Erneurung der heidnischen Antike: Kulturwissenschaftliche Bei-*

trage zur Geschichte der europaischen Renaissance, edited by Gertrude Bing. Leipzig: B. G. Teubner Verlag, 1932.

———. *Images from the Region of the Pueblo Indians of North America*, translated by Michael Steinberg. Ithaca: Cornell University Press, 1995.

———. "The Art of Portraiture and the Florentine Bourgeoisie." In *The Renewal of Pagan Antiquity: Contributions to the Cultural History of the European Renaissance*, translated by David Britt, 185–221. Los Angeles: Getty Research Institute for the History of Art and the Humanities, 1999.

Warnke, Martin. "Individuality as Argument: Piero della Francesca's *Portrait of the Duke and Duchess of Urbino*." In *The Image of the Individual: Portraits in the Renaissance*, edited by Nicholas Mann and Luke Syson, 81–83. London: British Museum Press, 1988.

Warstat, Willi. *Allgemeine Ästhetik der photographischen Kunst auf psychologischer Grundlage*. Halle: Knapp, 1909.

Wendland, Ulrike. *Biographisches Handbuch deutschsprachiger Kunsthistoriker im Exil: Leben und Werk der unter dem Nationalsozialismus verfolgten und vertriebenen Wissenschaftler*. 2 vols. Munich: K. G. Saur, 1999.

Werkner, Patrick. *Austrian Expressionism: The Formative Years*, translated by Nicholas T. Parsons. Palo Alto, Calif.: Society for the Promotion of Science and Scholarship, 1986.

Wertheimer, Jack, ed. *The Uses of Tradition: Jewish Continuity in the Modern Era*. New York: Jewish Theological Seminary, 1992.

White, Hayden. *Metahistory: The Historical Imagination in the Nineteenth Century*. Baltimore: Johns Hopkins University Press, 1973.

Williams, Raymond. *Keywords: A Vocabulary of Culture and Society*, 2nd ed. New York: Oxford University Press, 1983.

Winkler, Johann, and Katharina Erling. *Oskar Kokoschka: Die Gemälde 1906–1929*. Salzburg: Verlag Galerie Welz, 1995.

Woerman, Karl. *Führer zur Kunst: Die Italienische Bildnismalerei der Renaissance*. Esslingen: Paul Neff, 1906.

Wollen, Peter. *Signs and Meaning in the Cinema*. Bloomington: Indiana University Press, 1972.

Wood, Christopher S. *The Vienna School Reader: Politics and Art Historical Method in the 1930s*. New York: Zone Books, 2000.

Woodall, Joanna, ed. *Portraiture: Facing the Subject*. Manchester: Manchester University Press, 1997.

Yerushalmi, Yosef Hayim. *Freud's Moses: Judaism Terminable and Interminable*. New Haven: Yale University Press, 1991.

Zerner, Henri, "L'Histoire de l'Art de'Alois Riegl: Un Formalisme Tactique." In *Écrire l'Histoire de l'Art: Figures d'une Discipline*, 35–49. Paris: Gallimard, 1997.

ILLUSTRATION CREDITS

1. Pablo Picasso, *Portrait of Gertrude Stein*, 1906. The Metropolitan Museum of Art, Bequest of Gertrude Stein, 1946. © 2005 Estate of Pablo Picasso/ Artists Rights Society (ARS), New York.

2. Jan Van Eyck, *The Arnolfini Wedding Portrait*, 1434. © National Gallery, London.

3. Medieval icon, *Christ Pantocrator*, fourteenth century. Istanbul, Kahrieh Djani, outer narthex, dominical vault, east lunette, <http://www.joeberk photography.com>.

4. Anthony Van Dyck, *Thomas Howard, 2nd Earl of Arundel*, 1630. The J. Paul Getty Museum, Los Angeles. © The J. Paul Getty Museum.

5. Domenico Ghirlandaio, *The Miracle of the Little Boy*, 1482–86. Detail from Santa Trinità, Florence.

6. Dirck Jacobsz, *A Company of the Civic Guard*, 1529. © Rijksmuseum, Amsterdam.

7. Pierre-Auguste Renoir, *Marie-Thérèse Durand-Ruel Sewing*, 1882. Oil on canvas. © Sterling and Francine Clark Art Institute, Williamstown, Massachusetts.

8. Gustav Klimt, *Portrait of Margarethe Stonborough-Wittgenstein*, 1905. © Bayerische Staatsgemäldesammlungen, Neue Pinakothek, Munich.

9. Anthony Van Dyck, *Portrait of a Genoese Noblewoman*, 1622–27. © The Frick Collection, New York.

10. Oskar Kokoschka, *Child in the Hands of the Parents*, 1909. Österreich-

ische Galerie Belevedere, Vienna. © 2005 Artists Rights Society (ARS), New York/ProLitteris, Zürich.

11. *Caricature of the Pope and the Devil*, in *Caricature*, by E. H. Gombrich and Ernst Kris, 27. Harmondsworth: King Penguin, 1940.

12. Book cover. Guy Debord, *Society of the Spectacle*, first American edition, 1972.

13. Title page. Hans Tietze, *Die Juden Wiens: Geschichte-Wirtschaft-Kultur*. Leipzig: E. P. Tal, 1933.

14. Oskar Kokoschka, *The Dreaming Boys* (book illustration), Research Library, Getty Research Institute, Los Angeles. © 2005 Artists Rights Society (ARS), New York/ProLitteris, Zürich.

15. Henri Fantin-Latour, *The Studio at Batignolles: Otto Schoelderer, Manet, Renoir, Zacharie Astruc, Zola, Edmond Maitre, Bazille and Monet*, 1870. Musée d'Orsay, Paris, France. Photo: Hervé Lewandowski. Photo credit: Réunion des Musées Nationaux/Art Resource, New York.

16. Oskar Kokoschka, Poster for *Der Sturm*. Szépmüvészeti Museum, Budapest. © 2005 Artists Rights Society (ARS), New York/ProLitteris, Zürich.

17. *Historic Rabbis*, broadside printed by the Graphische Kunstanstalt, Breslau, twentieth century, 66.2872. The HUC Skirball Cultural Center, Museum Collection, Los Angeles. Photo: Lelo Carter.

18. *Portrait of Tzevi Ashkenazi*. Courtesy of The Jewish Museum, London.

19. Petrus Christus, *Portrait of a Carthusian*, 1446. The Metropolitan Museum of Art, The Jules Bache Collection, 1949.

20. Gilbert Stuart, *Portrait of Moses Myers*, ca. 1808. Chrysler Museum of Art, Moses Myers House, Norfolk, Va. (The historic houses are property of the City of Norfolk and their collections are owned by the Chrysler Museum of Art.).

21. Gilbert Stuart, *Portrait of Eliza Myers*, ca. 1808. Chrysler Museum of Art, Moses Myers House, Norfolk, Va. (The historic houses are property of the City of Norfolk and their collections are owned by the Chrysler Museum of Art.).

22. Quentin Massys, *Portrait of a Woman*, ca. 1520. The Metropolitan Museum of Art, The Friedsam Collection, bequest of Michael Friedsam, 1931.

23. Quentin Massys, *Portrait of a Man*, ca. 1520. The Metropolitan Museum of Art, The Friedsam Collection, bequest of Michael Friedsam, 1931.

24. *Portrait of Sara Moscheles*. Courtesy of the Jewish Museum in Prague.

25. *Portrait of Wolf Moscheles*. Courtesy of the Jewish Museum in Prague.

26. Frontispiece. C. Schiendl, *Die künstlerische Photographie*. Vienna: U. Hartleben's Verlag, 1889.

27. Guillaume Dubufe, *Aquarelle*, 1894. The J. Paul Getty Museum, Los Angeles. © The J. Paul Getty Museum. (Paris Photo Club, *Première Exposition d'Art Photographique*, 1894).

28. Heinrich Graf, photographic proofs, volume 1, #310 ff., Berlin. Research Library, Getty Research Institute, Los Angeles.

29. Heinrich Graf, photographic proofs, volume 4, #9422 ff., Berlin. Research Library, Getty Research Institute, Los Angeles.

30. Illustration 5. H. W. Vogel, *Handbuch der Photographie: Die Photographische Praxis*. Berlin: Gustav Schmidt, 1897.

31. Baron Albert de Rothschild, *Tête d'étude: Dans le style italien du XVIe Siècle*, 1894. The J. Paul Getty Museum, Los Angeles. © The J. Paul Getty Museum. (Paris Photo Club, *Première Exposition d'Art Photographique*, 1894).

32. J. S. Bergheim, *Portrait of a "Gazaleh,"* 1894. The J. Paul Getty Museum, Los Angeles. © The J. Paul Getty Museum. (Paris Photo Club, *Première Exposition d'Art Photographique*, 1894).

33. Heinrich Kühn, *Portrait of Eduard Steichen*. The J. Paul Getty Museum. © The J. Paul Getty Museum, Los Angeles.

34. Pablo Picasso, *Portrait of Ambrose Vollard*, 1909–10. Pushkin Museum of Fine Arts, Moscow. © 2005 Estate of Pablo Picasso/Artists Rights Society (ARS), New York. Photo: Bridgeman-Giraudon/Art Resource, New York.

35. Pablo Picasso, *Portrait of Daniel-Henry Kahnweiler*, 1910. Gift of Mrs. Gilbert W. Chapman in memory of Charles B. Goodspeed. Photography. © The Art Institute of Chicago.

Color Plates

PLATE 1. Andy Warhol. *Ten Portraits of Jews of the Twentieth Century: Gertrude Stein*, 1980. © The Andy Warhol Foundation for the Visual Arts/Artists Rights Society/New York. Photo: The Andy Warhol Foundation, Inc./Art Resource, New York.

PLATE 2. Oskar Kokoschka, *Hans Tietze and Erica Tietze-Conrat*, 1909. © 2005 Artists Rights Society (ARS), New York/ProLitteris, Zürich. Digital image © The Museum of Modern Art/Licensed by SCALA/Art Resource, New York.

PLATE 3. Giorgione, *Portrait of a Young Man*, ca. 1505–6. Gemaeldegalerie, Staatliche Museen zu Berlin, Berlin, Germany. Photo: Joerg P. Anders. Photo credit: Bildarchiv Preussischer Kulturbesitz/Art Resource, New York.

PLATE 4. Pontormo (Jacopo Carucci), *Portrait of a Halberdier* (Francesco Guardi?), ca. 1528–30. The J. Paul Getty Museum, Los Angeles. © The J. Paul Getty Museum.

PLATE 5. Gauguin, Paul, *Tahitian Woman and Boy*, 1899. Norton Simon Art Foundation, gift of Mr. Norton Simon.

PLATE 6. Oskar Kokoschka, *Portrait of Felix Albrecht-Harta*, 1909. Hirshhorn Museum and Sculpture Garden, Smithsonian Institution, gift of the Joseph H. Hirschhorn Foundation, 1966. Photo: Lee Stalsworth. © 2005 Artists Rights Society (ARS), New York/ProLitteris Zürich.

PLATE 7. Oskar Kokoschka, *Portrait of Lotte Franzos*, 1909. The Phillips Collection, Washington, D.C. © 2005 Artists Rights Society (ARS), New York/ProLitteris, Zürich.

PLATE 8. Oskar Kokoschka, *Portrait of Baron Viktor Von Dirsztay*, 1911. Hannover, Sprengel Museum. © 2005 Artists Rights Society (ARS), New York/ProLitteris, Zürich.

PLATE 9. Rembrandt van Rijn, *The Mennonite Preacher Anslo and His Wife*, 1641. Gemaeldegalerie, Staatliche Museen zu Berlin, Berlin. Photo: Joerg P. Anders. Photo credit: Bildarchiv Preussischer Kulturbesitz/Art Resource, NY.

PLATE 10. Edouard Manet, *Portrait of Emile Zola*, ca. 1868. Musée d'Orsay, Paris, France. Photo: Hervé Lewandowski. Photo credit: Réunion des Musées Nationaux/Art Resource, New York.

PLATE 11. Heinrich Kühn, *Still-life* [Reminiscent of Dutch Painting], 1895. The J. Paul Getty Museum, Los Angeles. © The J. Paul Getty Museum.

PLATE 12. Heinrich Kühn, *Walther and Lotte Kühn*, ca. 1910. The J. Paul Getty Museum, Los Angeles. © The J. Paul Getty Museum.

PLATE 13. Heinrich Kühn, *Portrait of the Artist's Children*, 1912. J. Paul Getty Museum, Los Angeles. © The J. Paul Getty Museum.

PLATE 14. Heinrich Kühn, *Portrait of a Man Seated Beside a Supine Child*, 1900–10. The J. Paul Getty Museum, Los Angeles. © The J. Paul Getty Museum.

PLATE 15. Edouard Manet, *M. and Mme. Manet, Parents of the Artist*, 1860. Musée d'Orsay, Paris, France. Photo RMN: Hervé Lewandowski. Photo credit: Réunion des Musées Nationaux/Art Resource, New York.

PLATE 16. Pablo Picasso, *Portrait of Art Dealer Wilhelm Uhde*, 1910. © 2005 Estate of Pablo Picasso/Artists Rights Society (ARS), New York. Photo Credit: Erich Lessing/Art Resource, New York.

INDEX

CATHERINE M. SOUSSLOFF
is a professor of history of art and visual culture
at the University of California, Santa Cruz. She is the
author of *The Absolute Artist: The Historiography
of a Concept* and the editor of *Jewish Identity in
Modern Art History.*

Library of Congress Cataloging-in-Publication Data
Soussloff, Catherine M.
The subject in art : portraiture and the birth of the
modern / Catherine M. Soussloff.
p. cm.
Includes bibliographical references and index.
ISBN-13: 978-0-8223-3658-7 (cloth : alk. paper)
ISBN-10: 0-8223-3658-8 (cloth : alk. paper)
ISBN-13: 978-0-8223-3670-9 (pbk. : alk. paper)
ISBN-10: 0-8223-3670-7 (pbk. : alk. paper)
1. Portraits, Austrian—Austria—Vienna—20th century.
2. Subjectivity in art. 3. Self (Philosophy) in art.
4. Art—Historiography—History—20th century.
I. Title. N7602.S68 2006
704.9′4209436—dc22 2006007728